BRISTOL INTRODUCTIONS

Philosophy and the Arts

THOEMMES

ALSO IN THE SERIES

BERTRAND RUSSELL

by John Slater, *University of Toronto*

With a Preface by Ray Monk

PHILOSOPHY, MATHEMATICS, EDUCATION, POLITICS
ISBN 1 85506 347 6 : 184pp : Hb : 1994
ISBN 1 85506 346 8 : 184pp : Pb : 1994

THE LANGUAGE CONNECTION

by Roy Harris, *University of Oxford*

With a Preface by Ray Monk

PHILOSOPHY, LINGUISTICS
ISBN 1 85506 497 9 : 216pp : Hb : 1996
ISBN 1 85506 498 7 : 216pp : Pb : 1996

Printed in England by Antony Rowe

PHILOSOPHY AND THE ARTS

Seeing and Believing

Andrew Harrison

University of Bristol

Preface by
Ray Monk

Series Editor
University of Southampton

THOEMMES PRESS

Published in 1997 by
Thoemmes Press
11 Great George Street
Bristol BS1 5RR
United Kingdom

ISBN 1 85506 499 5 – Hardback
ISBN 1 85506 500 2 – Paperback

British Library Cataloguing-in-Publication Data

A catalogue record of this title is available
from the British Library

ACKNOWLEDGMENTS

Plate 1: Matthew Smith, *Winter Landscape, Cornwall*, 1920. Oil on Canvas, 54.2 x 64.8cm.
Reproduced with kind permission of the Glynn Vivian Art Gallery, Leisure Department, City and County of Swansea.

Plate 2: Peter Lanyon, *Porthleven*, 1951. Oil on Board, 244.5 x 121.9cm.
Reproduced with kind permission of Sheila Lanyon and by courtesy of the Tate Gallery, London.

Plate 3: Leonardo da Vinci, *Bird's-Eye Map Showing Arezzo, Borgho San Sepolchro, Perugia, Chiusi and Siena*, 1502. Pen ink and watercolour, 33.8 x 48.8cm.
Reproduced by courtesy of The Royal Collection, Her Majesty Queen Elizabeth II.

Plate 4: Pieter Saenredam, *Interior of the Buur Church, Utrecht*, 1644. Oil on Oak, 60.1 x 50.1cm.
Reproduced by courtesy of the Trustees, The National Gallery, London.

Plate 5: Pablo Picasso, *Nude at her Toilet*, 8 March 1970 (III). Ink and coloured pencil on corrugated cardboard, 31.5 x 31.5cm.
Copyright: Succession Picasso/DACS 1996. Reproduced by courtesy of the Tate Gallery, London.

Plate 6: Andrew Harrison, *Untitled*, 1979. Watercolour on paper, 24 x 16 cm.

Figure 1: Paul Klee, Textual Illustration – Line Drawing, Pen and Ink.
Copyright: DACS 1996. Reproduced with kind permission of Paul Klee Siftung, Kunst Museum, Bern. Illustration taken from *Paul Klee: The Thinking Eye,* by courtesy of Lund Humphries Publishers Ltd, 1961, reprinted 1964, and 1992.

CONTENTS

PART TWO: BELIEVING

Chapter Three: Metaphor

PREFACE

People nowadays think that scientists exist to instruct them, poets musicians, etc. to give them pleasure. The idea *that these have something to teach them* – that does not occur to them.

Ludwig Wittgenstein, *Culture and Value*

That there are important truths to be learned from a novel, a painting, a poem, or a piece of music, that there are things that can *only* be learned, communicated, through works of art is a thought that is easy to accept but almost impossibly difficult to articulate clearly. If we could say exactly *what* we had learned, say, from a piece of music, we would thereby have shown that the truth it communicated *could*, after all, be put into words. This, I think, is the source of the reluctance that artists typically feel when asked to 'explain' their work. In the face of such difficulties, the only possible responses might seem to be an inarticulate gesturing or a resigned silence. For the most part, contemporary Anglo-American philosophy has chosen silence. Though there is a vast literature on aesthetics, recent discussions have tended to steer clear of the large and crucial question of what art has to teach us in favour of more manageable (and less interesting) topics, such as the analysis of our critical vocabulary.

Andrew Harrison's challenging book is a welcome return to the tradition of such thinkers as Aristotle, Kant, Schopenhauer, Nietzsche and Collingwood,

philosophers whose discussions of art were premissed on the idea that the understanding of art is of the first importance in understanding ourselves. For Harrison, as for Collingwood, art is first and foremost a means of communication, and what it has to communicate is nothing less than what it means to be human. Thus, a right understanding of artistic communication can lead to – is a necessary part of – a richer understanding of the possibilities of human living.

The task that Harrison sets himself is the formidable one of investigating the kinds of communication of which art, and art alone, is capable. He is led by this investigation to the Wittgensteinian image of *limits* to our language. Ordinary literal language operates *inside* those limits, while art pushes at the limits themselves, occasionally transcending them to offer us new possibilities of thought, perception, expression and experience. A good painting enables us to *see* things we did not, could not, see before; a good metaphor extends our language, enabling us to think and *believe* things that previously could not have found expression; a good novel provides us with a new framework within which to think of ourselves. 'Sometimes – just often enough', says Harrison, 'the result may be to establish a new possibility of a shareable world'.

Harrison brings to his discussion of these large themes a rich and varied knowledge of painting, poetry and fiction, and avoids altogether the trite examples of aesthetic judgement ('That is good', 'This is beautiful') that have too often blighted the work of philosophers when discussing art. If his own prose is sometimes difficult to follow, this is unavoidable. For, after all, he, like the artists he is discussing, is operating at the limits of the expressible. Wittgenstein offered us a ladder of logical theory which he advised us to kick away once

we had scaled its heights; Harrison begins with the ladder already kicked out of sight. As he shows, however – and as Wittgenstein himself emphasized – what can be learned through the contemplation of art is of far more interest and importance than anything that can be said with the seductive, but ultimately barren, clarity of the propositional calculus. What can be said at all can be said clearly, Wittgenstein insisted. But what can, in this sense, be *said*, by no means exhausts what can be *learned*.

Ray Monk
Southampton, 1997

INTRODUCTION

Meanwhile the mind, from pleasure less
Withdraws into its happiness,
The Mind, that ocean where each kind
Does straight its own resemblance find
But it creates, transcending these
Far other worlds and other seas

Andrew Marvell, *The Garden*

In this great poem Marvell set out what is still in many ways our primary concept of the place of the mind with respect to art. How do those other worlds and other seas (which the mind creates in delight) 'transcend' the 'normal' products of experience? How do what we experience and what we imagine relate to one another? Such a question is at the same time a question about understanding, even about what it is to understand this poem itself, but it is also a question about what it is to be human. However, the essential preliminary to that wider matter must have to do with varieties of representation.

This study concentrates on representational art, more specifically on the conditions for such representation. It has to do with how pictures, metaphors and stories mean what they do and with the different *ways* that they do, and with how they teeter on the brink of their own significance.

In an important sense it is not concerned with aesthetics, but not because aesthetics does not matter.

The problems of aesthetics are supremely important, very wide-ranging, and are by no means confined to such simple matters of whether beauty or ugliness lies in the eye of the beholder, or whether aesthetic judgements are 'objective' or 'subjective' in some way or another. Very generally, what we value aesthetically we value in such a way that we cannot, or maybe cannot *yet*, incorporate within negotiable moral codes and agreements – within the public morality of fairness and justice. In a certain way this lies deeper than our sense of morality. It is as if we were to ask how our 'official' values and beliefs relate to our 'unofficial' ones. It is important to us that we value lovely environments and charming objects, charming, graceful, entertaining and attractive people, more than we think we should value useful things or morally good people. We are seriously entertained by interesting and complex, if morally deplorable, people and are delighted by strange and fascinating artefacts more than by those that we can make good sense of and use in clearer plans and policies. Important, and often embarrassing. This is one of the most neglected areas in the philosophy of value. Richard Wollheim points our attention in a similar direction. 'It seems to me natural', he says, 'that art is more deeply rooted in human nature than morality, and I am surprised by the fact that philosophers make little of the fact that, though good art is more likeable than bad art, virtuous people do not enjoy this same advantage over those to whom we are drawn primarily for their charm, or their gaiety, or their sweetness of nature or their outrageousness.'[1] This may well seem outrageous, but to a large extent negotiating the problem it locates is left to art itself.

[1] Richard Wollheim, *The Mind and Its Depths* (London: Harvard University Press, 1993), p. x.

Often it has been claimed, with varying degrees of certainty, that aesthetic judgement belongs to what is set aside from our normal beliefs about explanation or value. Terribly perhaps, but significantly, to a painter a road accident may also present a fascinating study in scarlet and grey, a visually dramatic tangle of shapes and forms. Thus it may seem that such an aesthetic stance involves either a profound, and horrifying, moral irresponsibility or else indicates a deep indifference, a deep detachment from concerns of value or explanation. However, the paradox is that if a painter, a writer or dramatist is to communicate even – or especially – the particular moral horror of an event, that communication must, if it is to have the imaginative power of art, be validated by these aesthetic concerns. The moral content of Goya's terrible studies of war, of the huge tragedies of Sophocles or Shakespeare, of the tender delicacy of George Herbert's very personal form of religion, or of Donne's or Marvell's erotic verse, would count for nothing as art without a validating aesthetic power. Works can only have an authority over our imaginative responses in terms of their aesthetic authority, even though they may be the most admirable moral sermons, or scrupulous assessment of difficult facts.

Clearly we may value all sorts of things aesthetically which are not art. Equally clearly much of what this study is concerned with – pictures, metaphor, stories – need not be art either. It is essential to the very idea of art that it consists of works, the outcome of some maker's deliberate and conscious activity, and thus that in responding to it we are also responding to the evidence of another's mind as it may be embodied in the work. Then, further, if we concentrate on representational works that such minds also relate to a real or

imagined world. But this may be said of any form of communication. Then how does communication in art make an essential connection with aesthetic imagination?

The suggestion throughout what follows is that it does so in the following ways. Art comes about when the idea of *what* we are representing coalesces with that of *how* we represent what we do. We often think of the world 'itself' as quite a different matter from that of ways of representing it. Imagination in art cannot be like this. What we value aesthetically we value often, as it were, 'unofficially', in ways that may yet to incorporated within our organized scheme of things. Art functions not by a terrible indifference to the way things are, or how they should be, but rather by establishing new conceptions of a potentially shareable world of the hitherto personal and private, by pushing towards the limits of what can be represented or conceived. Then a pre-condition for approaching the status of aesthetic as opposed to other values becomes, perhaps oddly, that we can develop theories of how to trace and attend to the margins of communication. What follows is concerned with this introductory question.

Most core problems in philosophy tend in one way or another to be about the possibility of communication, and representation, of our ways of meeting other minds and our ways of negotiating distinctions between reality and appearance. What this study argues is that these are also the problems of art, especially of representational art. This is not to reduce art to philosophy, nor even to place it within the envelope of philosophy, but rather to suggest that the core problems of both art and philosophy need to be seen as in continuous debate with one another. At the heart of that debate lies a question about the limits of the 'cognitive', about what counts as thought.

The ghosts of two famous dead philosophers haunt the argument. Aristotle's may be obvious in many places. But Kant's is equally present. In different ways for both philosophers, the very possibility of art lies at the core of our idea of what it is to be the sort of beings we are. For Aristotle we are beings who delight in 'mimesis' – in the facts of imitation, or representation. Kant's account of aesthetic judgement may seem further removed. To be sure many of the interests here are not those of his account. But much of his more general agenda is. One of Kant's more obscure, certainly most disputed claims – quite unfashionable enough to be worth taking seriously – is that in the exercise of aesthetic judgement we discover or at least celebrate a hope in an underlying common humanity.

To this we may offer a complementary claim. This is that it is precisely when we attempt to transcend the limit of what we can express that we reach the domain of aesthetics: aesthetics has not to do with the inexpressible but rather with how we negotiate its limits. This introduction seeks to lay the groundwork for what happens when forms of communication push towards their own limits.

I would like to thank Norman Freeman for his constantly enthusiastic discussions of the issues in the first part of this book, and Mo Harrison for her tireless assistance with the final drafts.

PART ONE

SEEING

Chapter One
PICTURES

INTRODUCTION

Why should pictures pose a philosophical problem?
Despite the number of serious philosophical studies of
the nature of the pictorial during the last quarter
century, their impact on the rest of philosophy, and
indeed on the non-philosophical understanding of
pictorial art has been less than might have been hoped.
The ball started to roll in 1960 with the publication of
Gombrich's *Art and Illusion*,[1] which is certainly well
known, and virtually all subsequent discussions of
pictures – or of pictorial art – have taken their start from
issues raised by that book. Major contributors to that
debate, such as Goodman,[2] Wollheim,[3] Wolterstorff,[4]

[1] E. H. Gombrich, *Art and Illusion* (London and New York: Pantheon Books, 1960).

[2] Nelson Goodman, *Languages of Art* (Indianapolis: Hackett, 1976), *Ways of Worldmaking* (Indianapolis: Hackett, 1978), and Catherine Z. Elgin, *Reconceptions in Philosophy and Other Arts and Sciences* (London: Routledge, 1988).

[3] Richard Wollheim, *Art and its Objects*, 2nd ed. (Cambridge University Press, 1980); *On Art and the Mind* (London: Allen Lane, 1973); *Painting as an Art* (London: Thames and Hudson, 1987); *The Mind and its Depths* (London, and Cambridge, Mass.: Harvard University Press, 1993).

[4] Nicholas Wolterstorff, *Works and Worlds of Art* (Oxford: Clarendon Press, 1980).

3

Walton,[5] Schier[6] and Hayman,[7] have certainly received their due of respect, but somehow the respect has been given to them as if they were doing well what was not wholly pressing, either for an overall grasp of the philosophical enterprise, or for an understanding of art. Part of the reason is that behind all these enquiries there is a question which fits ill with much standard philosophy. It is this.

What might count as *pictorial* thought? The question, for pictures generally and thus for pictorial art, is whether thought may be exercised in, and communicated by, pictures as such, not as they may rely on non-pictorial assumptions, but in their own right. Philosophy is predominantly a linguistically centred discipline. The assumption is that questions about communication and of the quality of thought that may be communicated must be questions about language, since language is alone the proper domain of meaning. Hence, if there were such a thing as specifically pictorial communication, either pictures would turn out to be a kind of language (which seems implausible) or pictorial communication would not be concerned with the conveyance of 'thought' in any genuine sense of the word. In other words, if pictures communicate, that they do will turn out to be not a 'cognitive', but a 'causal' matter.

The question suggests that somehow pictures might be a rival to language. But to compete they would have to run in the same race. So what is that race? Suppose there was peculiarly pictorial thought, not expressible,

[5] Kendall L. Walton, *Mimesis as Make-Believe* (Cambridge, Mass.: Harvard University Press, 1990).

[6] Flint Schier, *Deeper into Pictures* (Cambridge University Press, 1986).

[7] John Hayman, *The Imitation of Nature* (Oxford: Blackwells, 1995).

or fully expressible, in words and sentences? Then we have a dilemma. For, if we reject this idea, we seem to be committed to the not very attractive consequence that whatever a picture can communicate could (in principle) be given a linguistic 'translation', as if what we see could be fully absorbed into what we say and understand. So why, then, have pictures at all? If, on the other hand, we accept that there may really be 'thoughts' that cannot be captured in any set of words and sentences, this seems even less attractive. It would mean, for example, that while we might talk about pictures in a search for precision or further illumination in the language of art history and criticism, direct talk of pictures would always remain at some distance from the picture-maker's or the picture-beholder's actual thought. Either way pictures become systematically elusive to our understanding.

So, while art historians and critics of the visual arts may be free enough to discuss the linguistically expressible 'background' to any particular picture, its historical context, the myths and beliefs that its topic may relate to and so on, its specifically pictorial content may become systematically elusive to any possible discourse.[8] This might be fine where the non-pictorial 'envelope' of a work is especially rich, interesting and illuminating, as in great history painting or pictures which have to do with great social, political or religious matters, but becomes far less satisfactory where, as often seems to be the case in twentieth-century art, 'pure' painting designedly wishes to avoid such references or to see them as essentially subversive of the

[8] See Michael Baxendall, *Patterns of Intention, On the Historical Interpretation of Pictures* (New Haven, Conn.: Yale University Press, 1985). See also a discussion of this issue in Baxendall, by Catherine Lord and J. A. Benardete, in Salim Kemal and Ivan Gaskell (eds.), *The Language of Art History* (Cambridge University Press, 1991).

'pure' exercise of painting and drawing. Cézanne's claims for his art centred on very much this claim, that everything that might be construed as 'literary' should be excluded from painting's reference. What mattered to him, as numerous anecdotes attest, was simply what could be rendered into paint. 'Sit like an apple', he allegedly told his wife – her portrait, some may think, shows the resultant strain. This is certainly not 'art for art's sake'. Rather it is a passionate insistence on letting the medium of painting speak for itself. 'Pure' painting can be pure in all sorts of ways. But one way, by far the most interesting way, depends on the idea that what cannot in principle be said, might well be drawn or painted, and that what this is is not a simple visual experience, but a 'pictorial thought' which the social, even the political, pressures of our 'logo-centric' culture tends to suppress and to marginalize. And that idea is not obviously silly either. Either way, the issue is central to early twentieth-century modernism, not only in art but in philosophy too.

The issue is the pictorial *as such* and is far wider than that of pictorial or visual *art*. However, if it were to turn out that the pictorial has a power to communicate not shared by language, or indeed a power that must fall short of language, then there will be a corresponding fact about painting, about sculpture too, as opposed to literature and drama, whether in prose or poetry. This was, for example, the central issue in Lessing's *Laocoon*,[9] and in general the topic of how these various arts (to say nothing of the different arts of music and dance) may relate to one another is a traditional topic in theories of art. Traditionally, as well as now, the philosophical issues this raises have been too little

[9] Gotthold Ephraim Lessing, *Laocoon*, trans. R. Phillimore (London: Routledge, 1874).

explored.

A very great deal of writing and thinking about pictorial art in any period, both among art historians, critics and philosophical theorists, gives the curious impression of avoiding the pictorial itself in exchange for an attention to what non-pictorial topics pictures are 'about', what narratives they illustrate, what values we may suppose the artist who painted them had with respect to what the paintings depict, and thereby seeks (or may be presumed to seek) to inculcate in the beholder. Such discussion is really concerned with the literary envelope of the pictorial, and it is obviously of great importance. But often it is as if there were merely a running admission that, 'of course', these are rather excellently made pictures. A respect for skill – admittedly of a very high order – becomes all that is left of a respect for the pictorial. Such a result will be inevitable if purely pictorial thought is either non-existent or radically elusive to any possible theory of communication.

Perhaps this is just the way it is. If so, we have a further difficulty. One of the central facts about the nature of art is that in any art *how* something is done cannot be systematically separated from *what* is done. For this constitutes the possibility of *style*, not as style may be thought of as a characteristic way of doing something, but as something more than that. Style in the former sense (what Goodman calls 'style as signature') is important enough in the world of art. Grasping the relevant clues lies at the heart of the connoisseur's craft, but where style becomes content, where our thought as beholders seeks to connect with the thought of the maker, our understanding must inevitably explore beyond such identification of the work's origins towards something far richer, something

that concerns not merely the connoisseur, but the critic. Art – even the most minor art – comes about as these demands become a requirement of a relevant response to a work.

To be able to respond to painting and drawing with any depth of appreciation must be to have some conception of the thought that necessarily belongs with the medium itself. If we cannot have a theory of that, we cannot have a theory of art at all – certainly not any theory of literature or drama as art. Thus any possible theory of art must be a theory of how minds can meet via the making of something, whether building, pot, picture, performance, poem, film or photograph, and any possible theory of *representational* art must be a theory of how such minds can meet concerning the representation of a real or imaginary world. The medium of painting and drawing is in its widest sense the resources of the pictorial, more narrowly the resources of the material out of which pictures are made: paint, paper, pencil, brush or, indeed, camera. The question is whether these are mediums of *thought*, and, if so, what kind of thought?

A central obsession in Modernism in the arts centres round this question. It is, for example, the driving question of Paul Klee's lectures to his students in the Bauhaus in the early 1930s (though Klee's line of thought began much earlier to the period 1909–20).[10] The parallels with early twentieth-century philosophical concerns with the scope of thought and communication, that is with the matter of meaning, seem curiously skewed to the point that it can seem to be a kind of intellectual bad manners to attend to them. Wittgenstein

[10] Paul Klee, *The Thinking Eye, The Notebooks of Paul Klee*, trans. Ralph Manheim (London: Lund Humphries, 1961).

famously concluded the *Tractatus*[11] (which we should
think of as belonging to the same period) with the
words, 'Of what we cannot speak, let us remain silent'.
Ramsey's riposte, 'And you can't whistle it either', is
nearly as well known. The point, of course, was to
block the idea that there may be thoughts that lie
outside, and could be expressed outside, the scope of
language. Many musicians and many artists have
virtually taken this for granted. Few philosophers have.
Might Ramsey as well have said 'and you can't paint it
either'? Perhaps not, for at least one way of reading
what Wittgenstein thought language to be was that it
was a system of communication best exemplified by
pictures. What has come to be called his early 'picture
theory of meaning' thus seems to presuppose an under-
lying 'meaning theory of pictures', though it is rarely
discussed in this way and it might be thought that his
idea of a picture was very far removed from pictures as
found in visual art. But then, on this view, pictures
could not have a communication role that belongs to
them alone. A natural response to this early theory of
Wittgenstein (as many read him, Wittgenstein's own
later response) is to say that this gets language wrong.
If (roughly speaking) pictures can be thought of as
'states of affairs' (typically patterns of marks on
surfaces), so that the picture-pattern manifests its corre-
spondence to another (as one may hold up a passport
photograph against the face of a traveller to check out
who he is) this is just *not* how language works.
Language, as a rule-governed activity, is a system of
learnt conventions for the interpretation of otherwise
quite arbitrary marks or sounds in a way that pictures

[11] Ludwig Wittgenstein, *Tractatus Logico-Philosophicus*, trans. D. Pears
and B. McGuinness (London: Routledge & Kegan Paul, 1961).

could never be. An equally important question is whether this is how pictures work – or whether, if it is, it is in any illuminating sense language-like.

In linguistic contexts the word 'mean' is double-edged. 'What did he mean?' can either mean 'What does *what he said mean*?' or 'What did *he mean* to achieve in or by saying what he did'. It takes little reflection to notice that we could not ask the second sort of question unless there was an answer to the first, and not much more reflection to see that something like the converse is true too. Yet they are clearly different questions. A great deal of the theory of language rests on exploring, in making connections and disconnections, across and between such familiar ambiguities. The simplest demand we might make of the idea that the pictorial could be a system of communication is that something *like* these ambiguities should be preserved. Otherwise a beholder's capacity to come to terms with the mind of a picture-maker via attention to the *picture itself* would collapse into something very like a version of the second of these questions. Any theory that met that demand would thus have to give some degree of precision to whatever the word 'like' here indicates, that is, to the analogies and disanalogies between the linguistic and the pictorial.

Within the debate we seem to have two rival approaches, roughly 'causal' theories and, equally roughly, 'cognitive' theories. The terminology here is admittedly obscure; whatever 'causality' will be involved will inevitably be a matter of mind, not of matter and whatever pictorial thought may turn out to be it will still have to be pictorial, still concerned with what can be visually presented to us. This may provide a reason for supposing that not very much turns on the issue. In fact I shall suggest that quite a lot turns on it, even though

the opposition can in the end be resolved.

EASY PICTURES

If we have a popular, common sense 'theory' of pictures it is that they are *easy*. Pictures are so familiar, so easy to grasp and to work with, that the idea that there even could be in principle any *deep* problem about understanding them can seem quite bizarre. Their easy nature seduces us into theoretical complacency. In fact the easy nature of the majority of pictures – that we can construe them apparently just by looking – is the central puzzle about the pictorial. It ought to astonish us far more than it normally does. Of course there are many pictures in art, in science, produced by children, or puzzlingly presented as data in art therapy, which are by no means easy, but perhaps these are in some ways special cases, whose un-easy nature needs explaining against the background of those that are easy. It seems to be on this assumption that we make our normal use of pictures, and from which most of our 'common-sense' beliefs about pictures seem to spring.

It is not that easy pictures are easy to *make*, most hand-made pictures require a skill beyond most of us (though most of us can make a sketch that will work well at a pinch, and with the mechanical aid of photography, even the problem of making highly naturalistic pictures is easily overcome), but that they are easy to *recognize*, both *as pictures* and in terms of *what they depict*. There are three underlying assumptions here: one is that *our normal ability to recognize pictures*, to easily see what they are pictures of, *far outstrips our normal capacity to make them*, certainly to make them well without mechanical aids; the second is that *our ability to recognize pictures seems to be closely tied to, perhaps even an aspect of, and is our ability to recognize*

whatever it may be that they depict. In both of these
ways pictures, regarded as ways of communication seem
(certainly for adults) to contrast dramatically with our
capacities with sentences. In general the sentences we
can understand are of the same kind and complexity as
the sentences we can produce for the understanding of
others. Not so for pictures: our inability to make a
Titian-type, or a Vermeer-type picture has little or no
connection with our capacities to recognize it.

The third assumption derives from these. This is that
pictures *achieve their function* not via some process of
understanding or interpretation on the beholder's part
but *causally*. Suppose that to respond properly to a
picture required that we had to acquire rules not only
for recognition, but for their production. This does
seem to be so for sentences, and indeed it seems to be
central to the idea of understanding: a parrot can
produce sentences without recognizing them for what
they are – if so, the bird fails to understand what it
says. But we do not have to be able to produce trees in
order to recognize them; in this sense recognition
contrasts with understanding. So pictures of trees
belong with trees rather than with sentences about trees.
To recognize the former is to recognize the latter: the one
ability brings about the other ability. It is simply a
matter of the 'spread' of experience from one thing to
another. Hume wrote of how 'imagination spreads itself
on objects' and we might in the spirit of this suppose
that so long as we have one sort of experience we can
then imagine another rather like it. Often we may not
be able to help it. Having seen something that vividly
impresses us we may see it 'in' random patterns in the
fire, in clouds or, to adopt a famous example of
Leonardo's, in crumbled walls. Pictures, then, enable us
to control, and thus to communicate, this.

What is communicated is not the object of some process of understanding, such as the meaning of a sentence one has learned to read, but rather a form of imaginative experience: what we 'see in' the marked surface is, when we get it right, how the picture-maker came to 'see' the subject of his picture.

Initially, we *need* a loose word here. The appropriate word is 'look'. How things look to us is not how we interpret them, still less need it be to do with what we (rightly or wrongly) interpret them *as*, but simply how it is for us that we visually experience them. In a rather simple sense of two complex philosophical terms, a theory of 'looks' is, or *starts* by being, wherever it may finish up, 'phenomenological' rather than 'epistemological'.

The commonest role of a picture is to *communicate how things look*. I want to buy a house or rent a cottage which I cannot get to see. Then show me a picture: thus at least I may get some idea, from a snapshot or a sketch, of how the place looks, at all events from a favourable point of view. I get mugged and the police show me pictures of suspects or I help a police artist to make a drawing and at least a start is made on how the mugger looked, at least to me, even if in panic in a bad light. And this remarkable and instant success comes about by the use of variously marked, normally small and flat surfaces, which really do look (easily look) very unlike the things they so easily depict. Henry VIII wished to know how Anne of Cleves looked, saw Holbein's portrait of her and in the event was most unfavourably impressed by the reality, of how in the event she looked. The Flander's mare, as he odiously called her, had been portrayed in too flattering a manner. For Henry, seeing Anne, it was easy to see how flattering her portrait was. So then the test of the failure of a picture is to compare

the look of the thing as partially conveyed by the picture with the actual real-life look. Easy: and even more dramatically easy if we think of the sheer directness of these cases. Nothing has to be learnt for the strategy of success or failure here beyond being able to sort out how we may recognize or fail to recognize things from how they look to us. So, specifically, pictures do not communicate, as language does, by a learned code. Pictures by English makers of them are not in English nor are French pictures in French. To be sure, pictorial styles may differ widely, even wildly, but not as languages do. When the cave drawings of western Europe were first discovered, there, recognizable on the rock surface, were pictures of bison and antelope, recognizable animals as (apparently) manifestly present to us as they were to their original makers.

The ancient myth of the Tower of Babel is of tribes divided by their mutual incomprehension of their linguistic codes. Pictures, it seems, do not suffer the curse of Babel, since for pictures the very idea of translation, or mistranslation, has no place. For nothing like the tedious matter of learning a vocabulary, or construing a grammar (those devices for rule-learning that enable us to construe the arbitrary marks of surfaces as signifying whatever they do), can be involved. Unlike the marks and sounds that in language we learn the meanings of, since they have no natural correspondences as shapes and sounds to what they refer, the marked surfaces that make up pictures are non-arbitrary, natural, so they do not require to be learned. The easily recognizable nature of pictures again springs from this.

So confident are we to suppose that the recognition of pictures is normally easy and natural just so long as our recognition of what they depict is easy and natural, that

we tend to use the former as more or less direct evidence
for the latter. We may test whether a child can recognize
a cat by showing her pictures of cats, whether an old
person can still recognize a nearly forgotten member of
the family by showing him a picture of her. Any
capacity to make such pictures clearly has nothing to do
with the matter. At best, lack of skill or unusual,
perhaps perverse, skill might explain the difficulty.

For then the problems of art, of ancient art, of strange
art, of abstract art or the 'difficult' pictures of children,
become one problem of deviance. Difficulty is deviant,
to be explained by various forms of incompetence or
strange graphic intentions that pull away from the easy
and natural nature of normal pictures. When faced
with difficulty we may not be quite sure what is depicted
or even not sure that we have a picture at all. It is
important not to confuse these two puzzles, for any
question concerning *what* is depicted could only arise so
long as we think we *do have a picture* of some sort. The
puzzlement people feel they have before startlingly avant
garde art – that they can see that there's a picture there
all right but can't make out what it's a picture *of* – is
perfectly coherent. There seems to be no doubt that
much of the difficulty new pictorial art presents to
people – that it is childish, or incompetent, or has some
obscure or sophisticated hidden agenda, but is also
disturbing – derives from this way of thinking of
pictures. It is as if the look of something must somehow
be conveyed by the picture, only we cannot quite pin
down what that look is.

THE PORTABILITY OF LOOKS
The easy picture theory is, if in a final analyis inade-
quate, far subtler than a mere prejudice in favour of
pictorial naturalism. It is, briefly, that *pictures capture*

the looks of things, that our ability to make and recognize pictures lies in our ability to identify and thus to *transcribe their looks into something else, namely the picture.* The central concept is '*the portability of looks*'. Since, as far as we know, only human animals make pictures (certainly easy pictures of the familiar sort), such a theory would, if true, be a significant component in our body of beliefs about the nature of the human. We then explain the power of the pictorial in terms of essential facts about how we experience the world we see.

How might we expand such a theory? First note what the theory does *not* claim. Since an easy picture may be the merest (if skilful) sketch just as well as the finest-grain photograph and since the theory is concerned with the naive idea of 'how things look' rather than with more sophisticated ideas such as 'what is presented within the visual field', which we will consider later, it is important not to confuse the easy and natural nature of 'normal' pictures with the quite different idea that 'normal' pictures are untaxing and 'naturalistic'. Easy picture theory can invite that thought, but it in no way implies it. Equally, and for the same reason, it does not claim that something's being a picture can be explained by the mere fact that it 'visually resembles' what it depicts. On the contrary, easy picture theory invites the thought that there is *no* relevant kind of mere visual resemblance here, for the looks that are captured by a picture are far from that.

RECOGNIZABILITY
Our thinking about pictures – especially in art – is dogged by ideas of 'naturalism' or 'realism'. Many see deep and significant differences between these two very unclear concepts. Popularly, perhaps, a picture is 'naturalistic' if it captures the natural and familiar look

of something (as opposed to the picture being naturally recognized or familiar: Disney pictures are hardly naturalistic, but are rather puzzlingly easy to recognize partly because they are familiar *pictures*). 'Realism' suggests something more than that – something rather hazily connected with the idea of how something really is, even if or especially in its visual dimension our popular prejudice is initially resistant to recognizing this fact.

A monochrome pencil sketch of a mugger, or Holbein's careful silver point portraits, however well or badly they may capture the look of the people they depict, not only do not themselves look the way their subjects do, they certainly do not capture '*the* way' in which their subjects look. Natural scepticism might lead us to doubt whether the idea of how something 'really' looks has any content. Even the best photographs often do not look very much like what they are photographs of (being small and flat), and certainly (since they must be from some point of view) do not capture the one and only way in which their subjects look. Still, to all intents and purposes *some* photographs might achieve something very close to that. A colour photograph of another colour photograph, or a black and white photocopy of a page of text can without doubt look almost exactly like what they are reproductions of, and do so, moreover, so well that as far as appearances go the two might be exchanged for one another. Significantly, however, such things are *not pictures* of what they are photographs of, though they may be copies, reproductions or forgeries. Photographic reproductions of pictures are neither naturalistic nor realistic pictures of what they reproduce. Replication of this kind rules out picturing, for it makes no attempt to isolate a relevant look.

RESEMBLANCE AND ILLUSION

Easy pictures are not illusions nor are embodied looks merely resemblances. 'Full' illusions are 'difficult' pictures since they are necessarily hard, and if fully successful, impossible to recognize as pictures. A claim (which seems to be indicated by Gombrich's *Art and Illusion*, but which is not, I think, Gombrich's view) that pictures function by presenting us with illusions of what they depict would seem on the face of it to be incompatible with the theory of easy pictures. For to directly recognize both that something *is* a picture and what it is a picture *of* is incompatible with mistaking the picture for something else, namely, what it depicts. To suppose even that to see a painted surface as great uncle Charlie is normally to be *inclined* to think the canvas *is* great uncle Charlie, is to land ourselves with the further theoretical task of explaining how we normally avoid that mistake. The problem is spurious – at least for easy pictures.

Should we take it that 'a is a picture of b' is a case (albeit a special case) of 'a visually resembles b'? Certainly not if the suggestion is that resemblance might explain depiction, or that depiction is some kind of resemblance. The idea that resemblance can explain depiction seems so natural that Goodman notoriously subjected it to well-known scorn. It is not always easy to persuade people that it is well deserved, for easy pictures seem so obviously to make resemblance manifest. His well-placed rhetoric suggests that he supposes that pictures do not resemble, even manifestly resemble, what they depict. They do, of course, but so more strongly, do things resemble one another where no question of depiction is involved. All the chairs in an exhibition may resemble each other far more closely than any swirl of paint on the wall resembles a person

it depicts. The chairs don't even begin to depict one another. So resemblance cannot be sufficient for depiction; not even a necessary condition either since the resemblance between a picture and its subject considered on its own can be quite tenuous while the depiction is manifestly successful. Any oil painting, since normally flat and rectangular, resembles a door-off-its-hinges far more than it resembles any apple or face. The problem of easy pictures is that they can make what would, if considered apart from pictures, be quite tenuous resemblance seem so manifest. Two rather obvious and connected facts may help to show why.

First, resemblance is a symmetrical relation, whereas depiction is not: if one apple resembles another then they resemble one another in the same respect, whereas a picture of an apple while it may resemble what it depicts in some way, is not thereby depicted by the apple. Second, resemblance, if it is to count within the pictorial, must be significant and relevant. Getting depiction right (either as maker or beholder) means excluding irrelevant resemblances and locking onto relevant ones. The shape of the frame or the crinkles in a piece of drawing paper are, in most cases (but significantly not in all), just *seen* not to be relevant. This depends on how the depiction is construed, not the other way about. The startling, and relevant, visual likeness that an area of paint in a flat surface may have to an apple or a face is a startling likeness that rides in on the back of depiction. It is then a strange sort of resemblance, a 'resemblance' that is located in successful depiction, and which absorbs its logic. For while we may see the apparently manifest resemblance between the flecks of paint and the apple this does not mean that we also see a corresponding resemblance between the apple and flecks of paint – *unless* we achieve that recognition *in terms of the*

picture.

It is not that pictures do not seem to make resemblance with what they depict startlingly manifest. It is that the kind of resemblance that is made manifest in depiction itself requires depiction to explain it.

LOOKS AGAIN

Will 'showing' the look of something (via a picture) do any more work for us than the idea of exhibiting a visual resemblance? At least the latter is tied to the visual in a more convincing way than 'showing' need be. Showing something need not be, though it sometimes may be, to exhibit it, still less replicate it. Showing another how something is or feels need not involve even partial replication of the feeling, or if replication is involved it may be so minimal and tenuous that by itself it would show nothing. A patient, for example, may (easily and naturally) show a doctor how a pain feels by spreading or clenching her hand to indicate whether it is a gripping or a spreading pain. Someone may show another how vast a landscape may be by a gesture or a facial expression that might be quite unintelligible out of context, but dramatically clear in the right context.

But surely something quite specific does need to be visible in the depicting surface for pictorial showing to play a part. If pictures make looks portable how could they fail to replicate them from one place to another? Yet looks are no more straightforward than visual resemblances. Objects we easily recognize have, for us, characteristic looks. Our common idioms suggest portability. Tom, like any other person, may present a rich and complex appearance within a variety of visual fields, a particular skin colour, a certain outline against whatever background he is standing, the complex colour of his clothes, and so on, all of which varies considerably

from moment to moment, and to most of which, if unprompted, or uninstructed, we would be hard put to attend, even to notice. What indicates Tom to those who know him is his long arms, short legs and slightly shambling gait, together with his manner of holding his head to one side. If a few strokes of a moderately skilled pencil can indicate that, then, with luck, we have Tom to the life. It is this analogy that we *see*.

It is tempting to see such recognition clues as simple resemblances, as we might recognize someone's coat as it resembles another's. (They are both that peculiar shade of pale orange.) But these too, like depiction itself, come adrift over symmetry. As P. G. Wodehouse describes him leaning out of his window, Lord Emsworth's look is that of an old sock. It is really not too difficult to imagine such a look with respect to His Lordship, but with respect to no old sock, and certainly not to old socks in general, is it possible to locate that resemblance to Lord Emsworth. Then, if depiction is grounded in looks as recognition clues, it is not grounded in simple resemblance. Looks relate to resemblance but do so, like depiction, via the ways in which we attend, not via the features that things simply have. To these facts we need only add another reflection, namely that we are able constantly to vary and adjust our stock of visual recognition clues. Styles of recognition, then, become as multiform and as plastic as styles of drawing, and for much the same reason. This is that our capacity to make and to recognize pictures goes in tandem with our capacity to overtly experiment with our visual recognition devices; it is this that we make portable into pictures. We are, then, with a slight adjustment of Aristotle's phrase, that animal which may deliberately celebrate mimesis, deliberately celebrate the elusiveness of imitation.

These few steps, then, each of which merely hop aside from the more obvious pitfalls in the idea of the representation of the looks of things, take us to some of the most central (if as yet poorly formulated) ideas about art, that is to say concepts of style, as they may be linked with concepts of imaginative attention. Thus, even on this least contentious of theories, they lurk surprisingly at the heart of the matter of the pictorial. This locates the possibility of pictures within a galaxy of other generally relevant human capacities, generally our ability to become systematically aware of our own psychological capacities.

We can, paradoxically, make use of pictures just so long as we are aware that things as depicted in pictures do not thereby preserve the same look. Hence we can make the visual central to the pictorial without relying on a naive view that a successful picture *replicates* a visual feature. This is the strength of the theory of easy pictures. It is also at the same time its central weakness.

For there is something unsatisfying about the story. It promises us too much and tells us too little. What it promises is that we can provide an account of pictorial competence along with an account of how we recognize things together with an account of how we may grasp a further concept of visual style. What it fails to tell us is how these apparently very different things can in principle be articulated together. 'How something looks' seems to cry out for further examination. How something looks to me may not be at all how it looks to you, or to me next time I attend to it. But the proper objection is not that looks are *subjective*, variable or optional, for the whole thrust of the naive theory of easy pictures is that the role of pictures is precisely to make such private and variable things public and fixed within the depiction.

The difficulty is that looks seem to be insecurely located within the categories of concepts we seem to need to understand the pictorial. The theory, while starting with a fact about the nature of our visual experience – of how we see the world – requires a further fact about the pictorial which it has no power to supply. It is frequently objected against those who find difficulties in any project of rooting an account of pictures in one of visual resemblance that they thereby too easily lose sight of the fact that the pictorial is, as Wollheim puts it, 'rooted in the visual'. What easy picture theory shows, on the contrary, is that it is a peculiar sort of recognition of the visual which is rooted in the pictorial. But this is not enough. For if the visual is vital, how something looks is not a purely visual matter any more than showing need be a simple matter of exhibiting. The look of something may be graceful, ungainly, clumsy or delicate, the look of a person may be graceful, awkward, confused, embarrassed, or shifty: these are manifestly aesthetic (even moral) ways of seeing, not purely and simply visual matters, but matters of *judgement*. And this is what we should expect as the outcome of any naive theory of easy pictures: on such an account (which must make the largest space for pictures as art, even if it is not confined to them) we should expect aesthetic and other attitudes to come in at the ground floor.

The irony of easy pictures is that those most seduced by them into supposing that we need no especially difficult theory of the pictorial, respond to that seduction by taking aesthetics too much for granted. If aesthetics or something of the sort, must come in at the ground floor we need to know the reason why. An idea of the portability of looks may thus point the way, but it cannot take us to where we need to go.

PICTURES IN ART AND SCIENCE

Pictures do invite big questions. Concepts such as accuracy and inaccuracy in pictorial representation (*some* analogue for concepts of truth and falsity) make obvious connections with familiar philosophical topics of appearance and reality. We want, not just photographs, but technical drawings and 'scientific' pictures, to be accurate and right in their representations. So what counts as pictorial accuracy? Better, what do we seek when we seek such accuracy? Perhaps it depends on the task. Is a technical drawing constructed with the greatest care more accurate than a rough scribble in a notebook – where half a dozen lines capture a landscape – or is this less accurate than a finished painting? There has been, since he painted them, a running dispute about Constable's landscape painting, whether his free 'sketch like' studies are closer to some depictive goal than his more highly finished paintings. Both convey looks, so simply to say that tells us nothing very much about what sort of depictive goal this could be. To many the 'sketch-like' paintings are more powerful. But what could we mean by 'power' here? Why it might be that in valuing a Leonardo drawing (apparently sketch-like) we value its pictorial power more highly than that of a casual and amateurish sketch? Pictures of great art, and even some modest art, have an 'authority' over our imagination that goes beyond the merely visual. Since pictures belong both to science and to art so do questions about these matters.

Consider what it is to draw a buttercup. In many schools children are even now instructed in how to recognize, and also how to make, certain kinds of easy pictures – pictures that convey what they do with a sufficient, if modest, authority. The art teacher will attempt to achieve in her pupils some capacity for the

'expressive' use of line, colour, of compositional form that goes beyond 'mere' slavish accuracy and to get some life into the result. Even in drawing a buttercup. Often enough such pupils will be earnestly told to use their eyes and not to draw what they merely think they see but what they 'really do' see, honestly and for themselves. The biology teacher will instruct her pupils in how to draw in such a way that the scientifically salient facts are made visually manifest as a clear pictorial record of the subject before them. They are also told to use their eyes. But in quite a different way. A child studying botany, and drawing a buttercup may be told to clearly show how petals and sepals, calyx and stamens fit together. To be seduced by the gleam and polish of the petals, the peculiar quality of yellow that the flower may startle with, how big the little flower can seem when it puts yellow on the end of your nose, with how pencil or crayon may bite or crumble on the paper, is to be far too 'arty' for the simple business of recording a botanical observation. Often enough one may even find that the two teachers are each convinced that the other is corrupting the youth. To be sure, each may recognize that the greatest biological drawings (Leonardo's always come to mind) somehow manage to combine both sorts of tasks, but one should not expect children studying for their examinations to attempt to be Leonardos. That kind of Renaissance universality is a mystery beyond the modest demands of a normal curriculum. It is sufficient to divide the styles, and to divide the tasks. Somewhere here lies the real issue of the pictorial, and we need sharper tools to dissect it than we have so far. Both tasks involve looks, but since looks depend on drawings as they may differ in art or science, it is these wider contexts of the pictorial to which we should turn to explain looks. Easy pictures

turn out to be less easy than they may seem.

PERCEPTUAL REPLICATION AND CAUSAL PICTURES
Pictures in the everyday environment of the twentieth
century tend to present us with two paradigms, each in
their own way bedevilled by easiness. On the one hand
we are surrounded with photographic products which
achieve easily and automatically a seemingly astonishing
degree of verisimilitude unimaginable to earlier periods,
while on the other we have become used to varieties of
ways of depicting, in both serious and popular art, that
in no way seem even to hint at this. The invention of
photography and then of all that follows from it has
gone hand in hand with a popularization of graphic
pictorial devices at the other extreme, where the merest
hints and sketches are part of our culture of easy recog-
nition. This is as much a fact about our everyday visual
environment as about serious art. The tension between
these two kinds of pictures is sufficiently dramatic to
suggest that they perform radically different functions.
It underlies not only many of our anxieties about visual
art, but even about the nature of visual experience itself.
While the root problems are not new, we live in an age
that is both self conscious – often embarrassed – about
these matters and at the same time far too little surprised
by them.

PHOTOGRAPHIC REALITY
Consider the television news. A camera team is present
at the event and we see it live on our screens. Is this not
simply a way of extending our visual and other senses?
We might have used binoculars to enhance our view.
Elaborate mirrors and periscopes might have helped a
little with the sight-lines. Now a portable colour
television will solve both problems for us: we can use the

device to see better and from a greater variety of angles and positions than we ever could unaided. Better still, we can replay the video and see the action all over again, slowly or even backwards. Such technology can be metaphysically seductive. Just as mirrors are devices for enabling us to see round corners, lenses are devices for enabling us to see objects enlarged as if closer, so new technology enables us to see past the barriers of past time. As far as 'the content of experience' goes, if we can (as with film or tape) 'translate' an order in time into an order in space we may travel about in time perfectly freely, for it is only a purely temporal order that debars us from surveying it in whatever sequence we will. This might be one way of reading the central argument of Kant's Second Analogy:[12] that our experience of the difference between a succession in time and a succession in space is given to us in terms of what we can do at will. Thought of that way it might well suggest the rather un-Kantian thought that such alterations in reality are merely 'virtual'.[13]

This brings resemblance and causal replication right back to the centre of the stage along with their attendant baggage of sceptical philosophical questions. We might well think of film and video as sensory extensions, even sensory prosthetics, and replays (however altered) as replications of such experience. This will inevitably apply to still pictures as well. Of course objects seen via video or film may appear differently to us from how they are seen with the naked eye, just as objects seen while wearing spectacles appear differently. Replication and sensory 'extension' are no less so for being partial. If

[12] Immanuel Kant, *Critique of Pure Reason*, trans. Norman Kemp Smith (London: Macmillan, 1929), pp. 218 ff.

[13] See Kendall Walton, 'Transparent Pictures: On the Nature of Photographic Realism', *Critical Inquiry*, vol. 11, no. 2 (December 1984), pp. 246–77.

they were complete they would be of no use. The technology improves on our imperfect senses. Why should this not provide an ultimate concept of pictorial realism, the direct 'capturing' of a visual 'reality'?

But this, if correct, would imply that any *knowledge* of visual reality would belong firmly to the *non-pictorial*. Whether a film or video is fact, fiction or fantasy would depend entirely on external information, caption, commentary or voice-over. The picture itself need provide no guide. Because virtual reality is no reality, its total, or even partial, success subverts the very idea of reality itself.

One stock sceptical argument goes: suppose you were nothing but a brain in a vat receiving impulses that produced precisely the same experiences as normal seeing, touching or hearing would produce. The idea is surely not unimaginable. Then your belief that there is a real difference between hallucination and veridical experience might be systematically false. But if *total* success collapses all distinctions between appearance and reality, *partial* success may be even more disturbing, for it has the effect of subverting the role of the visual. Seeing is no longer believing. One of the most disturbing aspects of a world saturated by television pictures that seem totally naturalistic, and in an important sense *are* just that (since they tend to define for us what normal appearance is), is that to know what it is that we are 'really' seeing we need to trust *too much* to what we are told.

Since the invention of photography it has frequently been held against it that it is inimical to the concerns of art. Such objections associate a 'logical' fact with an 'aesthetic' principle. The logical fact is this: if a photograph, film or video, like a footprint, is causally connected to what it is a photograph, film or footprint

of, then that the photograph exists implies that something that produced the image existed – even though we may be confused about exactly what. Hence we can use a photograph, video or a footprint in evidence in ways that we cannot use drawings or paintings. In general, causal connections between things permit us to infer from the outcome to the existence of the cause. To be knocked down by a flying pig implies that there was a flying pig. To merely fear, hope for, or think about flying pigs, implies no such thing. Here 'flying pigs' are merely the 'intentional objects' of the thought that pigs might fly, not the 'material' objects of collisions with airborn pork. Since Quine[14] philosophers have tended to label the latter 'opaque', the former 'transparent'. Only in the former case will implications of existence, as it were, cross the barrier. The distinction applies equally to pictures. Sir Arthur Conan Doyle once defended a series of pictures that purported to be photographs of fairies. Drawing fairies does not imply that there are fairies. Photographing them would. If there are no fairies the photographs were fakes. Fakes may be photographs of *something*, but something only purporting to be a fairy. The principle here is that a purely causal process such as how light produces an 'image' in a camera rules out a psychological one. It leaves no space for the role of picture-making as the exercise of, and communication of, thought. Any such 'space' will be outside the process.

The connected 'aesthetic' problem about the 'photographic ideal' takes off from here. For if the marked surface is blind to the photographer's process of thought, simply because it is produced automatically, or mechanically, then all that is left is that either we fake the

[14] W. V. O. Quine, *From a Logical Point of View*, 2nd ed. (Cambridge Mass.: Harvard University Press, 1980).

marked surface (so that what the observer takes to be honest photography is in reality darkroom tricks, or other special effects) or we fake the subject matter so that what the observer thinks was photographed is in fact something else. If the literalistic realism of photography stands merely as an extension of seeing, or recording, of the optical qualities of an object, then the framing and focusing of camera work reduces to the mere invitation to look in certain ways at what is exhibited to us, or to look at a different time. It is important that for recording purposes – such as automatic surveillance – we can so limit our conception of the role of a camera. But then it is tempting to think that since we can then think of photography as the literalistic reporting of visible 'facts' (as in science or journalism) such pictorial devices by their very nature displace imagination in depiction, so that imagination's only role is to provide external commentary or to connive at fake, fraud or voyeurism.[15]

This is certainly profoundly unfair to the arts of film or photography. In fact it commits an interesting, subtle and common fallacy. What makes it hard to see this fallacy for what it is is the astonishing kinds of marks photography can make. The marks seem to replicate visual appearance itself. Random snapping makes dramatically recognizable pictures in ways that random brush dabbing cannot. However the fallacy is to confuse the causal history of what is made as an artefact-that-communicates with its 'thought content' or lack of it. They are easy to confuse, but it is how the causal process is made use of that incorporates thought. In fact the merely causal processes of photography

[15] See Roger Scruton, *The Aesthetic Understanding* (Manchester: Carcanet Press, 1983). Scruton concludes that all photography tends to the condition of voyeurism.

(literally 'light-drawing') are no more directly (and non-psychologically) causal than are the causal processes that enable ink to be placed on paper by a loaded brush or an engraving tool to cut copper. How they are used constitutes the exercise of pictorial imagination in drawing. The whole art of photography begins where the camera's capacity to record traces is incorporated within a photographer's – or film director's – capacity to convey thought via such traces. The camera is merely a more complex marking instrument than a brush or burin. Photographic thought may seem beguilingly simple, as in that photo-journalism that almost relies on the dramatic awareness we have of the 'captured' frozen moment stolen out of the flow of time. Alternatively, it may be as complex and subtle as in the rich variety of framing of points of view, of close up, of altering angles of vision, of colour intensity or tone, the use of apparent reversals of time, that opens up whole vistas of dramatic possibility not present in other media but film. Either way, photography, as art, must transcend the merely optical, but this is in principle no different from saying that drawing must be more than simply making marks on paper. Even if the effects are different, randomly pointing and snapping is no different from randomly dabbing with a loaded brush.

CAUSAL PICTURES AND STYLE

What, however, the effects of photography can seem to dramatically demonstrate is that visual recognition is in no literal sense a matter of decoding but of recognizing. It can make it seem obvious that pictures do not communicate as language does, that they do not need to be interpreted, construed, nor do we, in any literal sense, have to learn to read them. This is a very much wider issue. Richard Wollheim in *Painting as an Art*, in many

ways the most sophisticated account we currently have of how paintings communicate, describes pictures as a 'conduit' whereby the state of mind of the maker of the picture is transmitted to a properly informed, or instructed beholder. His metaphor suggests a causal channel via which we may simply have access to another's state of mind.[16]

It is innocuous to suppose that telling someone something performs the function of altering their state of mind. Then a properly informed listener told what the informant believes has a state of mind 'transmitted' from one to the other. But this misses the point. The idea is that somehow a 'visual experience' should be capable of being *transmitted* in a manner that bypasses what would be the linguistic hurdles of learning the 'rules' of language, construing, interpreting, or understanding.

But then *what* is transferred via the 'conduit' of the picture? The 'content' of a picture of something is not the look which what it depicts has 'in itself', nor just any way it might look to someone, but how in painting or drawing the object, *it looked to* the maker of the picture.

[16] Wollheim is difficult to summarize fairly. See *Painting as an Art*, especially p. 22: 'The marked surface must be the conduit along which the mental state of the artist makes itself felt within the mind of the spectator if the result is to be that the spectator grasps the meaning of the picture.' Such an account, which Wollheim calls a 'psychological account', has, he says, 'quite rightly been chased out of the field of language through the influence of Wittgenstein [but] is at home in painting'. He certainly contrasts this with what he calls (p. 40) the 'Contagion theory' which holds that 'for the spectator to grasp what the artist meant, there must be re-created in his mind when he looks at the painting precisely the mental condition out of which the artist painted it. This view was embraced by Tolstoy in his old age but has nothing else to recommend it.' Later on p. 304, referring to the visible content of a picture, he insists that 'visibility, like meaning itself, cannot be private'. I believe that a tension runs through these separate claims he makes which needs to be resolved if we are to come to terms with pictures.

It is this idea of the *object-as-depicted* (as opposed merely to the *object which is depicted*) which we must suppose a successful picture conveys. This, unlike the idea of merely 'mechanical' photography, is an intentional object – an object of a certain kind of thought. To respond 'properly' to a picture is to grasp that.

It is a logical consequence of this that the maker of a picture (assuming the making is not automatic) must adopt two roles: that of maker (or marker of surfaces), and of beholder of what is made or marked; for unless this is so no maker of a picture could know what he was doing. This is so in a stronger sense than that he needs to be merely conscious. The picture-maker needs to be able to connect how the surface is (in painting or drawing progressively marked) with *how* in doing so the object it depicts is depicted – with how the picture is made. When we cannot peel off the idea of how something is done from that of what is done we have the concept of *style*, not merely as we might use it as an indication (as 'signature') of who made something, but as an invitation within the work for us to engage with the maker's thought in making or doing something. A painter develops his own mature painterly thought as he matures his own style in this way.[17] It is this which we attend to as we respond to the work. In effect a painter's grasp of his own mastery is then reciprocated in how we learn to construe the picture (and at the same time in how the painter construes his own work as he makes it). We certainly do not, certainly not *normally*, 'see'

[17] See especially: R. Wollheim, *Painting as an Art, op. cit.*, pp. 19 ff.; 'Pictorial Style: two views', in Beryl Lang (ed.), *The Concept of Style*, (Ithaca, New York: Cornell University Press, 1987); Nelson Goodman, *Ways of World making, op. cit.*, pp. 23–40; E. H. Gombrich, 'Style', in David L. Sills (ed.), *International Encyclopedia of the Social Sciences* (New York: Macmillan, 1968); Andrew Harrison, 'Style' in David Cooper (ed.), *A Companion to Aesthetics* (Oxford: Blackwell, 1992).

paintings or drawings 'as' what it is that they depict, certainly not as one might construe some vague shape in the mist as a post or a friend coming to rescue us. In Wollheim's terminology, recognizing pictures is a sophisticated extension of what it is to see pictures 'in' the fire, in clouds, or (as in a famous example of Leonardo's) landscapes in crumbled walls.[18] Pictures – specifically painting and drawing – as it were, 'stabilize' this rather wandering and personal sort of 'projective seeing', which is for him at the primitive level of visual imagination, into something firm and public, seen, not as the outcome of wanton imagination, but *correctly*. As Hamlet demonstrated, there is no right or wrong way of seeing a camel or a whale in a cloud.[19] There are many wrong ways of seeing something in a pictorially marked surface, and thus a right way. The right way is how the maker of the picture intended it to be seen. But it is the picture which must show us this. There is something deeply right about this. The problem is how to explain it.

Certainly psychological states may be as much the subject of causal production – thus why not then *reproduction* – as physical ones. All we need is a clear concept of the same – or relevantly similar – outcome independent of the particular causal input. Surely nothing could be easier? If a tickle makes you itch or tiredness makes you yawn, then so may talking of fleas make you itch or exhibiting yawns make you yawn. This certainly shows us something interesting about itches and yawns, but it may equally disguise something too. Are the itches that result from flea-talk quite the same as those that result from tickles? Perhaps this

[18] See Gombrich, *Art and Illusion, op. cit.*, p. 188.

[19] See Wollheim, *ibid.*, esp. pp. 40ff., and 'Correspondence, projective properties, and expression in the arts', in Kemal and Gaskell (eds.), *op. cit.*

hardly matters. But consider what may seem to be a parallel. Someone is, or has been, frightened and their fear is so palpable that we cannot help but catch it, or they tell a story, the effect of which is that the audience are frightened too. Does the audience now have the same experience from a quite different cause? Suppose the story-teller was not frightened at all, but simply set out (like the Fat Boy) to make our 'flesh creep'. Is something – the same sort of thing – here produced that could be *re*produced?

Tragedy, Aristotle famously reminded us in the *Poetics*,[20] produces pity and terror, and enables us, by facing it fictionally, to get it out of our system (he says tragedy 'purges' us of pity and terror: the metaphor is the same). But, as he also reminded us, how we feel before a fiction is – even when we admire its realism – *not quite* as we feel before the real thing. Any doubts of this sort about what is produced, or may be reproduced are likely to make the idea of cause in these contexts unhelpful. Of course, some sort of causality has to be involved, but here it seems to be far too slippery an idea to give us any sort of a grip on what is really going on. Much the same applies to pictures.

How could we know whether or not the two 'states of mind' of painter and beholder fitted together in the appropriate way? Not even the painter could know that contemplating his *own* picture. Often enough a painter, writer or composer may leave off a work half-finished and find it impossibly hard to even recall what imaginative state of mind he was in at the earlier stage. Sometimes it can seem as if this is an impossible barrier

[20] *Aristotle's Poetics and Rhetoric, Demetrius on Style, Longinus on the Sublime*, trans. T. A. Moxon (London: Dent, 1955). *The Poetics of Aristotle*, trans. Stephan Halliwell (Chapel Hill University of North Carolina Press, 1987).

to continuing with the work. He has lost the thread of it. This kind of 'block' can be a terrifying experience, but we misconstrue it (even, or especially, for the maker) if we think of it as primarily a problem of memory and recall. The heart of the problem lies not in the 'inner', 'private' psychology of the artist, but with the work itself, even, paradoxically, in an imagined work. It is as if the work (even half-developed) is insufficiently realized to provide its own authority about how it might further develop. The inadequacy is in the sketch, the draft, itself. Even if the draft or the sketch is 'in the maker's head', in this sense privately imagined, adequate imagining must still be of something that can be made public and overt. The problem is how to provide an account of this.

THE PROBLEM OF PRIVACY

Wollheim acknowledges that what he says about pictures would, if said about language, be subject to 'well-known Wittgenstinian objections'. These well-known objections have to do with the problem of 'private language'.[21] There is no space here to digress on any detailed account of this issue, on which the literature is vast[22] but it may suffice to make two brief observations. The 'problem' can, both in Wittgenstein's original discussion and in subsequent literature, be given two slants. One, more recent, is to see it as focusing on the linguistic matter of what it is to follow a rule for the use of a word, since it is such rules that constitute what

[21] L. Wittgenstein, *Philosophical Investigations*, trans. G. E. M. Anscombe (Oxford: Blackwell, 1958).

[22] Where to start is partly a matter of taste and convenience, but a good starting point is David Pears, *The False Prison, A Study in the Development of Wittgenstein's Philosophy* (Oxford: Clarendon Press, 1988). Volume two deals with the later Wittgenstein and surveys the literature in a digestible manner (see esp. chap. 13).

it is for a word's sense to be so embedded in a community of understanding that they may be said to possess a concept (what the word really, not merely idiosyncratically to one speaker, means).

A mere hint about why this would not apply to pictures might then be that pictures do not, as language does, require anything remotely like dictionaries, or rather, to the extent that they do, they pull away from the pictorial. Often the borderlines may be tantalizingly tricky. Think for example of the convention of haloes – drawn circles round the heads of saints. At one level they 'work' just like words, as if the sign simply 'said' 'Here be an holy person'. To misconstrue the circles as (say) hats or soup plates would be to misconstrue the kind of communication system we have.[23] However, when Leonardo painted haloes he painted them as nimbuses, circles of light, like auras that we are to imagine sanctity really might produce in the appropriate (if imagined) circumstances. Such haloes then return to the pictorial. In fact there is a constant interplay in pictorial art between these two levels which, for many, is the problem at the heart of art history.[24]

None of this would make any sense, however, if there was not a basic sense in which the pictorial is *not* like this, in which it is located in something so much to do

[23] The 'interface' between pictorial systems of communication and linguistic or quasi-linguistic ones is a far deeper matter than is often supposed, not least because it seems that written languages somehow 'emerged' from pictorial systems via a process of radical abstraction and simplification of the pictorial signs. But it cannot simply be a change in sign, but a radical change in content as well (see below, chap. 2). For a very popular but very useful sketch of this 'interface', as well as for an account of visual illusions, see Richard Gregory, *The Intelligent Eye* (London: Weidenfeld and Nicolson, 1971).

[24] A useful introductory study in the sources and content of the variety of concepts of 'iconography' and its interplay with the devices of the pictorial is Michael Ann Holly, *Panofsky and the Foundations of Art History* (Ithaca and London: Cornell University Press, 1984).

with visual recognition that no rules of meaning have to be learnt or acquired to respond to pictures. If we construe Wittgenstein's 'well-known problem' as being solely concerned with following rules or acquiring 'conventions' in this way it cannot, must not, apply to pictures. However, the problem of privacy may be construed in a wider way, which earlier discussions of Wittgenstein tended to concentrate on. This is that if the significance of anything used to communicate were to rest on its fitting an essentially private mental object, communication would be ruled out from the start. In fact not only would communication be ruled out, so too would any significant sense in which painters, composers, makers of works, produce genuine works that may stand in their own right.

 Works, paintings, drawings, must somehow establish their own 'publicity' without it being dependant on any assimilation to language. Or, to put the matter another way, if something like 'linguistic' meanings are to occur in pictures they need to be set against something equally non-private. The traditional candidate is not a mental state but something apparently far less psychological. It is worth taking it seriously even if we may in the end reject it.

SIMPLY SEEING AND SEEING SIMPLY
Can we think of pictures as making public what we ourselves see? Surely the idea of 'simply seeing' is hopelessly naive. The central claim of Gombrich's *Art and Illusion* is that the idea of the innocent eye which merely sees has no sense, and certainly *can* have no sense if we are to take pictorial art seriously, and one may almost find a consensus among recent philosophers to this effect. Yet for Ruskin in *Modern Painters*[25] it was

[25] John Ruskin, *Modern Painters* (Orpington: George Allen, 1888),

a battle cry in his defence of Turner and the slogan 'paint what you see, not what you think you see' has had a constant resonance within the practice of visual art. It is a deeply ambiguous slogan. Gombrich claimed of *Art and Illusion* that its central theme was to attack the doctrine of the 'innocent eye'. For Kant, the very idea of experience devoid of conceptual classification was absurd, just as to more recent philosophers; to those such as Hayek and Popper quoted by Gombrich,[26] or to Quine, the idea of there being bare perceptual inputs is a dogma of Empiricism best discarded.[27]

But it is not clear that within the history of visual art the idea of innocence-in-experience *is* taken for granted, nor even that it is quite what philosophers take it to be. For a different concept of innocence in experience is not that of experience devoid of interpretation, but rather of someone's experience uncorrupted by an externally imposed conviction of what it is that experience 'ought' to be, as opposed to how honesty in observation should find it to be.

Within the history of art it is not hard to perceive a pervasive philosophical enquiry explored as it were in practice. Though it relates intimately to standard philosophical theorizing, it does not quite parallel it. Very skilful picture-making was in the sixteenth century as startling a new science as computers are now.

PERCEPTUAL ERROR

For Descartes a central question in the theory of knowledge and error is to ask what is it that is *given* in

edited and abridged by David Barrie (New York: Alfred A. Knopf, 1987).

[26] See introduction to *Art and Illusion*.

[27] W. V. O. Quine, 'Two Dogmas of Empiricism', in *From a Logical Point of View, op. cit.*

experience? If we grant as Descartes did, that God doesn't, can't by His nature, deceive us, then the question we are left with is how do we manage to make the perceptual mistakes we do. Descartes' answer,[28] which seems inevitable, as well as pious, is that we deceive ourselves. Perceptual error is then, like moral error, a price we pay for the gift of freewill (as if only an unfallen angel, which we could not be, or a mindless machine, which we should not be, could avoid such error). It is our own wilful over-ambitious interpretations of what we simply experience that lead us astray. Our senses by themselves cannot deceive us. So what might we *simply* experience, before, as it were, the opportunity for error is available to us? This is indeed the central obsession that Descartes bequeathed to Empiricism. It became a search for bare (and unpolluted) experience. Suppose we confine our question to the visual. Could we not think of an ideal sort of picturing as capable of merely capturing what is *directly* given to sight or would be directly *given* if it were not for a misleading interpretative overlay, so that an ideally successful picture would show us what we really *do* see, rather than what we *think* we see?

However, this thought is ambiguous, at best unstable, between the idea of what is really seen as being free from any interpretative overlay, or being free merely from mistaken or wanton interpretation. For surely on the evidence of such things as myopia and colour blindness, clearly our senses do frequently deceive us, a deception that we need to correct by an improved theory of optics. When things look fuzzy or too small to see they are not really so. (But aren't they? Isn't fur from a proper distance really fuzzy; are not motes really too small to see unless distorted by deceiving lenses?) Optics, by

[28] Descartes, *Meditation IV*.

providing a theory of good spectacles (and perhaps also a theory of bad ones too) or of good or bad microscopes or telescopes, can put us right. But suppose our interpretation rather than our weak eyes has led us astray? Might a good picture rooted in good theory then provide a similar corrective?[29]

This can be a haunting thought about pictures. It is this thought which lies behind a pervasive philosophical and moral dream. We should not despise this dream: it is a central component in the drama of the history of European art. How it is projected onto the hard details of science and painting can be more puzzling. For this dream is still radically ambiguous. One strand is that pictures are what we in fact see, *tout court*, so isolate pictures and locate that unpolluted source. Another is that pictures may provide the strongest theoretical tools we could have for finding out what such unpolluted experience should be. The distinction marches with the distinction between 'no polluting *theory*' and 'no *polluting* theory', between absence of theory and modesty in interpretation.

It is no accident that Descartes' account of perceptual error is an extrapolation of a traditional theological argument about free will and sin. (The error of the over-ambitious interpretations of the intellectual will is an error which we can commit as a consequence of our freedom to do as we will with what God provides to our senses.) One way of responding might be to seek to abandon interpretation altogether, but this would be equivalent to abandoning our own free will (exactly

[29] Cf. Svetlana Alpers, *The Art of Describing. Dutch Art in the Seventeenth Century* (London: John Murray in association with University of Chicago Press, 1983). Among many other illuminating discussions note her attention to an issue between Kepler and Descartes – whether it is 'we' or our senses 'by themselves' that deceive us.

comparable to supposing the purely mechanical camera to be paragon of probity – which is no probity at all). It could not have been Descartes' implication. The response invited by the theological parallel is to seek the virtue of modesty in interpretation. Then the question within painting is not how – by some innocence of the eye that rules out mental activity – to locate the 'given' in experience but the much subtler question of how painting can achieve a triumphant humility in experience. Humility of this sort cannot be a passive virtue.

If we think of such humility as a quite passive matter it is easy to think of the eye as an humble non-interpreting camera and thus as a mere visual replicator. Then if a marked surface can reflect light in such a way that the bundle of light rays so produced is qualitatively identical to those produced by reflection from another object, have we not thereby constructed a visual replica of the right sort? For don't we know that whatever structures that bundle (light or pigment) is optically (until the 'inner processing' takes over), it is all that we are visually given from the 'external' world? Locke put it that what we really receive in perception is, 'a plane, variously coloured', adding 'as is evident in painting'.[30]

But why ever might this be 'evident in painting'? One answer can be that just as in seeing a marked flat surface we think of it, 'mentally alter its appearance' as three-dimensional, but this cannot be enough. It is tempting to suppose that by 'flat plane' here he means the retinal image, but there is no need for him to have intended this, and the connection with painting would suggest otherwise. It is far more plausible to think that in line

[30] John Locke, *Essay Concerning Human Understanding*, book 2, chap. 9, section 8.

with familiar explanations of perspective theory the 'flat plane' corresponds to what causally determines, and thus characterizes, the quality of the bundle of light rays. Place a colour plane at right angles to the line of vision and it becomes the cross section of the bundle. The variegated quality of the cone of vision can be defined by the colour of its base or at any parallel cross section. This is what the mind 'straightway' composes as a visual appearance of something, and it is this which parallels the idea of a depicting marked surface. It is on this view composed out of what is 'simply given' in experience to that type of innocent eye that is apparently favoured by Empiricism and the target of philosophical counter-attack.

But generally this simply is not evident in painting, manifestly not in drawing (monochrome line drawing clearly makes no attempt to replicate via a reflecting surface the bundle of coloured light that the eye receives). However, why not 'in principle', since even rough line drawing will provide the structure we need for the replication process? Locke's point was to demonstrate something about perception, but it cuts both ways. Even if few actual pictures even seek to achieve such replication, those that do not – sketches, drafts, monochrome or monochrome-perfected works – convince us with their pictorial power because we can construe them as on the way to this naturalistic ideal.

To many this is how we might think of an ideally successful painting in full colour and on the appropriate scale, as it can be tempting to think of a full colour photograph or, say, Vermeer's *View of Delft*. It may be rather more than a coincidence that Locke was Vermeer's exact contemporary, for Vermeer's painterly modesty of observation may be not too far removed from the spirit of these philosophical experiments. But

if so, despite appearances, we are at the opposite pole from passive 'photographic' replication. The ideal is not that of no interpretation, no style of picture-making, but of most modest, but at the same time most active, interpretation. Vermeer's painting is not the trace of a passive reception of experience but an active construction of it. As the virtues of modesty are not those of no desire, but of a particular exercise of desire, so the virtues of modesty and 'objectivity' in art are emphatically not those of the 'mindless' camera.

This may seem both philosophically naive and naive in terms of all that we know about pictorial art. But however justified that philosophical objection may be (and most of the weight of traditional argument supports it), it is unfocused. It fails to target a quite different idea, essentially a painter's argument, about pictures and perception – about how *pictures*, *perceivers* and the *perceivable world* might, in a case of extreme accuracy, lucidity and modesty in depiction, be uniquely connected together. In the present century this is a highly unfashionable view of visual art, largely because we have lost sight of what was once a deep connection between the ideas of visual art and those of observational science. This is not concerned with looks but with an active search for the objective-in-appearance.

Theories of art tend to be hag-ridden by anxieties about the subjective/objective distinction, not merely because of the persistent belief that aesthetic reactions are irreducibly subjective, but for the much deeper reason that the very idea of communicating experience from one mind to another tends to come to grief at this point. For the root of the problem is that of privacy. Pictures, no more than any other form of communication, can simply evade this issue.

THE PUBLIC PROJECT OF PERSPECTIVE

The most obvious candidate for the idea of a public 'space' that provides systematic criteria for pictorial content is the traditional idea of the objective public visual space of perspective theory. It is in these terms that it makes the strongest claims on our philosophical attention.

There are two ways in which we may intuitively respond to the idea that we 'see in perspective', one is to think of the project of perspective as providing a recipe for replicating (*adequately*, if partially, replicating) the phenomenological content of visual experience, how whatever it is that we see *seems to us* as we see it. An alternative way is to think of it as a way of making the 'objective' appearance of objects in the visual field open to public inspection. Most thinking about perspective, both popularly and within the history of art, confuses these two very different things or attempts to run them together as part of a larger independent theory of seeing itself. What is a quite different matter concerns the project of perspective pictures. This makes the project of perspective a project of art, but of an art which celebrates a concept of an objective world to be seen, 'out there' and beyond us. But more than this is implied: if a central topic in philosophy is that of appearance and reality, the project of perspective becomes in effect a form of (largely practical) philosophical *enquiry*, providing questions about appearance itself, rather than mere reports of it.

It should perhaps surprise us that the perspective project came so late in European art and seems to be so rare in picture-making in general. For how could we fail to notice that objects look smaller, occupy a smaller portion of our visual field, as we move away from them? Doesn't that mean that we *must* see in accordance with

classical perspective, for the obvious reason that light travels towards our eyes in straight lines? Significantly, the root concept is familiar in astronomy, long *before* it becomes articulated within a pictorial enterprise. The moon and the sun may look the same size, but if the latter is a long way away it must be correspondingly very much bigger. The geometry is then quite simple. Since we can measure a length by the gap between two compass legs hinged at one end, then for any standard length of these rods the angle they make at the hinge varies exactly with that angle. In astronomy the apparent size of an object just *is* the angle measured in degrees. (As Bishop Berkeley pointed out in his *New Theory of Vision*, this cannot be how the *eye* measures apparent size, since nothing at the point of the eye itself has a capacity to measure angles.)[31] Hence the actual size of a body for any given apparent size will depend solely on distance. This means that we can think of bodies as if they were placed with a cone of vision whose apex is at the point of observation, namely the eye. As long as we don't think of measuring distances from an eye-point alone, it is irrelevant to this construction that a single unaided eye is (unlike a sextant, or any other device where we can stand sideways on to the sighting rods) incapable of measuring a visual angle. Real sizes and apparent sizes simply do relate thus in terms of distance from the point of observation.

We should contrast this concept of 'apparent size' with a commoner notion of how big or small something 'looks to us' – the phenomenological experience of 'constancy' of scale. People do not look bigger to us as they approach us. They look the way things that don't

[31] George Berkeley (1685–1753), *New Theory of Vision and Other Writings*, introduction by A. D. Lindsey (London: Dent, 1910).

alter in size look as they get nearer. On the other hand the moon as it rises over the horizon, does look to us far bigger than it does isolated in a clear sky. (The psychological explanation for this is here irrelevant: as irrelevant in its own way as the idea that we 'see' or do not 'see' retinal images: what matters is picture-making.) Either we may carefully take a sighting of the moon and measure the fact that at each point it, say, occludes a sixpence held at the same distance or reflect that it could not really be nearer the earth at these different times (nor have shrunk with the passing hours). The fact that these two concepts of apparent size are still difficult to distinguish without reflection, is what enables the cone of vision construction to provide a bridge between them.

In effect the 'astronomical' concept has to be incorporated within a geometry of 'objective' pictorial construction. The simple way to describe the latter is that the visual cone is inverted to produce the basic structure of a plane of pictorial construction, so that a centre point within the picture corresponds to objects on a distant horizon becoming vanishingly small. The construction is greatly helped by looking for pictorial subjects which, like the parallel edges of streets whose vista we gaze down, can be made to correspond to the lines of the inverted cone.

However, this alone fails to describe the pictorial construction. For the same overall geometry must be made to perform a further purpose, namely that the imaginary lines that project elements of what we see in three-dimensions with elements in the marked two-dimensional surface (the orthogonals of pictorial construction), converge in accordance with the visual cone. Perfectly coherent projections of three-dimensional objects onto two-dimensional surfaces can be constructed just so long as the orthogonals have a

coherent geometry. They do not need to converge. In nature the shadow cast by an object on a sunlit wall fairly early or late in the day will, for example, provide a parallel-oblique projection which reproduces foreshortening but fails to reproduce perspective (very like the pictures on Greek vases and in modern systems of technical drawing). We can learn to construe pictures even when the orthogonals diverge, a sort of 'reverse perspective' so that distant edges of, say, tables, are drawn smaller than near ones. The tables still 'look' solid enough.

So how do the looks of things become coupled with their objective appearances? A way of imagining the perspective synthesis, notoriously that of Alberti's fifteenth-century treatise *On Painting*,[32] can then be to think of the two-dimensional marked surface as if it occupied the plane of a window through which we look when it is at right angles to our direction of view, then the picture is as seen through a window, a world constructed by imagination and artifice that may correspond in its rational geometry to the real world as we might see it through a real window. Then think of the imagined plane of an open window as 'just like' the projected image on the flat wall of a pin-hole camera, a natural picture-making that compares and contrasts with the natural pictures made by shadows. It is not difficult to imagine that it is this imagined experience of seeing vistas through windows that drives the perspective enterprise into the arms of an already-present astronomical construction.

But this imaginative experience, however helpful, can at the same time be quite confusing. It leads to the

[32] Leon Battista Alberti, *On Painting*, trans. with introduction by John R. Spenser (New Haven and London: Yale University Press, 1966). See esp. book 1.

thought that we can naturally reconstruct the visual
cone as a pyramid on a flat base. As Leonardo saw, this
leads to paradoxes, for standard distances make up the
inside of a sphere of which the viewpoint is the centre.[33]
True apparent size reduction can only occur on the inner
surface of a sphere whose centre is the viewpoint. Since
any plane – for instance a dusty window pane through
which we see a landscape – will lie at a tangent to this,
projecting one onto the other will produce an 'apparent'
departure from the apparent-size rule. For consider a
row of equal sized objects placed at right angles to the
line of vision (more or less, 'the direction we are
looking') then the peripheral objects will be occluded by
a larger area on the imaginary window pane, despite the
fact that they are further away. (For since the plane lies
at a tangent to the inner surface of that sphere which
corresponds to equidistant points from the eye, the
periphery of the 'window pane' is further away from the
eye than the centre of it.) Thus the pictorial construction
by converging orthogonals onto a flat surface will not
exactly correspond with the inversion of the cone of
vision.

What has all this got to do with art? The simple
answer is that pictures are exhibited artifacts, often
framed, and always seen in their own right.

Alberti's treatise *On Painting* talks of visual pyramids,
rather than cones. In effect this strangely privileges the
idea of a flat, normally rectangular picture as part of
optics itself, while at the same time identifies it with the
imaginary window *through* which we perceive an
imagined (depicted) world. Yet we achieve this via a
framed surface which we in fact look *at* rather than
through. This is a tremendous, if subtle, imaginative

[33] Cf. Gombrich, *Art and Illusion*, *op. cit.*, p. 255. He makes, in my view,
rather heavy weather of the 'problem'.

leap: it can still leave us uneasy whether we do 'look' *'through'* or *'at'* such paintings.[34] In fact an 'exact' perspective geometry would only 'work' if the pictures that resulted were projected onto the inner surface of a sphere – or a dome. One result would then be that there would be just one 'privileged' position from which the whole would fully convince.[35] Pictures, of course, need not be on flat surfaces, and certainly need not be rectangular, but so long as we think of them as imaginary windows on an imagined world we tend to suppose the imagined glass of the window to be at one and the same time equivalent to:

(a) *The actual flat surface of the canvas or paper.*

(b) *To the (flat) cross section of a cone of vision (a cross section that fails to obey the law of distance reducing apparent size)*, then to:-

(c) *the cross-section of the bundle of light-rays that enter the eye* (which, should the apparent size rule be adhered to is, of course, a sphere), and then finally, to,

(d) *the aesthetic concept of the compositional (usually rectangular) area.* This may be identified by the frame of the picture or by a view through an imagined window or in fact by virtually any system of projective composition which makes a *picture*. (We easily come to think of this as contriving the 'pictorial space' of a bounded picture.)

[34] Gombrich's insistence that we cannot at one and the same time attend to the marked surface and to what it depicts (countered by Wollheim's concept of 'twofoldness' that claims the direct contrary) seems to inherit just this tradition.

[35] See Martin Kemp, 'Perspective and Meaning, Illusion, Allusion and Collusion', in Andrew Harrison (ed.), *Philosophy and The Visual Arts, Seeing and Abstracting* (Royal Institute of Philosophy Conferences), (Dordrecht: Reidel, 1987). Kemp's argument focuses on the 'icono-graphic', in fact propagandist, force of a use of this type of privileged point by the Jesuit priest and painter Andrea Pozzo in the late seventeenth-century church of Sant Ignazio in Rome.

Each of these are very different. It is perfectly possible to articulate them in different ways. How they are articulated establishes the power of the imaginative idea of pictorial objectivity. A great deal of loose talk about pictures and the 'picture plane' does not so much link these ideas as confuse them. Much of our popular prejudice not only about painting but about perception owes more to Alberti's thought about the form of an imaginary world than we might like to admit. But it is a stupendous sleight of hand and eye that gives birth to the idea of a painter making a new visual world for us just beyond the marked surface into which, by a controlled act of imagination, we can leap. At the same time such a construction privileges us, the imagined observers. The project of perspective is thus an *aesthetic* project, a project of art, from the start. Projects of art are inevitably concerned with publicity.

It is in fact the imaginative power of (d) which encourages us in thinking about pictures, and thus in making or beholding them, to connect (a), (b) and (c). In effect this encourages us to think of the quite objective concept of ('astronomical', or geometric) 'apparent size' – where the moon is always the same apparent size from the earth unless it moves away or shrinks – in terms of the 'subjective', 'phenomenological' apparent size of the moon (which always seems to look bigger nearer the horizon).

Don't we 'in fact' see in perspective?[36] If what is claimed is that we (normally) see things from rather restricted points of view and that from any such viewpoint the area of the visual field occupied by a

[36] Goodman, in *Languages of Art, op. cit.*, pp. 10ff., has often been understood as insisting that we do not, but that we take pictures to establish this is a learnt convention. I take him to be saying, rather, what I think to be true, that the claim that we do or 'just do' see in that way lacks sense. So then, of course, would its denial.

given object diminishes with distance, who could deny it? Only if light failed to travel in straight lines or, less improbably, we could see round corners, would this cease to be true: objects within the visual field occlude one another in terms of a simple rectilinear geometry. But that simple fact fails to capture both how we visually experience the world and how an 'objective' depiction of it 'must' succeed. Beyond this there can be very significant variety. In constructing pictures we are, for one thing, far from restricted to a fixed point of vision *from* which a scene should be viewed. Equally coherent may be a set of points towards which objects can be seen, and there is no reason why the corresponding point from which they are seen should not itself be 'within' the imagined space of the picture's subject. As the great Dutch master of space, Pieter Saenredam magnificently demonstrated[37] (see plate 4), we may within a pictorial space, be lead by the picture to 'project' the point towards which we look from a variety of imaginary 'eye points' within the picture, looking from one point then towards another. We may equally well be invited by the picture to project our eye point further 'into' the space of a picture than its overall perspective might suggest. An object within a perceptively constructed space may appear as it would be seen from far closer-to and viewed differently from what would be possible should all the scene be 'in focus' at one time. In this way we unconsciously ignore any apparently grounding prejudices in favour of single point perception.

[37] See, for example, Alpers, *op.cit.*, esp. chapter two. She suggests that the anti-Albertian 'Northern' projects of perspective of 'distance point' as opposed to single vanishing point perspective, tend to abolish the 'picture plane'. Rather I think they tend to recognize the distinctions, which I suggest, the Albertian system conflates and to give them lives of their own.

As Michael Ann Holly says commenting on Panofsky's study of perspective 'the system of perspective...enters the Renaissance exactly halfway between the two worlds of subjective and objective experience':[38] in other words it constructs for us a pictorial conception of individual experience made public and shareable. What makes pictorial sense is what convinces us visually and aesthetically. As much to the point, it can convince us philosophically, for within the project of objectivity there can be many varieties of pictures, many ways of 'framing' and projecting our visual experience.

[38] *Op. cit.* See also Erwin Panofsky, *Perspective as Symbolic Form*, trans. Christopher S. Wood (New York: Zone Books, 1991).

Chapter Two
DRAWINGS

ARBITRARY AND NON-ARBITRARY SIGNS

If photographs stand at one extreme on the scale of apparent pictorial literalism most drawings seem to stand at the other. Yet really all handmade pictures are drawings. Any sketch, and fragment of graffiti, can dramatically demonstrate that recognizability need have little to do with any sort of replication of experience. Drawings are essentially artificial.

The big difference, so goes an absolutely standard argument that hardly anyone would deny, between language and pictures is that whereas the signs of language are 'arbitrarily' connected to the world, the signs that we recognize as pictures are not.[1] Thus the word 'cat' in English bears no more natural connection to cats than the word 'chat' in French or any other sign for cat in any other language. Then, in the sentence 'the

[1] The root idea of the arbitrary sign goes back to Ferdinand de Saussure. Its complexities are far subtler than I have space to indicate here. See F. de Saussure, *Course in General Linguistics*, ed. Charles Bally, revised edition (Glasgow: Fontana/Collins, 1974). See Roy Harris, *Reading Saussure: A Critical Commentary on the Cours de Linguistique Générale* (London: Duckworth, 1987) and *Language, Saussure and Wittgenstein, How to Play Games with Words* (London: Routledge, 1988).

For a general discussion of the implications of this for pictures see David Summers, 'Conditions and Conventions: On the Disanalogy of Art and Language', in Kemal and Gaskell (eds.), *The Language of Art History*, *op. cit.*, and Andrew Harrison, 'A Minimal Syntax for the Pictorial: The Pictorial and the Linguistic-analogies and disanalogies' in the same volume.

cat sat on the mat', the connection between that inscription (or the corresponding sound) and some furry animal having parked itself on the floor is correspondingly arbitrary. In short we have to learn the connections by acquiring linguistic conventions, and 'learning the rules for language'. However a picture of a cat on a mat – certainly a photograph of one – is non-arbitrarily connected with the state of affairs it is 'about'; in the case of a photograph the connection is causal, by some process of replication, and in other cases less directly (psychologically) causal, by some process which captures the looks of things or imagines the look of fictional things. So long as we can engage in that process nothing has to be learned of convention and, not knowing the 'rules' is no bar to recognition. More positively, whatever is involved in learning to recognize cats can be recycled in recognizing pictures of cats. The word 'cat' has, it is argued, no corresponding connection with the word 'dog'.[2]

But what does this argument really show? The natural way of distinguishing between, say, the word 'cat' and a picture of a cat, is that the second – if it 'works' at all – must 'look like a cat' while the former makes no such demands. However, suppose we break the picture up (or 'down') into its component marks. Unlike certain photographs where the 'grain' is microscopically fine, any drawing will loose its depictive power when suitably fragmented. At first we may have details – a cat's head as opposed to its whole body – that make perfect sense as pictures of parts of the whole, but beyond a certain point, a point reached very quickly in a pen and ink

[2] This is somewhat of an abbreviated parody of an argument of Wollheim's, first in *Painting as an Art*, *op. cit.*, and then at slightly greater length in the final chapter of *The Mind and Its Depths*, *op. cit.* It is an important argument for him, and, I think, a bad one.

sketch, all that we will have is a mark that has no apparent pictorial force on its own. One may depict a face with about four marks (two eyes, a nose and a mouth). No one mark on its own will have any pictorial significance. It can vary dramatically from picture to picture and from subject matter to subject matter, but (with the apparent exception of very fine grained photographs) any picture will have a 'pictorial mesh'[3] below which the marks on the surface are as 'arbitrary' as we wish. It is a useful experiment to perform on any picture to measure its pictorial mesh by masking off progressively smaller areas of the picture until its depictive force is lost. (See plate 6.)

The general significance of this has been given far less attention than it deserves, for it can be via this fact that we can have access to two further central facts about pictures that cannot be captured by either the idea of looks or of replication. The first has to do with what for want of a better word we may call 'facture', the manifest evidence within an object that it has been made, the second with what kind of communication system pictures belong to. That pictures have a structure – a structure of significance – is indicated well enough by these facts. But what gives rise to these facts? One answer can be to go back to perception. If we believe that all perceptual recognition involves imposing pattern and order on what is 'given', then perceptual recognition must inevitably be structured, and will itself have a recognition mesh size very comparable to that found in pictures. A mere coloured patch makes no recogni-

[3] See Andrew Harrison, 'Representation and Conceptual Change', in G. Vesey (ed.), *Philosophy and the Arts, Royal Institute of Philosophy Lectures*, vol. 6 (London: Macmillan, 1973). The idea is used again in Andrew Harrison, *Making and Thinking* (Indianapolis: Hackett 1978). Others have made, it seems, less overt use of it, though it is implicit in much writing on picture-making.

tional sense; only in the context of other ordered patterns of items of experience would it, for example, be capable of being seen as a big red bus. In general terms this is undeniable.

But in such general terms this is where the problems begin, for the next step is to ask what constrains the structure of perceptual recognition. How much variety could there in principle be? It is here that the problem of pictures can seem to lock onto the problems of perception, for styles, ways of making pictures that 'work', are quite astonishingly variable. Some we suppose to be more realistic, or more naturalistic, than others.

It is this variety that makes it systematically impossible to suppose that variations in pictorial style characteristic of the history of art could in principle track corresponding variations in 'how we see' the 'real world' of visual experience. It seems undeniable that to recognize something is to recognize it in terms of a certain pattern (often very simple in the case of familiar objects, so about four marks will 'do' for a face). These patterns can reveal themselves in the recognizability of very simple and easy drawings, but many other styles can be recognized as 'natural' or 'realistic' to the same person or within the same visual culture.[4]

The precise sense of these tricky terms do not much matter, what matters more is what sorts of tacit theory such distinctions may depend on. One simple theory may be that realistic drawing, like realistic fiction, attempts to explore the way things in general 'really' are as opposed to merely naturalism's attachment to how they merely, if 'naturally', seem. But in this context 'really are' seems to mean 'really are as visual objects'

[4] A constant hint that this is so seems to colour much of Gombrich's writing on art.

which is hard to tell from 'really look', perhaps as opposed to 'merely seem to look'. As we have seen, a central role of perspective theory is to attempt to give sense to this idea, to make *public* the *general principles of individual* visual experience. Something like this is possible only if the very idea of the 'objective' can be grounded in a theory of 'intersubjective agreement' (a concept that lies at the heart of Kant's philosophical theory of perception). This conception of pictorial realism is not only deeply philosophical, but philosophical in a quite specific way. Unlike Kant's conception,[5] however, the testimony of pictorial realism is that it is by no means monolithic: it exhibits a public reality that is both plastic and various.

However, this overlooks a further fact. This is that the very possibility of drawing makes it plain that questions about what the 'objective' world of visual experience could in principle be supposed to be (questions about knowledge and existence) can never be altogether pulled apart from quite different questions about deliberate, intended, or acknowledged activity. For if drawings are things that represent they are at the same time things that are made. Drawing is irreducibly an *activity*. Drawing and painting, along with modelling and sculpting, lies at the intersection of these apparently quite different topics. Handmade visual art virtually boxes the philosophical compass.

THE MARKS OF MAKING
Each picture will have a different depictive 'mesh size' – frequently one that varies from place to place within the marked surface – and much of what we loosely call the 'expressive' quality of pictures can be related to this in the following way. In highly 'finished' paintings the

[5] In the *Critique of Pure Reason*.

size of the individual brush marks on the surface may be significantly smaller than the pictorial mesh, in more 'painterly' works much closer to it, and in others – especially those which manifest their role as drawings – may even be significantly larger than the minimal area of depictive significance, so that a whole contoured object may even be indicated by a single mark, that is to say a mark which we can fairly easily recognize as having been made more or less all in one go.

EXPRESSIVITY

What lies behind our connecting this phenomenon with 'expressivity' is that the relationship between the two scales of significance on the surface enables us to connect two essential facts about representations of this sort: that they refer beyond themselves to something else, real or imagined (what the surface depicts), and that they are essentially artefacts made as the outcome of deliberate, in various ways controlled, or less controlled, activity involved in how the surface was made. This link is significant in two ways. First, it connects two sets of ideas which become often infuriatingly intertwined in the philosophy of communication: that of 'intention' and that of 'intentionality'. The former, very broadly has, as we might expect, to do with an action not being accidental, that is to say the outcome of some agent's thought which controls and to that extent explains the result; the second has to do with how thought may be 'of' or 'about' something. The linking concept here is that of thought.

We often think of 'expressivity' as being concerned with feelings or emotions, perhaps hidden amorphously within the soul until given form and substance within a work, and many theorists (notoriously Collingwood)[6]

[6] See R. G. Collingwood, *The Principles of Art* (Oxford: Clarendon Press, 1938).

have wanted to impose something very like this picture on all art, or even to make it a defining feature of genuine art. But this idea of art as essentially being emotional expression, even of emotional self-expression, absurdly sentimentalizes art. In the wrong hands – and there are too many of these about – it can reduce the arts to a very high-flown form of laughter or weeping. Artists, poets, composers, are not, contrary to popular myth, more emotional than the rest of us, and if they are it tells us little or nothing about art in general (though in particular cases, or for particular movements in art, it might tell us much). That art is – or that artists are – expressive in this way has rightly been given a pretty bad press. More to the point, however, this way of looking at things is unfair to the concept of expression. Certainly feelings, emotions and moods can be expressed, but so equally can all sorts of thoughts. To consider in general what a given set of signs expresses, or to consider it as an expression, need not be to think of something like a grin; it may be (think of the idea of a certain mathematical 'expression'), to ask simply what it means, and thus what someone may mean by it.

INTENTION AND ITS OBJECTS
In a mainstream of philosophical discourse the idea of an 'intentional object' is that of the object of thought, or in general of those psychological verbs which contrast dramatically with verbs of material connection – what someone may be thinking about, fearing, hoping for, and so on. Thus if I sit on a chair, dragon or Pegasus, there is a chair, dragon or winged horse that I sit on, whereas if I am looking for a chair, thinking about one, or drawing a picture of one, no such implication follows. As we have seen, photographs give trouble because their apparently merely causal nature does carry

just such an implication. It would be delightful but unlikely that there might be a photograph of Pegasus.

In much unreflecting popular and philosophical talk someone's having an intention is firmly, and often exclusively, connected with their having a purpose or further goal in mind, with what they are doing something for. This naive view of intention has most unfortunately infected philosophical discussion of the arts, so that it is frequently believed that an artist's 'intention' must mean whatever further or external purposes or desires the relevant work of art might serve. Then it is often taken to follow that any attempt to understand or criticize a work of art on the basis of intentions would run the inevitable risk of distracting your attention from the work itself; such thinking must always be fallacious.[7]

[7] The literature on this is vast, much of it dismal, and would require a book on its own. The 'classic' starting point is the invention of something called 'The Intentional Fallacy' by Wimsatt and Beardsley, see W. K. Wimsatt, *The Verbal Icon* (Lexington: University of Kentucky Press, 1954 and later editions). Anti-intentionalism still has its adherents since the stance appears to establish the 'autonomy' of a work from threats of irrelevant and unfounded biography of the work's maker. Post-modernist obsessions with the abolition of the author follow within the same sceptical tradition. For an excellent, quite early, rebuttal see Stanley Cavell, 'A matter of meaning it', in *Must We Mean What We Say?* (London: Cambridge University Press, 1976). See also Monroe C. Beardsley, *Aesthetic Inquiry* (Belmont, California: Dickenson, 1967), and *The Aesthetic Point of View* (Ithaca, New York: Cornell University Press, 1982). For a systematic account of a firm use of concepts of intention in art history and criticism see Michael Baxendall, *Patterns of Intention, op. cit.* Part of the difficulty is a persistent tendency for theorists to adopt concepts of intention that in effect collapse into those of purpose, ulterior motive, ends towards which what one does is a means, and so on. Often these concepts are vital; equally often they can be profoundly misleading. One such example is the use by both Baxendall and Wollheim in *Painting as an Art* of the idea that the 'intention' behind or beyond all painting and drawing is to achieve 'visual interest'. This would be as if one were to say that the intention behind all language was 'to communicate'. But since communication is constitutive of language (it would not be language otherwise) it could not at the same time be a means to that further end. For a (fairly) sustained attack on some of these mistakes see my *Making and Thinking, op. cit.*

But this is simply silly. Intention connects with something more general, with what is marked by the difference between talking of the action of rain on sandstone being responsible for its becoming pitted and the action of Tiny Tim in stabbing his penknife in the desk top making him responsible for its becoming pock-marked. The rain doesn't do it *on* purpose, Tiny Tim did – even if he had no further purposes in mind, did it for no particular reason. What he did was intentional if that was what he took himself to be consciously and deliberately doing.

What we do when we are responsible for our actions cannot be peeled off what it is that we suppose ourselves to *be* doing. We might then forge a link between an intentional object and the idea of an intention as further purpose if we limit our conception to a certain kind of communication, more or less that of setting out to convey a thought. A typical case is telling or warning someone of something. Then, *what* is told becomes the intentional object of what is said, and what is intended is that someone *should believe it*, or perhaps consider it, fear it, hope for it and so on. But this would make a great deal of pictures (as well as much other art) quite unnecessarily puzzling. For, while some uses of pictures may well fit this account (advertisements, didactic, moral or religious art), it is really not at all clear when we look at a painting or drawing that we take seriously that anything like that kind of question is appropriate. What a work may centrally demand of us is that we attend to it in its own right, not in terms of what it, beyond this, may seek to inform us. This can give the idea of the 'intentionality' of such works as much of a bad name as that of their 'expressivity'.

But in fact we have no need of such restrictions. The intentionality of drawing simply means that what we see

is deliberately made in a way which connects with how it depicts. The action of drawing is the action of exploring a depictive possibility by the making of marks on a (normally flat) surface. It is a process of thought.

THE PROCESS OF KNOWLEDGE AND DECORUM: TWO KINDS OF PRIVACY

The nouns drawing(s), painting(s), sketches, derive essentially from verbs. In a note in *Zettel* Wittgenstein asked 'how is it possible to learn the truth by thinking?' and offered as a paradigm case how one may learn to see something by drawing it.[8] Then a kind of acquisition of knowledge or a focusing of visual belief, is shown to be an essentially practical matter. Wittgenstein was making an explicit analogy with the practice of philosophy, with 'learning the truth by thinking'. It is virtually a cliché within the history of art teaching that to learn to draw is to learn to see. It might be objected to this that seeing is not the sort of thing we *can* learn to do, that we just do it so long as our eyes are in order. This is probably false[9] but even if it was true it would miss the point. For in any more interesting sense than that of merely receiving 'sense impressions' seeing is far more than mere visual acuity. As with the other senses, most of what lies before our eyes, placed so it produces the required optical image, we (fortunately) do not notice, and much of what we might notice subtly or otherwise within our visual field we (less fortunately) fail to attend to, while even what we may notice we may not fully realize *how* we notice. In this sense, which is a perfectly everyday sense not one which belongs specially to artists, we are most of us in different ways more or less able to see what is before us.

[8] Ludwig Wittgenstein, *Zettel* (Oxford: Blackwell, 1967).

[9] As Locke saw with his discussion of the so-called 'Mollinaux effect', *loc. cit.*

Hume in his important essay 'Of the Standard of Taste'[10] centres his account of how it can be that people do in fact differ in both their response to taste, and then in the Judgements of Taste, on the fact that we differ remarkably in how well we are able to attend to the more subtle features of what is around us. He sees these differences as lying at the heart of the matter of judgement in and about the arts but, in common with most philosophers, fails to connect them with the practice of art-makers as opposed to that of art-'consumers'. In fact what audiences, beholders, or readers and listeners are really invited to learn from the 'mimetic', or representational, arts is how central the processes of knowledge that are incorporated within art are to our own capacity to make sense of the world around us. Drawing, like the process of describing, is a way of making sense of what the world presents to us, or of how we can attempt to imagine it. It can present a paradigm of understanding that we ignore at our peril. Drawing is, whatever else, a process of coming to know, towards knowledge of what is seen in terms of what is made.

However, paradoxically, this may provide a reason for the philosophical neglect of drawing. We often find it difficult to negotiate the difference between a concept of privacy as *decorum* (what should not be made public) and a concept of privacy as it may be applied to thought that cannot be made public. For we often tend to associate drawing with something personal and private to an artist, with ways of working something out before submitting it to final scrutiny. Essential to what constitutes a work for an artist is what it sets out to make public. If we look behind the scenes what we may see

[10] David Hume, *Of the Standard of Taste and Other Essays* (New York: Bobbs-Merrill Library of Liberal Arts, 1965), p. 65.

may genuinely be irrelevant to its understanding. The problem is what in different kinds of art, as in communication generally, is to *count* as improperly looking behind the scenes.

The idea of a sketch (indeed actual sketches, often tentative and tenuous scrawls and scribbles that can be found in the notebooks of the most proficient artists) is of something personal and unformed, on the way to making sense of things, but falling far short of what the artist may fully intend to stand by as exhibitable, as a full 'realization'. Moreover it is here that there seem to be dramatic differences between traditions and kinds of art. Most painting in its handling of brushwork, in its exhibition of ways of laying pigment on a surface, like much sculpture, provides for us public evidence of the process of visual thought and decision of a kind that is deliberately hidden in (say) the preparation of a finished, completed, poem or novel for publication. The corresponding evidence may well emerge in scholarly variorum editions, but what emerges is *not* the work, but something else personal to the work's maker, which it is part of the work's intended nature to keep back. It may be significant that a possible exception to this is in certain sorts of philosophical writing, where either 'artificially' and formally in the form of a dialogue or a meditation or confession (one may think of Plato's, Descartes' or Rousseau's models) or in the quite unformal style of the later Wittgenstein, what the reader is shown is quite as important as what is concluded. Perhaps even more important is *how* the conclusion was reached. The decorum of the privacy of process of engagement with thought, as opposed to the exhibition of its results, has never quite been, and for many should never be, a privilege of philosophical writing. But to a significant extent it can still apply to sketches. They are

frequently not intended for publication, artists are frequently insistent on their privacy, and (quite significantly) we often do not find in sketch books those signs of finished public style in handling and presentation that permits us to date and place them within a stylistic period.

It is not too fanciful to locate the beginnings of a certain strand of modernist thinking about the visual arts at the point where this concept of privacy becomes open to doubt. This brings into the foreground of our awareness something inherent in all depiction, that imagination is an *activity* in which we *engage*.[11] Think of Constable's 'oil sketches' and Turner's use of notebook style in his later exhibited paintings, later of Monet's use of the style of a sketch in fully final work. That we may respond powerfully to work which earlier 'taste' considered indecorously unfinished is not just a matter of a new taste for the appearance of handled surfaces, but pays a deeper tribute to a recognition that something far more like the principles of decorum, appropriate to a process of enquiry (inherent in any art, but more apparent in the practice of philosophy), applies equally to art itself. This is the sense in which it is very far from fanciful to consider the practice of drawing, as inherently 'philosophical'.

THE FIT OF DRAWINGS TO WHAT THEY DEPICT

If 'drawings' etc. are verbal nouns, in a less obvious sense so is the 'view' or 'prospect' of a landscape: here, too, something, some form of attending, looking, active direction of visual experience is invoked, rather than mere passive reception. Neither drawings nor what

[11] In *Dejection, an Ode*, Coleridge refers to the loss of the 'shaping spirit of imagination' (*Making and Thinking, op. cit.*, is concerned with the core activity of making).

they make manifest to us exist naturally as a boulder may but as the outcome of a certain kind of directed thought. One boulder or chair may, perhaps, closely resemble another, but the 'fit' of a drawing to its subject matter is not like that, for what converges where drawing is successful is an active way of seeing (or visualizing) something with an activity of making its representation. Thus to regard a drawing or painting for what it is, is to be invited by it to track that convergence. The 'direction of fit' between a drawing and its subject matter goes, as it were, both ways, for what a non-fictional drawing is accurate to is not the world (or item in the world) *tout court*, but how that item is seen by the maker of the drawing. It is very largely this which constitutes the authority of the picture. What can make this difficult to grasp is that we do here have a kind of symmetry, not the simple symmetry of resemblance, but rather of two processes of (asymmetrical) 'realizations' that come together. In other words – even when there is such a successful convergence – the picture does still not stand to the landscape as the landscape to the picture (the landscape does not come to depict the picture, any more than the sitter depicts her portrait), rather it is that how we regard the picture (make visual sense of it) becomes how we make a corresponding visual sense of the landscape or the sitter.

It is rather more than a metaphor to say when we cannot make sense of something that we are unable to make anything of it. From a picture-maker's point of view it expresses a literal truth. From the point of view of a beholder of the work, to grasp the visual 'sense' of what is depicted is to see what the painter made of it.

It is natural to think of regarding a marked surface and seeing what it depicts 'in' it, but from the maker's point of view it is equally natural – indeed necessary – to see

the marked surface in the object (face, still life, landscape) that is being depicted. Gombrich in *Art and Illusion* talks of making a picture as a matter of 'making and matching', rather as if the picture-maker progressively marks a surface and then compares it with what can be seen and adjusts accordingly. Quite apart from the obvious objection that this could in principle only apply to drawing in front of an object, sitter, landscape, still life and so on, this way of putting the matter makes it seem as if the materials for making the adjustment were somehow 'out there' and ready to hand, rather as one might cut a piece of floor covering to a given and unadjustable floor. But it is quite unclear that the world of even visual appearance is quite like that. To visually attend is inevitably to select and construe. One who draws an object, sitter or landscape has just as much to see the drawing or painting in the landscape or sitter as the other way about, to attend selectively, that is, to just those features of the subject that can be rendered in the appropriate medium. It is irrelevant to attend to colours and soft masses if the medium to hand is black or grey pen or pencil (though it may be essential to attend to what cannot be directly rendered in a given medium as it cannot be rendered). To paint in water colour as opposed to oils is to watch the highlights and the whites in the view in a totally different order from how it is possible to attend while painting in the other medium.

Surfaces cannot be marked by hand all at once. Part of the structure of a drawing or a painting is that it necessarily has to be built up in a certain kind of sequence – it is this sequence that even, or especially, in such 'objective' drawing or painting (objective in the sense that the activity is continuously constrained by attention to something outside, different from the marked surface) establishes the convergence between

marking and seeing. Object-directed seeing in this context is impossible to peel apart from making. The user of a pencil or a brush as much sees with those instruments as with eyes alone.

The mirror of this process lies in the eye of the informed beholder. Gombrich rather notoriously insisted that to attend to a picture in terms of what it depicts excludes attention to it as a marked surface, presumably for the reason that it disrupts the illusion inherent in the pictorial. This massively distorts the nature of painting and drawing. What Wollheim sets against this he calls 'twofoldness'. This requires that any intelligent beholder must attend to both roles within the picture in one act of recognition. He is clearly right. Without something of this sort the very idea of drawing or painting would make no sense. This is also why, contrary to the prejudice of 'easy pictures', pictures cannot track looks *tout court*.

This need not mean that all such seeing is accompanied by active marking, for the process may incorporate relatively substantial periods of apparently inactive contemplation of the seen objects – that is both the developing surface and the realized perception. That drawing and painting may be fast or slow activities is itself integral with the process of attention involved. Some pictures from the beholder's point of view may be either fast or slow. It is a curious fact about certain drawings and paintings that they may make even the sense of time in their process, and thus in what is appropriate attention to them, manifest.

However, to learn how something looks by drawing is to explore its appearance with a task in view – how to render it, not just to oneself but publicly to others. Drawings – thus paintings and so on – do not match

looks, but rather make looks, and the activity behind
them, manifest. To see what that means it is necessary
to consider drawing from a different point of view.

UNITS OF SIGNIFICANCE
Something like a philosophical enquiry within drawing
may go in another direction. Experimenting with depic-
tively successful marked surfaces, we may construct
minimal pictures: if four marks, properly placed, will
give us a face-depiction (of sorts) how many will be
required for other things, for cats or trees or old boots,
and how many for recognizable particular faces, trees,
cats or boots? No great skill is required so long as the
depiction is of something generally or more or less
recognizable, more and more skill for greater subtleties
and particularities. Comparing naive, not very
competent, sparse drawing in this way with highly
skilled drawing can be hugely instructive, and at the
early stages any incompetent – even the average
philosopher – can do it. What such experiments are
concerned with is that the mesh is the *boundary of the
arbitrary*. Beyond, or below, that boundary the marks
on a depicting surface will be as 'arbitrary' as the sounds
and shapes of any isolated linguistic unit. There need be
no natural similarity, no natural causal connection of
any sort between such isolated surface marks and what,
within a picture, they clearly depict. What enables them
to depict is how they 'work' together – their inter-
connections. In general, the more familiar a type of
object is the more we have become used to – may even
on some views be biologically programmed to –
recognize it in terms of simple patterns, the simpler a
depiction of it may be.

ARBITRARY AND NON-ARBITRARY STRUCTURES

Pictures are essentially structures. But, equally, and equally 'obviously', so are linguistic units. (It was this parallel which stood as the core idea in Wittgenstein's *Tractatus*, that pictures, far from being set in opposition to language, should provide a concept for language itself.)[12] Any theory of linguistic significance must also be a theory of structures, patterns that enable significance to be possible. If there is a radical difference between pictures and language it will rest on the kind of 'structures' that the two systems require, their 'syntax'. As far as language is concerned the idea of linguistic arbitrariness is far less appealing and straightforward when applied to syntax. Indeed contentions over this may be said to constitute the content of philosophical disputes over the very nature of language.[13]

Here is not the place to be side-tracked into the philosophy of language, but it is important to note how many philosophical questions raised by language are raised equally by drawing. In general these are concerned with how far we could or should 'project' features of language 'onto' the world. For some philosophers it is the original sin of philosophy to take it for granted that the 'structure' of language reflects 'reality', for others the original sin consists merely in not taking enough care.

Often confusion – or jokes about – grammar belong to the trivia of linguistic understanding. The difference

[12] Ludwig Wittgenstein, *Tractatus, op. cit.*, I have stressed the importance of this concept of a picture in previous papers. See especially 'Minimal Syntax', *op. cit.*

[13] See for an excellent recent survey Steven Pinker, *The Language Instinct, the New Science of Language and Mind* (London: Penguin, 1995). How far the structure of language (its grammar) can be read onto the world can virtually be thought of as the core topic of twentieth-century analytic philosophy. Part of the question is what counts as 'real' as opposed to apparent grammar, or as Chomsky puts it 'surface' or 'depth' grammar.

between 'Bill-stickers will be prosecuted' and 'Bill Stickers will be prosecuted' is hardly serious. But even trivial mistakes may have serious consequences, though whether they do may depend on rather more than context. When, in *Cider with Rosie*, the young Laurie Lee at his first day at school was told to sit and 'wait there for the present', his confused disappointment mattered. The young Wordsworth might have been told to 'wait there for now' and still *now*, that impact of the moment, that 'spot of [present] time', never came to him, wait as he would. Though a very similar case, this would have mattered in a different way.

Moore famously pointed out that there was an absurdity in saying 'Some tame tigers exist' on the model of 'some tame tigers growl'. Kant equally famously, apparently more technically, made a corresponding point that 'existence is not a predicate'. J. L. Austin in the same vein remarked that 'some people think that being is like breathing only quieter'. His students 'cap and categories in hand' laughed at his joke and saw the point about existence, but the poetry of Wallace Stevens or early Charles Tomlinson is virtually dedicated to the idea that this is precisely what 'being', 'existing' is. Deep metaphors communicate by being 'ungrammatical' in these ways, a fact that can infuriate philosophers.[14] They invite us to step across the boundaries of our deeper beliefs, beliefs about the structure of the world itself. If, say, language distinguishes between nouns and adjectives, does the world contain corresponding differences between things and their properties, as unexamined grammar might suggest?

[14] See next chapter.

WORLD FEATURES AND PICTURE FEATURES: THE
AUTHORITY OF DRAWING
The point here is that *both* pictures and language require
a rather important kind of care concerning what it is
that rightly belongs to the nature of the 'system' and
what belongs to whatever the forms of communication
are about. We cannot naively assume that we 'just
know' what it is that belongs to the (visible) world and
what belongs to the nature of pictures.

An obvious contrast between pictures and language is
that whereas both pictures and what they depict are
visual, no comparable restriction applies to language.
Paul Smith in his recent and excellent little book[15]
discusses Cézanne's insistence on the unreality of
outline, despite his vivid use of outline drawing within
his most carefully observed painting. Outline is to be
sure something visible, visible in the marked surfaces of
painting and drawing: for that reason we might
conclude that it does not exist within those aspects of the
visual world that such paintings and drawings make
manifest to us.

Distinguishing between 'world features' and 'picture
features' may seem easy, but we can very soon find
ourselves in trouble. A portrait drawing of a face in pen
and ink will, perhaps, consist of a swirl of black lines
and a few fortunate, some less fortunate blots, on faded
yellowish paper. (We may imagine comparing the
drawing and the sitter together.) The face has none of
these colours and none of these lines as an even remote
aspect of its visual appearance. But it is a startling
likeness for all that. So *what* is it like? To say it captures
the look of the face tells us nothing further. Perhaps it
captures the sitter's profile, and that together with the

[15] Paul Smith, *Cézanne* (London: Tate Gallery, 1996).

characteristic tilt of the left eyebrow and the shape of her forehead, renders it such a startling likeness. Then what captures all that? The only possible answer must be a pattern of drawn lines, and this is just what no sitter's appearance *could* present.

Drawings may accurately depict the world via outline profiles just as sentences can describe the world by adjectives. But just as we can ask what it is that corresponds to adjectives (not other adjectives, but properties, and not always and inevitably properties either), so we can ask the same question about profiles.

There is a certain kind of person whose face really does rather dramatically resemble a lightly buttered boiled potato. Another may in the same manner have the startling look of a not very clean, partly used cake of soap – smooth, somewhat expressionless, slightly slimy. To be sure, none of these resemblances are enough to cause confusion in recognition, rather the reverse, but once noticed they can be remarkably hard to ignore. However, none of these people, even with the same stretch of satirical imagination, or by any stretch of imagination, resemble in the same manner a piece of bent wire. Almost any curved line drawn by a black pen on flat paper will directly resemble, by a far smaller imaginative stretch, just such a piece of wire. One might indeed be easily mistaken for the other. But a particular curved line of this sort, presented at the appropriate angle to the viewer, can be instantly recognized as the salient element in a portrait drawing of John (the soap or potato-faced John, to the life). It is as if, once it is lodged firmly within the scope of our grasp that we *have* a drawing, the right resemblance bounds free – as his profile to the life. It depends on there being before us, or on our being able to imagine, a drawing.

An apparently natural psychological question might

be, why when simply noticing a person, we 'prefer' a potato similarity to a bent-wire one. This would be a bad question. In isolation the 'option' makes no sense. It would be as if we asked why, ignoring language, we 'prefer' to ascribe properties to things rather than things to things. Our 'bias' is not a 'preference' in isolation. It is concerned with how description, or linear depiction 'works', with what kind of *reality* we are to grant to what we 'see' or describe. To bring the profile into play – even as part of an ongoing search for recognition – requires that this search be located within the pictorial conditions of a (more or less flat) marked surface.

Profiles are depictive facts, not features of the visible world in itself, as horizons are. To be sure, if we change the depictive context, much the same might be said of potato and soap-shapes. Those shapes are in their own right sculptural. Our 'preference' for 'solid' rather than two dimensional recognition-comparisons does not, however, imply that sculpture is more 'naturalistic' than pictures are. If it implies anything of much significance it may merely be that we take it for granted that people are three dimensional. Of course potatoes and bars of soap are 'part of the world', just as wire is. But from this point of view representation in general is simply a matter of taking one part of the world as we isolate it, attend to it or make it so that it can manifest another part of the world.

Visual representation is often thought of as if it were always a matter of representing a three-dimensional object in two dimensions. This is obviously not true. Pictures are only one way of depicting the visual. An equally naive assumption concerning pictures, encouraged by a simple conception of perspective, is that we can only render a depiction of three dimensions on a flat surface by the use of proportional occlusions

– near objects hiding far ones – which are inevitably
indicated by the use of boundary lines. In fact the
standard resources of drawing are far richer than that.
Outline may not even be of great importance. Volumes
can, of course, be rendered by shading, relying on the
coherence of shadow patterns, sometimes called
'modelling', but even this need not be important. Far
more intimately connected with the resources of
drawing is the fact that elements of the marked surface,
such as linearities, may systematically play multiple
roles, whose impact on us may be immediate, but which
are often quite astonishingly complex. Lines (which
may at the same time provide evidence of the process of
a drawing's composition, hesitations, false starts, or a
breathtaking all-in-one execution) are the very same
lines that trace contours over the surface of a volume,
that can correspond at relevant points with horizons,
they may even cluster so that they provide the
appearance of shading which in fact depends on their
deriving from contours. Compare the drawing by
Picasso (see plate 5), from which it is possible to
construe the speed and tempo of the drawing's process
simply from one aspect of the drawn lines – how the
absorbency of the cardboard records the points at which
the pen changed speed.

A similar principle applies to the use of colour. Colour
in itself may present a depiction of volume, not by
simply imitating or corresponding to the particular hues
and saturations of parts of objects as they are seen, but
by producing a sequence in the painting which corre-
sponds rather to their colour-relationships with one
another.[16] For example, when normal daylight illumi-

[16] See Michael Podro, 'Depiction and the Golden Calf', in A. Harrison (ed.),
Philosophy and the Visual Arts, op. cit. and Adam Morton, 'Colour
Appearances and the Colour Solid' in the same volume.

nates the surface of a more or less neutrally buff-
coloured object (especially one within a daylit illumi-
nated room) there may be a succession on the surface in
which the highlights are relatively warm, the mid-tones
cool and the next darker areas warm again. This will
be dramatically affected by the reflections of the colour
of surrounding objects. Almost without modelling with
light and shade a sense of volume may be produced by
recording not the exact hues 'as seen' but by 'mapping'
that sequence in a different, often exaggerated, 'scale'.
(A painter may even 'reverse' the direction of the
relational pattern and, as Matthew Smith does in his
Cornish paintings, represent a blindingly chalky sky by
a near-black.) (See plate 1)

Does 'the world' as such contain such contours or
such colours? It is an odd question. We might say that
of course it contains contours since it contains volumes,
and that of course it contains such colour sequences
for the same reason. Are they visible features of the
world we see? Again, it depends on what we take
'seeing' to be.

Certainly few landscapes that we walk over contain
many linearities that correspond to the contour lines on
a map. They may contain some which coincide with
such contours such as the level path round a hill or the
wall of a flat terrace, and in drawing a landscape (unlike
making a conventional map of it) such features can be
vital to emphasize. So can similar features such as the
edges of garments or folds of flesh in drawing human
bodies. Such features serve, where they are utilized in
drawing, to emphasize the relationship of one part of a
solid to another, for a pattern of contours is a pattern of
relationships in terms of which a volume can be under-
stood. In the case of heavily contoured drawing the
impact of such understanding seems more 'purely' visual

than in the case of maps, but unless visible objects such
as hems or walls are utilized the lines in the drawing
correspond no more to visible objects than the contour
lines in a map do.

What is remarkable about our recognition of such
drawing is how readily we grasp this, how very rarely
we do misconstrue the drawing as a picture of a volume
(landscape, body or face with veiled in wrinkles or
scratches). The error in seeing the drawing that way
would be very like attempting while walking to follow
a contour line on a map in mistake for a footpath. In
pictures just as in maps we need to construe the
difference between the varieties of significance a mark
may have. There is frequently this difference however,
that since a hem or a wall, a wrinkle or a narrow
shadow may be indicated often perfectly adequately by
a line, the line itself may do double duty both as a
visible-object indicator and as an indication of a
relationship. It is this capacity for multiplicity of roles
– the vitality of economy of means – that constitutes the
imaginative power of depiction, the authority of
drawing.

Consider a landscape where we make the same
comparison between a drawing and what we might see
before us. The drawing perhaps consists of a very few
lines of brown and white chalk on coloured paper.
None of the colours and none of the qualities in the
drawn lines, their delicacy, the ways in which they
traverse from firm pressure to the most subtle crumbling
at the edge of the stroke, is a feature of the landscape in
its own right, yet again it is a startling 'likeness' of that
landscape and somehow no other.

Paul Klee talked of 'taking a line for a walk'.[17] The
metaphor lies in wait for any drawing. The line follows

[17] See Paul Klee, *The Thinking Eye*, *op. cit.*, p. 123.

Paul Klee, Textual Illustration – Line Drawing, Pen and Ink.

the path over the volume that we may imagine a path taking over a hill, a fly over an object in a still life or a line of touch over a body. In the latter context the sense of the caressing line of a pencil or a brush can hardly fail to be deeply erotic, and it matters a great deal that the connection here between figure painting and landscape painting should be at this point of tactile imagination. Much landscape painting (perhaps all that does not merely exploit occlusions) belongs with that form of visual imagination that includes painting and drawing human bodies. In Cézanne's still life and landscape subjects it is as if it were simply bodies he felt happier to wander over and past than human nudes.[18] Something of the sort is clearly true of Turner, just as many of Degas' pastels, Titian's nudes or even (perhaps especially) Michelangelo's last great studies of the virgin and child are a variety of human landscape. Rembrandt's handling of paint re-enacts the passage of an eye as it explores the surface of a face. In each case it is as if a landscape and a body are metaphors for one

[18] See Paul Smith, *ibid*.

another. Often it is as if such works involved a form of displaced eroticism, a 'metaphorizing' of one category or thing in terms of another.[19] One aspect of this type of crossing of domains has been frozen into that technical term in visual art description which refers to 'tactile values' as if seeing and touching mysteriously become one and the same thing. But this is only one aspect of a wide range of similar devices from which the imaginative authority of the pictorial springs. The sense of mystery of wonder at such aesthetic power that such works produce is something we despise at our peril.

MAPS AND MODELS, THE 'SYNTAX' OF THE PICTORIAL

Gombrich, in a paper given to the Royal Society,[20] contrasted two ways in which it is possible to think of pictures: on the one hand, if we think of the paradigm of photography, as a distant extension of the idea of a mirror; on the other, as an extension of the idea of a map. It is not hard to connect the two conceptions. There are two ways of doing this. One is to think of how accurate map-making can be achieved. We may think of a landscape as 'turning into' first a bird's eye view, by progressively lowering the horizon (or equivalently raising the view point) until what is depicted is an area seen from above, and then into a view virtually from nowhere. Compare Leonardo's drawing. (See plate 3.) In effect this is how aerial and satellite photography is used in cartography. But the same thing can equally be done in imagination. In twentieth-century painting something of this sort, together with attendant

[19] See Wollheim, *Painting as an Art, op. cit.*, chap. 6. Despite his extensive discussion of pictorial metaphor in practice, he in my view leaves it inadequately defined. See next chapter.

[20] E. H. Gombrich, reprinted in *The Image and the Eye: Further Studies in the Psychology of Perception* (Oxford: Phaidon, 1982).

ambiguities, can be found in Peter Lanyon's painting of Porthleven. (See plate 2.) Within the tradition of perspective this is like thinking of it as seen from so 'high up' (yet so clearly) that the imaginary lines of correspondence (of projection) between items within the marked surface and the landscape can be thought of not as converging to a vanishing point, but as running parallel. A parallel 'square on' projection of this sort becomes in effect a kind of God's eye view.[21] Perspective need not invoke naturalism. Even photography need not: it may equally, perhaps must equally, invoke the question 'how would the world look from elsewhere, or even from nowhere?'.[22]

Another way of closing the gap is to start not from the idea of visual perception but from something also inherent in all representational art, the fact that representation makes a kind of magic, that one thing may seem to 'become' another, without our being even slightly tempted to think that it really is that other thing.

In Gombrich's early paper 'Meditations on a Hobby Horse'[23] Gombrich asks how is it that the imaginative magic is achieved whereby a child can so play that a broomstick 'becomes' a horse, despite all appearances to the contrary. The answer is that in the game of playing horses the broomstick plays a role – fills a slot – that would be occupied by horses in real life. The game here provides a simple pattern of regarding an aspect of the world that is simple enough to be filled in this way. Perhaps simply riding about. Leaving the horse to stand on its own in a field, being kicked by it, would probably

[21] See Alpers, *op. cit.*, chap. 4.

[22] *Kepler's Somnium*, trans. Edward Rosen (Madison: University of Wisconsin Press, 1967). See below.

[23] E. H. Gombrich, *Meditations on a Hobby Horse and Other Essays on the Theory of Art*, 4th ed. (Oxford: Phaidon, 1985).

render the broomstick inadequate. Perhaps legs, head, saddle and rump would be required. In general the thicker the analogy in the game is the more naturalistic the props will have to be. In the same way playing trains might be possible by just using wooden blocks, but as shunting, point changing, timetable-keeping and so on get included in the pretence so the model train will approach naturalism, to the point where maybe only size differs from a real train.[24]

In general, where the structures are external to the model, so the model or toy is simply a proxy for the appropriate item in the real world within that enveloping analogy, as the analogy 'thickens' we can imagine a more or less smooth transition from very 'abstract' models (such as blocks of wood for railway engines) to a kind of super-'realistic' point at the other end of the scale, where playing trains, or playing horse-riding more or less collapses into the real thing. This point of collapse is perhaps inevitably queasy, it depends how seriously we take what we are doing. (Is someone who 'works' on an amateur steam restoration project or goes pony trekking in a theme park playing or not? Is the modern British monarchy pretend politics or real politics?) Realism then equals accepted richness.

A model is an analogy that depends on a structural parallel so that units in the model stand to one another in the same way that units in what the model represents are related to each other. This is a 'syntactic' fact which provides the condition for what, following the same loose linguistic analogy, we might term the semantic 'content' of any particular model.[25] This may either be

[24] For further discussion of this see David Summers and Andrew Harrison in Kemal and Gaskell (eds.), *op. cit.*, and Harrison 'Representation and Conceptual Change', 'Dimensions of Meaning', *op. cit.*

[25] Gombrich's later talk of 'schema and correction' in *Art and Illusion* corre-

thought of externally or internally.

The broomstick-horse is enveloped within an external structure: one object can stand for, take the place of, another, which it depicts, within such a context. The whole game the child plays is what corresponds to a whole picture. A drawing must have an internal structure; it is how the overall ordering of the marks on the drawing's surface are organized together that enables the whole to project onto what it depicts. Then marked elements within the surface, like the broomstick, succeed as they do only when supported by the envelope that gives them significance. To grasp the depictive power of a drawing is then to grasp how its overall structure may depict. This is why drawn lines may be ambiguous in something very like the 'logic' of how they achieve their function. A line indicating the direction of a plane or the shape of a profile is a mark that 'stands for' how things are related to one another, not to what is related. The logical analogy (the 'syntax') is then this. Suppose a formula 'R: a, b' or more perspicuously 'aRb',[26] to understand the formula is to know that, conventionally, 'R' stands for relations and 'a' and 'b' for what is related. If we understand it we grasp the point that it stands for a two-unit situation not a three unit one, even though it consists of three letters. Compare this to a cup or a face drawn in outline. To understand the drawing is to know that it does not depict an object with a black line round it. But drawings are more subtle than

sponds to that latter account. There is no reason to see them as in opposition; in fact one requires the other.

[26] This is the notation in the *Tractatus*. At the severe risk of tedium I have never deviated from my conviction that the *Tractatus* was correct in holding that this is the essential syntax of the pictorial, and that the error of Wittgenstein's early thought was that this could provide a model for the underlying structure of language. For a slightly expanded version of the takeover of Wittgenstein for current purposes see A. Harrison, 'A Minimal Syntax for the Pictoral' in Kemal and Gaskell, *op. cit.*

this. We are as much invited to see the drawing in the
object as we are to see an object in a pattern of lines.
What we are invited to attend to in the real or imagined
world is what provides a certain kind of pictorial
salience.

Since (more or less) outside the arts a flat model is a
map or a diagram, to point out these features of drawing
and painting is to regard pictures as maps or diagrams.
To many this is deeply objectionable.[27] For all sorts of
maps contrast dramatically with pictures in that they
cannot be understood for what they map without
relying on quite non-visual, more or less linguistic clues.
Moreover, maps, diagrams and models do not capture
the visual in ways that pictures must.

The simple (and correct) reply is that to claim that
pictures are a species of model, then a sub-species of
maps, is not at all to say that diagrams and models are
a species of picture. However there is more to the
matter than that.

The familiar map of the London Underground which
merely indicates connections between stations in
sequence, 'abstract' circuit diagrams or engineering
drawings, as well as familiar ordinance survey maps of
Great Britain, all seem remotely far away from what we
think of as pictures. In these cases 'conventions' that we
simply have to learn, as we would learn any words in a
language, such as the use of circles for stations in the
map of the Underground, for standard components in
circuit diagrams or for rights of way and parish bound-
aries in ordinance survey maps, pulls such representa-

[27] Esp. Wollheim, see *Painting as an Art, op. cit.* He often writes as if what
he objects to were the claim that all maps are pictures, which is obviously
false, rather than the claim that pictures, along with maps and models are
all species of the same genus, which if he granted may be true he would,
as I understand him, think to be un-illuminating. I think this to be a
mistake.

tional systems far away from the pictorial. Maps may have to be 'read', pictures, somewhat metaphorical talk to the contrary, do not have to be. What we need to check out by studying the 'key' to a map contrasts dramatically with how we simply recognize pictures for what they are.

The problem here is not primarily that of recognition versus reading. Certainly that is part of the problem, and it can notoriously apply to pictures too. To return to an earlier trivial example, misunderstanding haloes as pictures of people with straw hats or soup plates on their heads is to confuse a pictorial role for a sign with a quasi-linguistic one, even though the same line (say the inner edge of the halo) may again do double – or even triple – duty for the line of the curve of a brow or a hairline. Why do pictures need to incorporate such nonpictorial elements? Why, indeed, should maps and diagrams need something similar? This has to do with the *limits* of the communication 'systems'.

THE LIMITS OF THE PICTORIAL

What in general could a structural analogue of the visual communicate? Recall that the simplest objection to mere resemblance being able to explain depiction is that resemblance is a symmetrical relation whereas depiction is not. The asymmetry derives from the fact that any depiction, map or picture, will necessarily be simpler than its topic. One has, we may say, always to be economical with the truth. A map which, in contrast with the schematic map of the Underground, included everything about the railway, not only every twist in the line but right down to the finest possible details of the landscape would, if literally inclusive of everything, merely be a duplicate of the original, but even if it were simply very rich indeed it would be uninformative. If we

could find our way around a map as complete as a landscape we would not *need* maps. The same applies to the visual world. Pictures have value because they are *not* duplicates – even of visual experience. A way of putting the matter is that faced with the rich complexity of the ways in which the world is, or may be regarded, it is the function of depiction to construct limited variants of such complexity.

PICTURES VERSUS NARRATIVE
The second thing to note is that a map or picture projects 'all of a piece' one complex onto another. It is as if the 'logic' of such projection has no internal brackets. Pictures by themselves cannot tell stories. Suppose a picture of fighting cats, or of a murderer stabbing his victim. We can see from the picture that it is the visual shapes of cats fighting or of a man holding a knife in or to another's back. But what those shapes cannot in principle show is either that if the cats were to continue fighting there might eventually be no cats left, nor even whether the man with a knife intends to kill his victim or is attempting to remove the knife. We might say here that such facts of consequence or purpose are not visual matters. But this is ambiguous, for it makes perfect sense to say that we did indeed 'see' the murder, or that we did 'see' the cats fighting to extinction. Perhaps not in every sense of 'see'. What we can say we see goes far beyond mere optics.

More to the point it also goes beyond the pictorial. What we can *say*, is beyond what we can *picture*. We may say that the person depicted is especially holy or is someone's father. But for a picture to carry that information by caption or a device such as a halo it must adopt resources that go beyond the merely pictorial, in very much the same way that, while a map may show

the shape of a path, that it is a right of way will require a different kind of significance, such as the red peck-lines on an ordinance survey.

While a picture may illustrate a story, no picture, whether it is a book illustration or the high art of history painting, can *directly* tell a story. We have to tell the story *for* it. Someone without knowledge of the theological narrative could not know from the painting what story it was Michelangelo's ceiling was concerned with any more than someone unaware of Dickens's stories could know what the illustrations relate to.

It is impossible to photograph or draw a picture of four cows in a field so that it depicts the fact that 'these might be the last cows we shall see if...', or to draw or photograph the fact that the murderer was responsible for his victim's death. Here what we can readily say we cannot draw. The 'logic' of depiction does not in itself contain the devices of narrative or consequence: a picture of something that might exist is no different from a picture of what does exist or what might only exist if other things did. Pictures, unlike sentences, have too 'thin' a 'logic' for that. For these considerations lie outside the scope of simple projection.

A world in which we communicated only via pictures would be blind to precisely those features of the world which traditionally radical empiricists are sceptical of, to consequence, cause, responsibility. To imagine a society limited in this way is to imagine one in which such concepts would be deeply mysterious, pressing in from beyond the boundaries of significance.[28] This is

[28] There may be evidence for this in fact. See Gregory, *The Intelligent Eye, op. cit.* Gregory quotes Sir Alan Gardner in *Egyptian Grammar*: 'the most striking feature of Egyptian...is its concrete realism...subtleties of thought such as are implied in "might", "should", "can", "hardly" as well as such abstractions as "cause", "motive", "duty", belong at a later stage of linguistic development....' Ancient Egyptian is, of course, a deeply pictographic, thus still pictorial, language.

precisely what such philosophers as Hume believed not to be given in the perceptual data base, for in effect that data base is conceived in strictly pictorial terms. For Hume our concept of causal connection, or the self, cannot be provided merely by what is 'given' in experience, not because what we see are individual items rather than their relations to one another, for he is quite sure their spatial and temporal relations can be experienced, and certainly not because we cannot in everyday talk say that we 'see' that people are sometimes responsible for what they do. It is rather that what such positivist scepticism has difficulty with is what we in principle could not simply draw or photograph.

Yet, we may insist, this is also precisely what serious or great pictorial art is concerned with. Vermeer's women, as we respond to his paintings, are dramatically responsible for their own lives, evidently are persons in their own right. Somehow the paintings transcend the conditions of the pictorial itself. They do so because their visual authority in depiction invites us to place them within an unavoidable narrative envelope. His paintings of women reading letters that we cannot see invites the inevitable narrative of someone seeing what the beholder of the picture cannot see. They invite the thought of other eyes – thus other judgements – than our own.[29] It is the essential 'positivism' of the pictorial that inevitably invites us to transcend its limitations. We connect pictures with beliefs that only language can articulate.

DEPICTION VERSUS EXEMPLIFICATION

A further restriction may seem more surprising, both hard to grasp, or at the very best a quibble. Alternatively we may see it as a knock down objection

[29] My debt here to Alpers, *op. cit.* ought to be obvious.

to the idea that pictures are structural analogues of what they depict. For if pictures require structure then there can be no projection onto 'unstructured' properties. Something may be drawn next to something else, having a relationship (even a colour-relationship) to another thing. This means that while a picture may easily depict something that is red or green (perhaps by depicting it as red or green) it cannot depict its colour though it may easily exhibit it. Even more surprisingly this will apply equally to aesthetic qualities. In the same sense if pictures are maps – of a sort – they cannot map or project the beauty, the grace, the energy or relaxed quality of an object. In fact it is here that pictures gain their most important power.

THE FUNCTION OF MODELS

Consider models in general. The most important facts about models can be most easily hidden from them when we are seduced by their apparent realism. A die-cast model car, cow or toy soldier really does look astonishingly like a real big car, cow or soldier to the extent that we could think of it as a replica merely reduced. What seduces us is that we are lead by the model's success into overlooking how much is left out in the replication. Model soldiers or cows seduce us less since they manifestly refuse to bleed or moo, but the idea of replication still dominates our imagination. Model cars may be quite successful even if they do not drive on their own, and are certainly successful even though their fragility fails to comply with a reduction in scale from the original. If it did they would be crushed by a falling matchstick, which would make them useless as toys though, for certain purposes, 'better' models. In fact what seduces us is that we make tacit assumptions concerning relevant analogies as opposed to irrelevant

ones. Models, like pictures, do not simply rely on resemblance, rather they establish relevance of resemblance. They do so because the ways in which the parts of the model stand to one another selects a recognizable structural analogue in the original. These toys select a relevant visual and spatial pattern at the expense of other structural features. A child playing with such a toy is in reality doing something far more sophisticated than we may realize.

Philosophers have lost sight of something important as they have forgotten their childhood experience. As the term has come to be used in modern thinking, especially in the philosophy and theory of science, 'model' has come to be virtually synonymous with the term 'theory' so that 'modelling' becomes in some quarters an equivalent for theory-making. In fact it is hard to see how a model could be a theory, though it may illustrate, test or instantiate one. A theory will say in effect 'Things are like this, analogous to this'. It is the model which the word 'this' refers to. This extension of the idea of a model is actually quite a recent development and most of our more familiar (more old fashioned) concepts of model or model-making remain in full vigour. Does this involve a split in the concept of model or an extension? Concepts, of course, may become so stretched that they eventually split under the strain, but the latter explanation is more plausible, despite superficial appearances.

In talk about science a 'model' can mean a very abstract set of equations and accompanying concepts which instantiate a conception of what is being studied. We might think of the pre-quantum model of an atom conceived of as a little solar system where particles orbit a central nucleus as planets orbit the sun, then replaced by subtler patterns which eventually break free altogether from such familiar analogies. Even rabbits

can be models – where they are the victims of experiments with drugs to see how poisonous they might be to humans. Then the question is whether they are sufficiently like humans to be worth experimenting on. Chemists model molecules by crudely scaling them up to reveal the patterns of connection within them. To understand such models it is, among other things, necessary to know what features are irrelevant. Engineers use models to test the real world normally by mimicking it in miniature or in another medium (which might be small model ships in water tanks or constructions hidden in computers) as experimental tools. Last, but very far from least, children play with model soldiers, trains or farmyard animals.

The principle of model-making is that what we may call representation by projection permits *further* representation by *exemplification*.[30] Note we now have three stages, a basic 'syntax', a projection system, then exemplification, in that order.[31] The main function of an engineer's model is the transference of *properties* from topic to model. Models are used to examine, even to test the nature and existence of properties which they exemplify. This is why, in the practical world of model-making, scaling is all important. A model ship in a water tank may well test the properties water flow and resistance, but only if it is not too small. For this the colour of the ship model will be unimportant. But colour might matter for other purposes.

[30] The concept of representation as exemplification is Nelson Goodman's, *Languages of Art, op. cit.*, pp. 65–7 and *Ways of Worldmaking, op. cit.*, pp. 63–70. The richness of this concept has, I think, been inadequately explored, as has the systematic connection of exemplification with systems of projection.

[31] See A. Harrison, 'The Terror of Aesthetic Presence', in Neil Brown (ed.), *Occasional Seminars in Art Education* (Sydney: University of New South Wales, 1993). The discussion that follows is a highly abbreviated version of the argument there.

We began with the idea of pictures depending on the portability of looks. It turns out that what is wrong with this is not that pictures do not make looks portable, but rather that the idea of portability is both stronger and more widespread than any mere idea of a pictorially established look could capture; moreover its possibility depends on what can seem, if we are not careful, to be a quite different – far more bloodless – account of pictures. Far from being opposed these ideas are mutually dependent. Together they can take the pictorial towards ways of communicating of quite astonishing power, a power which we can, paradoxically, understand only in terms of the limits of pictorial communication.

A model has to achieve two things, one a logical condition for the other. The first is to exhibit a structure which will project onto the topic, so that it can show itself to be a model of that thing and not of something else. The second which can only then be achieved is that the model has to be capable of exhibiting the property to be examined. A carefully crafted architectural model may exhibit the appearance of the planned building, but be quite incapable of exemplifying its structural cohesion. For that a visually far less realistic model (even a visually unrecognizable one) may perform the purpose far better. Similarly, a die-cast toy car may perfectly exhibit certain visual or aesthetic features of a car, but be quite incapable of exemplifying the car's resistance to impact, since for a two-inch model car to do that it would have to be crushable by a fallen match stick. All this may seem to take us a long way from the visual arts. In fact it takes us right back into the heart of the matter.

If pictures are a species of model, just the same principle applies. Then, just as we may ask what the

function of an engineer's model is, to which the answer may be to exhibit, then test, tensile strength or air or water flow, the central question about pictures in art is what do *they* exemplify and similarly 'test', experiment with. The short answer is *aesthetic properties*.

STYLE AND AESTHETIC PROPERTIES

Why do we not think of toy soldiers as tiny statues, or of military statues as large toy soldiers, or everyday drawings and pictures as art? Why are not soft toys art works? Perhaps they are. This can seem like a very large unwieldy question, one reason being that a natural response is to wonder why we shouldn't do so if we wish. Certainly many military statues are better thought of as rather large toy soldiers. It would be disappointing if it was merely a matter of size, subject matter or collector's value. Rather it is a matter of their imaginative function. Representations in art do more than merely represent their subject matter, however significant. Rather they celebrate its significance via the celebration of the work's *facture*,[32] the evidence of how the work is made.

Such works necessarily invoke a deep concept of style. 'Deep' here is not merely honorific. There is a 'shallow' sense of style in which the style of how something is made or achieved is simply a diagnostic mark of who did it, or perhaps to what period it belongs. In this sense of what Goodman calls 'style as signature' it is perfectly possible to detach a concept of what is done from how it was done. In the deeper sense it is not. In sculpture

[32] I do not know of a better alternative word. 'Facture', often, and traditionally, like so many key aesthetic terms, stolen for theological purposes, means that all-pervasive evidence in a material complex of the activity of the mind that brought it into being. Mystically, it warrants a believer's love of the 'works' of nature. Less mystically, it warrants a response to a work of art as testimony to the presence of the maker's mind.

the quality of the handling of materials, in depiction how the picture or drawing is made and 'built up', how the paint is handled, become an essential aspect of how and what is depicted. The depicted object is celebrated in how it is depicted. This certainly may be true of certain model soldiers, or certain soft toys, just as it may be equally true of certain engineers' models (one only has to think of traditional shipwright's models which clearly celebrate a pride and wonder in the projected ship that is thereby represented), but the point is that this is normally not central to their function. Indeed to attend too much to this may (as attending too much to the style of a diagram) positively subvert its function. Just as style in the wrong place may sometimes be meretricious (think of the invitation to admire the style whereby someone apologizes for a forgotten duty) so style misplaced may at other times (we might think of a drawing in a biological text book) be merely confusing. In such contexts aesthetic considerations may simply be out of place.

That we cannot *depict* the gracefulness of a tree, or the relaxed quality of a nude, the energy of a landscape of piled rocks, is no more of a problem than the fact that a model bridge cannot in the same sense model the bridge's strength: in each case the possibility of modelling permits exemplification. It is the drawing of the tree, the nude, or the landscape, which has these properties and which may thus represent them in their topics by exemplifying them. Such qualities are not strictly represented, but presented to us in what represents the tree, nude or landscape.[33]

The connection of this with style depends on the fact that many aesthetic qualities are closely and necessarily

[33] As well as Goodman and Wollheim on style, *op. cit.*, see A. Harrison, 'Style' in Cooper, *op. cit.*

related to what we may call 'gestural' features and thus to 'facture'. That drawings are made permits us to attend to the outcome of their making as we attend to how they represent. The hesitancy of a line, its nervous or relaxed quality, its smooth grace of movement, derive from the fact that we can act in these ways. It is not that we need to be nervous or relaxed in fact to make such movements of graphic marks, rather we need to be able to act in that way, to 'detach' such features from their causal 'origin' (where they may simply be symptoms of the states of mind that we may be in) so that they may become expressive features in their own right.[34] Then it is these that we may further use to exemplify qualities in the depicted world. It will be objected to an account like this that it is irredeemably metaphorical. Trees may perhaps be graceful, but literally rocks hardly have energy any more than a line may literally be relaxed, though the line-maker might be. However, we have such art which takes what might otherwise be a metaphor to the level of a quite non-metaphorical idea. Pictorial art drives the conceptual process that establishes these descriptions as features of the world itself.

It is a philosophical commonplace to suppose that the very idea of aesthetic properties being 'in the world' is absurd. Surely beauty must be, if anything is, in the 'eye of the beholder', and thus with ugliness, grace, delicacy, awkwardness, and so on. These, we think we can be sure, are essentially subjective matters. But it is the function of art to make the subjective public, to incorporate what we may suppose to be private within a public space of understanding. It is representations in art which enable us to explore the aesthetic properties

[34] Goodman treats the application of these terms as metaphorical. I think it important that they are not. See A. Harrison, 'Dimensions of Meaning', *op. cit.* and below on metaphor.

that they themselves *present*, and which may also be present in less isolated and identifiable form in the world that art represents.

FEAR OF AESTHETIC PRESENCE

What can be shocking about art – perhaps especially visual art – is in this sense its power of *presence*. It is this power which is also the source of its greatest capacity to confuse us. For just as a grey picture need not be a picture of a grey object, any more than a large picture need be a picture of a large one, a beautiful picture need not be a picture of a beautiful object, nor an ugly of an ugly one. If pictures make looks portable they certainly do not do so in such a simple manner as that. Yet at the same time exemplification lies at the heart of the matter. The problem is how we negotiate this.

An analogy might be this: a soft toy, like a teddy bear, represents a friendly bear and given that it is soft exemplifies the cuddly quality of what it represents. But for many children it exemplifies far more than this: its silence (apart from the squeak) speaks volumes for its capacity to return uncritical love. This latter 'projection' on the part of the child is a fantasy, if a harmless one. But compare a statue of a god, or a 'portrait' of the Virgin. Both represent what they do and exemplify the awe-inspiring nature of the one and the beauty of the other. But suppose a believer also thought that the statue exemplified power, and the painting itself the capacity to forgive. What is a harmless fantasy for the child becomes in these cases a form of idolatry which in religious terms is the tendency to confuse the represen- tation of an object of worship with the object itself. (We are very unlikely to confuse the linguistic description of something with what it describes, though

the 'expressive' use of language invokes something close to this problem.) Deep anxieties about the danger of representations of this sort run through our religious history and form a crucial component of the history of European art.

The command not to 'make graven images' attests not only to something deep within the history of monotheism, but to something deep within the possibility of representational art. The puritan jibe that it is dangerous to confuse the beauty of holiness with the holiness of beauty has an impact well beyond theology. The problem is not a mis-ordering of values but rather that we may confuse them. Haloes, as we have seen, are not always pictorially depictive devices; often they function much as words do, but frequently in medieval religious art they are encrusted with the most precious gilding and jewellery, much as the colour (ultramarine) used for the Virgin's cloak was chosen not merely because it was blue, but because it was precious and rare ultramarine, from beyond the seas. Gold in a painting is about the worst material we might use to depict gold[35] but that was not the point. The point was that the preciousness and beauty of these decorations should exemplify the rare beauty of the divine. But for many this took such works to the edge of idolatry, for it can seem a small step towards the wrong type of identification of what is presented in the work with what is presented. The apparently simple solution to the problem which is to remind child or believer that Teddy is only sawdust or that the statue is only plaster, will not do, for nobody doubts that. It is not even that the power of the representation suspends that doubt, as

[35] See Michael Podro, 'Depiction and the Golden Calf', in Harrison (ed.), *op. cit.*

fiction does, but rather that even in doing so it exerts a further disruptive pull on our normal concepts of fact, fiction and metaphor.

The greatest power of art comes about where it transcends its own limitations; in pictorial art as it pushes towards the boundary of the pictorial towards the linguistic. It is now the place to look beyond these further boundaries.

Plate 1 Matthew Smith, *Winter Landscape, Cornwall*, 1920.
Oil on Canvas, 54.2 x 64.8cm.

By 'reversing' the pattern of tone and colour Matthew Smith can represent a
chalky sky by a near-black (see page 78).

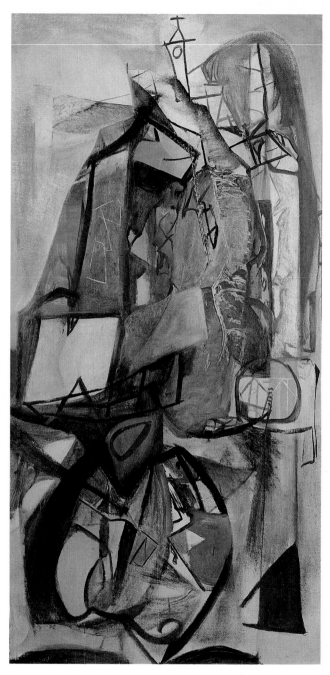

Plate 2 Peter Lanyon, *Porthleven*, 1951.
Oil on Board, 244.5 x 121.9cm.

The painting seems to stand between what we tend to see as
a map and what we see as a picture (see page 82).

Plate 3 Leonardo da Vinci, *Bird's-eye map showing Arezzo, Borgho San Sepolcro, Perugia, Chusi and Siena*, 1502. Pen and ink and water-colour, 33.8 x 48.8 cm.

A landscape seen from above virtually becomes a view from nowhere (see page 81).

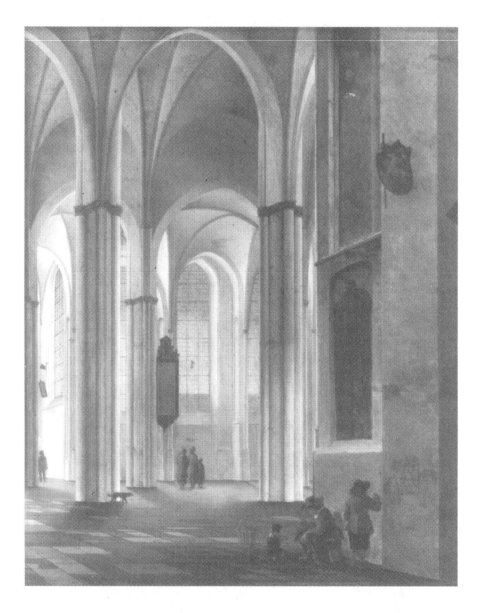

Plate 4 Pieter Saenredam, *The Interior of the Buur Church, Utrecht*, 1644. Oil on Oak, 60.1 x 50.1cm.

Within the pictorial space we may be led by the picture to 'project' the point towards which we look from a variety of imaginary 'eye points' within the picture, looking from one point then towards another (see page 52).

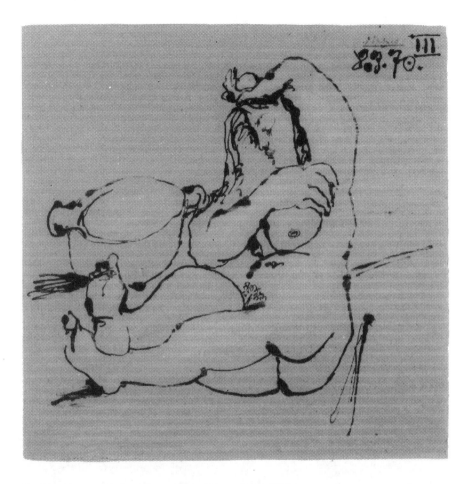

Plate 5 Picasso, *Nude at her Toilet,* 8 March 1970 (III).
Ink and coloured pencil on corrugated cardboard, 31.5 x 31.5cm.

We can construe the speed and tempo of this drawing's process simply from one
aspect of the drawn lines – how the absorbency of the cardboard records at which
places the pen changed speed (see page 77).

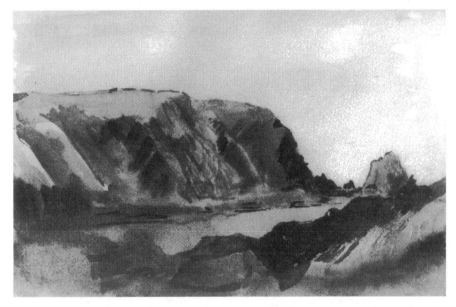

Plate 6 (a) A. Harrison, *Untitled*, 1979. Watercolour on paper, 24 x 16 cm.

Plate 6 (b) detail

Plate 6 (c) below the mesh

It is a useful experiment to perform on any picture to measure its 'pictorial mesh' by masking off progressively smaller areas of the picture until its depictive force is lost (see page 57).

PART TWO
BELIEVING

Chapter Three
METAPHOR

BEYOND THE LITERAL?
The communication systems of imagination, what in the widest sense we can think of as 'mimetic' or representational art, achieve their greatest power when they push against their own inherent limitations. But language itself pushes against its own boundaries. This is the domain of metaphor.

Normally any philosophical problems concerned with metaphor are assumed to belong to a rather minor subsection of the philosophy of language. Once we have tidied up the thickets of literal meaning, we are faced with a tangled growth of strange simile, hyperbolic exaggeration, apparent contradictions and downright puns that can suggest radical ground clearance rather than a careful exploration of meaning. Yet metaphor is all about us. Incarceration within the literal would imply a radical blindness not only to the arts, to poetry and drama, but to most human interaction. Metaphor seems to reek of the human, to belong to our tendency to be self-indulgently seduced by flights of fancy and equally to the capacity of language to engage our creativity and our imagination. For we have metaphor-making minds. If artificial and technical languages eschew metaphor, no living natural language can. Metaphor constitutes the life of a language, and perhaps the life of any system of communication. The problem

103

of metaphor is the nature of such life.

Does metaphor involve a distinctive type of thought, rather than an odd style of expression? Could such expression be replaced by a literal equivalent, less decoratively perhaps, but without essential loss of 'content'? Then what is 'content' and what might count as successful replacement? Is it even confined to the linguistic? Could it include, for example, pictorial content? If we tacitly take content to be located in the linguistically literal we will, of course, have pre-empted these questions. As we shall see, it is astonishingly hard to avoid this pitfall.

If the difference between poetry and prose is concerned with forms of language, the deeper opposition between the prosaic and the poetic is concerned with something wider, with ways of thought, not merely with ways of speech and writing. And recently, most notably by Arthur Danto[1] and Richard Wollheim,[2] visual metaphor has been discussed in the context of what it is to understand the pictorial, indeed as in some way central to that idea. Goodman,[3] too, approaches his discussion of metaphor within the context of the pictorial, and so too (perhaps surprisingly) does Davidson,[4] whose official topic is exclusively theories of language. For Danto, indeed, the metaphorical lies at the heart of the very idea of art itself. The realm of metaphor seems wider than the linguistic. In any moderately deep discussion of the impact of serious metaphor some concept of the pictorially metaphorical seems

[1] Arthur Danto, *The Transfiguration of the Commonplace* (Cambridge, Mass.: Harvard University Press, 1981), pp. 165–208.

[2] In *Painting as an Art, op. cit.*, esp. chap. 6.

[3] Nelson Goodman, *Languages of Art*. The chapter that focuses on metaphor is entitled 'The Sound of Pictures'.

[4] Donald Davidson, 'What Metaphors Mean', *Critical Inquiry*, vol. 5, autumn 1978. Reprinted in *Inquiries into Truth and Interpretation*

unavoidable. And we must suppose that in such discussions the term 'visual metaphor' (sometimes 'pictorial metaphor') has not been used metaphorically but literally. To suppose this is to suppose that the very same concept that has to occupy a considerable area of our understanding of language (yet gives so much trouble to our understanding) can be applied to our understanding of pictures, that is to say our understanding of what pictures are and our understanding of particular pictures or certain kinds of pictures. A related, not much easier, question would then be what, for pictures, is to count as securely non-metaphorical. Perhaps for pictures 'literal' is merely a variant on 'naturalistic'? But that would be to explain the obscure by appeal to the contentious.

In any case it is as well to start with language, where at least the presence of metaphor is uncontentious.

WORD-MAKING

Are metaphors replaceable in principle by the non-metaphorical? Most disputes about metaphor may be regarded as attempts to answer this. One approach (often associated with Aristotle) can be to think of metaphor as a more or less complex device for extending our descriptive resources. After that the non-metaphorical takes over. The core concept is that of a simile: metaphor, as school grammarians used to say, being simile with 'like' or 'as' left out.

We may think of it like this. No language could in principle contain enough ready-made terms for isolating and identifying the rich subtlety of the world around us. The wide opening of a river to the sea has, we may note, no word of its own so we borrow it from a word already in place for another sort of wide opening and

(Oxford: Clarendon Press, 1984).

call it a mouth. Our colour vocabulary being restricted (blue, green, yellow, and so on) we borrow a character-istic term for a fruit and call the bathroom suite aubergine, or a red puce (the colour of a squashed flea). We have no word in its own right for a peculiar stumbling gait, so we call it shambling, like the way cattle walk towards a shambles (towards their own death). The list is virtually endless, can always be extended and the form of communication can be given a quite standardized pattern. We say, first that A is B, (or like B or like B-type things or features), but cannot say – since at this stage we have no words for – in what precise respect there is a similarity, so leave the audience (really the linguistic community) to guess the likeness. Then the initial device or linguistic forms derived from it, become standardized labels for the newly recognized feature of the world – becomes enshrined as a 'secondary' meaning.

The important point here is that once the 'guessing' stage is over the result – while new – is as 'literal' as any other use of a word. Moreover, since virtually any use of words requires some degree of intelligent guessing as to context – which shade of established meaning and so on has been adopted or intended – there need be no radical difference of principle between what it is to understand the meaning of metaphor and what it is to grasp the meaning of other uses of language. Whatever degree of subtle good sense we need to grasp that a hydraulic ram is not a watery male sheep comes into play in grasping that finding an argument hard to swallow is not to do with a blockage in the oesophagus, even though it may literally make us gulp. The process of word-making thus derives from convergent guesses at intended classification.

Of course, this may sometimes go astray. The clichéd

metaphor 'Richard is a lion' so oddly beloved by
philosophers,[5] might have meant not that Richard was
brave – the assumed characteristic of the (assumed) king
of the beasts – but that he was lazy, greedy, smelly and
inclined to let his female companions do all the work
while he has the best part of the kill, this being a
commonly observed way of actual male lions. It is not
very hard to guess why this was not the most appro-
priate way of taking the assumed comparison in the
case of King Richard Lionheart. In any case this is an
unfortunate example to begin with since we may assume
that the stereotype lion as King of Beasts was well in
place before the compliment was paid to Richard. But
it is not hard to find cases where the pattern of appro-
priate guesses within the linguistic community is less
clear-cut than this and where it may even diverge suffi-
ciently to converge on a variety of extended meanings
from a common source. One of the main fascinations
of dictionary reading can be to trace such patterns of
linguistic uptake within the history of a language as
'secondary' and further meanings become established.
Essentially, then, the achieved 'logical form' of a
metaphor is simply that of quite normal (literal)
comparison of one thing or one feature with another,
with the difference that the basis of the comparison is
necessarily (at the first stage) tacit. The corresponding
'thought' is simply that of noticing what may not have
been labelled before, and the function of metaphor is
that of vocabulary enlargement. If there are deep issues
here they will all centre on the question how firmly the
possession of a new label can be tied to the capacity to
recognize a new feature, more technically, and (often less

[5] It seems to have been introduced as a standard example by Max Black in
 Models and Metaphors (Ithaca, New York: Cornell University Press,
 1962).

clearly) whether having a new word is equivalent to having a new concept. Of course this important question is by no means confined to metaphor. Such a theory would also imply that if metaphor is crucial for literature – for language as art – then a central role of such art is simply to enlarge our grasp of the world about us.

We should not abandon such a theory lightly. It fits a huge number of cases, is simple, and above all incorporates the understanding of metaphor firmly within the orbit of what it is to understand any other use of language. It goes a long way towards explaining most of the narrative incorporated within any good historical dictionary. However, it manifestly fails to fit all – or all possible readings – and certainly fails to fit the most dramatic cases. For it assumes in the outcome no conceptual tension, no violence to thought concerning what could *in principle* be the case. Milton's reference to blind mouths that look up and are not fed (could a mouth be blind?), or Marvell's to a 'green thought', even our common clichéd admiration for the looks of quite inedible things as good enough to eat, indicates that something quite different is going on. For if such tensions (what Goodman calls in *Languages of Art* 'deliberate category mistakes',[6] itself, of course, a metaphor according to its own definition) are essential to much metaphor, the simple theory will then fail. It cannot merely be a matter of new labels, for labels cannot incorporate such tension. If such 'tension' is involved as part of the 'thought' metaphor conveys, there will be no 'respect of likeness' to find that will not be internally inconsistent, and the 'content' of the metaphor will systematically resist any analysis in terms

[6] See for the idea of a category mistake Gilbert Ryle, *The Concept of Mind* (London: Penguin Books, reprint 1995).

of literal description, even a new one.

All so-called 'interactive' theories, theories that call for conceptual dissonance, that insist on the central role of radical ambiguity, pay various tributes to this. But then the problem is that, in terms of simple concepts of sense, metaphor transcends, or perhaps simply abandons, sense. By the same token, it also departs from straightforward conceptions of what may be imagined or visualized. This seems to present the most obvious difficulty for the idea that metaphor applies to the picturable as well as to the describable.

Yet metaphor is second cousin to imagery, which looks like a visual concept if anything is. Perhaps we have here located a bridgehead between linguistic and pictorial thought? However, at first glance the crossing seems awfully perilous. If understanding metaphor might in principle traverse the boundary between such different systems of communication at least the idea of what we can visualize or even imagine will cease to be simple and straightforward.

METAPHOR AND MEANING

To the question 'what do metaphors mean?' in his paper 'What Metaphors Mean', Donald Davidson answers 'nothing more than what the words in their most literal interpretation mean': metaphor is not a matter of meaning, and certainly not of special meaning. This paper has recently been enormously influential. Partly what makes it worth discussing is that, despite his dissociating himself from those who would think that metaphor has no place in serious discourse, it *has* been associated with something very like that old view. In what follows I shall argue that, quite contrary to a tradition that sees metaphor, especially serious metaphor in poetry – the fine art of language – as beyond 'the

cognitive', the core of metaphor lies at the core of our cognitive abilities.

Simon Blackburn in his survey of the philosophy of language, *Spreading the Word*,[7] claims to broadly follow Davidson's line. (It is fair to note that Blackburn's subheading for his discussion is 'Metaphor and Truth', even though much of what he says is couched in the vocabulary of 'meaning' and 'understanding'.) He takes the tradition at least as far back as Hobbes: 'For seeing [metaphors] openly express deceipt; to admit them into Council, or Reasoning, were manifest folly.' Significantly, Hobbes's rejection of metaphor strongly resembles Plato's rejection of fiction as lies, as deceit. We are here, incidentally, seeing the tip of the iceberg of a very intense seventeenth-century dispute over the status of the imaginative power of language.

Blackburn concludes his brief account of metaphor: 'Sadly...I incline to Hobbes's view that understanding things metaphorically is not understanding them at all ...[metaphor] does not have truth conditions, but is successful in another dimension.'

The concession here to 'another dimension' is liberal but unfocused. What is worth pausing on is the assumption of what the *object* of our understanding should be here taken to be. Is it 'understanding *things* metaphorically' or understanding *metaphors* that is in question? In some contexts there may seem to be little difference. To understand a normal declarative sentence is normally to understand what sort of situation would make it true, or alternatively false (to understand 'things' or supposed things). This is the thought that motivates most theories that seek meaning in verification, that identifies meaning with methods of verification.

[7] Simon Blackburn, *Spreading the Word, Groundings in the Philosophy of Language* (Oxford: Clarendon Press 1984).

A slightly softened version of this idea is that meaning can only be sought in how we would target such an assertion's 'truth conditions'. (This is clearly more relaxed since we might easily imagine what the truth conditions for an assertion might be, say that there are some unicorns somewhere in the universe, without having the slightest idea how we could enquire into such alleged facts. Maybe it is the nature of unicorns to hide from any scientific enquiry.)

This position bears a remarkable similarity to the idea that to understand pictures is to grasp how whatever they purport to depict might look. Easy sentences go well with easy pictures. Recall the role of Holbein as Henry VIII's surveyor of a potential bride. An ambassador reporting the character of Anne of Cleves would have been in the same predicament. But, as Holbein's painting *The Ambassadors* demonstrates, it all depends where you stand. The so-called 'anamorphic' skull is only a strange shape from one point of view. Stand sideways to the picture and what is shown is a very different matter. Much of what we say as well as what we show is not concerned to assert facts in this way. To invite someone to imagine or to conceive of something is not always to do this.

Yet such examples do show why the idea of fact-directed communication is basic. Surely to be invited to imagine something seems inevitably to be invited to envisage certain facts. Bearing this in mind does at the very least keep our feet on the ground. Much the same may be said of the idea of easy pictures, for that idea holds that the basic concept of a picture is that in recognizing it we must be able to imagine what visual states of affairs would have to be the case if the picture genuinely (and non-fictionally) represented it. To be sure, to achieve this we also need to know that we have

construed the picture in the appropriate way. What makes easy picture theory deceptive is that it obscures this catch. The same applies to metaphor.

When verificationist theories of meaning were at their primitive beginnings, so that it was acceptable to say that the meaning of a claim simply was its method of verification, an equally simplistic riposte was that since we could hardly be in a position to know whether or not something was verifiable in this way unless we could understand the assertions in the first place, at best such a verificationist theory must require two senses, or stages, of meaning (and thus of understanding). There is no reason to revive this old debate here to see that distinctions along these lines must be needed for metaphor. A necessary condition for even suspecting that something is a metaphor must be that we can understand the (normal) language it is expressed in. (If anything like metaphor occurred in non-linguistic contexts something adequately like that condition would apply too.) But then, what of the corresponding second stage?

It seems that the nub of Davidson's challenge to metaphor's meaning depends on two moves. The first argues that, since to recognize that we have a metaphor it is necessary, and also perhaps *almost* sufficient, that we should understand the words in the linguistic figure of speech in their normal sense; there is no need to invoke any further *metaphorical sense* as a key to metaphorical understanding. Each word requires to be taken in a 'normal' sense for there to be any reason for supposing that in the whole unit we have a metaphor. Davidson might have concluded, but does not, that metaphorical sense applies to complexes of meanings rather than to units within them.[8] Instead he concludes

[8] See William Empson, *The Structure of Complex Words*, 3rd ed. (London:

that metaphor is not a cognitive matter.

The second argument is that since metaphor invokes no clear or determinate truth conditions, metaphor is not a matter of meaning at all, though it may be a matter of how various rhetorical devices may well perform the role of drawing our attention to what we may otherwise have overlooked: that something may *cause* us to notice what we might otherwise overlook is in itself no reason for supposing that the 'cause' depends on any process of understanding meaning.

'CAUSAL' THEORIES OF MEANING AND PRIVACY

It is in this connection worthwhile to compare Davidson's account of metaphor with Wollheim's view of the pictorial. Davidson's account is, if we think about it, really quite startling, and it undoubtedly has all the attractions of tough talk. Put baldly it is a terrible argument. It simply does not follow that because the units in an utterance have no special metaphorical (or any other) sense that such a sense cannot be found in the complex that they make up. Moreover, all sorts of complex uses of words, warnings, commands, certain kinds of insults, make perfect sense without having truth conditions. It would be no better to say that since no single letter or syllable in Davidson's paper provides an argument or makes a claim (alone) his paper fails to do so (as a whole).

Still, nonetheless, a conclusion may be true independently of the arguments that are taken to support it, so to be fair we might consider the conclusion in its own right. Whatever could be meant by a 'causal' theory of metaphor (as Wollheim has it)? It is this way of putting the matter that attracts Wollheim. It connects metaphor

Chatto and Windus, 1977); also *Seven Types of Ambiguity* (Harmondsworth: Penguin Books, reprint 1961).

with the pictorial from the start, for that is exactly the kind of communication Wollheim ascribes to pictures. Davidson's comparison is explicit.

> In fact there is no limit to what a metaphor calls to our attention, and much of what we are caused to notice is not propositional in character. When we try to say what a metaphor 'means,' we soon realize there is no end to what we want to mention. If someone draws his finger along a coastline on a map, or mentions the beauty and deftness of a line in a Picasso etching, how many things are drawn to your attention? You might list a great many, but you would not finish since the idea of finishing would have no clear application. How many facts or propositions are conveyed by a photograph? None, an infinity, or one great unstable fact? Bad question. A picture is not worth a thousand words, or any other number. Words are the wrong currency to exchange for a picture. (*ibid.*, pp. 46–7.)

This is strange (deeply metaphorical) rhetoric, given that metaphor is standardly thought to be a matter of words. Most metaphor is in the currency of words, and if the point is simply concerned with appropriate rates of exchange, few words may ever be precisely exchanged for others. The metaphor of cash-exchange is singularly inept. Moreover, it involves a strange mixture of examples. In the case of the coastline, though less certainly in the case of the Picasso, we may well think that a fact or a proposition lurks significantly in the wings to be called on at will. If we assume the map to be non-fictional: '*That* is the shape of the coastline!', to be sure we have no precise words for all the details, but we certainly do for the most salient features. If a chart shows a navigable inlet or a short coastal walk where there is none, we have quite as much right to feel misin-

formed about the facts as if we are told we may sail straight in or told we may walk directly round the coast. This is what using a map seriously is. Even concerning Picasso we might ask why is it not a *fact* that his line is deft as another painter's is not? The underlying thought may be elsewhere, however. It might well be argued that while we may linguistically be confined to those facts which we inevitably make salient in terms of labels and predicates, pictures and maps are not so confining. The map's drawn coastline as a whole indicates a continuum of information concerning the landscape which we might, if presented with the relevant linguistic task, be able to elaborate indefinitely. In Goodman's terminology maps and pictures are 'replete' as sentences are not.[9] However, Davidson insists that it is characteristic of *any* use of language to be open to indefinite spelling-out, and in any case this kind of openness is not repleteness in Goodman's sense. Further, this in no way implies that either maps or pictures belong beyond 'the cognitive'. It is hard to see how the comparison helps with metaphor. The best guess at the underlying thought would seem to be that pictures and the like do indeed provide a paradigm of a merely 'causal' form of communication. We have already seen the difficulties this idea presents.

If a 'causal' theory of imaginative language had a place at all it would attach not to metaphor, but to what most current philosophers of language pay little specific attention to – *imagery*. Moreover it is imagery that might seem to connect naturally with pictures. Are not both a matter of looks or imagined looks? Imagery in prose and poetry is often loosely confused with metaphor (it is, after all, a type of trope) or even regarded as an equivalent term for the same thing.

[9] *Languages of Art*, pp. 225–31.

Taking imagery seriously is, moreover, far commoner among close readers of literature as 'critics' than among philosophers of language. For really it is a concept that stubbornly fails to fit convincing theories of linguistic meaning and comprehension. Imagery is indeed a candidate for a 'theory of effects'.

IMAGERY AND THE VISUALIZABLE
Suppose that what may be pictured (even in words) is at least what may be visually imagined. The word 'imagery' pays a compliment to the fact that certain metaphors, along with other uses of language, seem to require for our response more than a mere understanding of the words used, an ability to *visualize* what they invite of our imagination.[10] Is this not a matter of looks, and are not looks the business of pictures? But these are not, for all that, 'visual *metaphors*'. In itself the idea of imagery is quite inadequate to capture the concept of the metaphorical, and the idea of metaphor equally inadequate to that of imagery. It is certainly inadequate for what might be transferred from language to pictures. For even an apparently simple simile may be a form of *imagery* that goes far beyond its natural pictorial illustration. Herrick's 'Her feet, like little mice, crept in and out' (describing a girl setting out to dance) expresses a simple similitude between her feet, mouse shaped with mouse movements, as they poke out from the hem of her dress, and little mice, but, of course more than that, more than merely looking the same, their acting the same, nervously, independently, frightened. We may certainly imagine here what we could, or others might, draw. We may here visualize specific mouse shapes peeping out, but what further

[10] See Gilbert Ryle, *The Concept of Mind*, op. cit., chap. 8 on imagination. His discussion is central to the division at that period between the culture of philosophy and that of literary criticism.

thoughts the metaphor also conveys, that for instance the feet seem to have a timorous nervous life of their own, are not, in themselves, visual matters – are even strictly unvisualizable.

Even a denied simile has no direct pictorial equivalent: 'my mistress's eyes are nothing like the sun' could hardly be translated into a picture of her with un-sunlike eyes. More radical cases such as Shelley's 'Life, like a dome of many coloured glass, stains the white radiance of eternity', while a vividly visual image, has no clear pictorial equivalent. Any attempt to render that expression in purely visual terms would be at best banal, at worst irrelevant. A picture of a coloured glass dome would hardly get close to capturing the thought here. (One might well imagine a certain type of pretentious visual artist attempting such a thing. The attempt would at best need the laborious aid of extensive exhibition notes.) The vivid image of murdered Duncan, 'his silver skin laced with his golden blood' could hardly be translated into paint as golden rivulets on a silver-white skin, not when the royally dead Duncan is also the corpse of an old man with an astonishing amount of blood in him. For all its visual demands on us, 'imagery' in this sense belongs firmly with language, not with visual depiction.

Perhaps this uses 'visual' too narrowly? Is it not genuinely to see, to see face to face, to see that something has been done to something, that Duncan has been murdered, and is horribly, yet royally, dead?[11] But,

[11] Cf. Wollheim, *Painting as an Art, op. cit.*, p. 65. He rightly stresses the fact that the 'scope of vision' is wider than the merely optical, one of his examples being that 'we may see something doing or undergoing something, even if what it does or undergoes cannot be identified except by referring to something we cannot see' – hence it would follow that to see Duncan thus would be, for Wollheim, 'seeing face to face'. But cases such as this can only serve to show that there is a problem about what can be visually depicted, not, as he seems to suppose, that the problem can be eased out of the way.

then, we still need to distinguish that, if we can, from seeing the point of a joke, the weakness of an argument, or of a retaining wall, or, indeed, the outrage of a murder, and it seems that a natural way of doing that must have to do with how these things might be or might fail to be 'translated' into the pictorial. There may well be more to seeing than meets the eye, but what that more is, or could be, while still *remaining* a visual matter, just is the question whether there can, or when there can or cannot be, pictorial equivalents for such devices or. whether there can be linguistic equivalents for what the pictorial may get us to see.

For Wollheim, as we have seen, pictures are the 'conduit' via which the state of mind of their makers may (under appropriate conditions) be transmitted to the mind of their beholders. As he rightly sees, such a view is dramatically like that most often ascribed to Locke concerning the meanings of words, and famously the target of Wittgenstein's so-called private language argument: I have an experience, something in my mind, perhaps my experience of *red*. 'That's red', I say. You, receiving the word, are caused to have (or to have the image of) the same inner experience. Bingo! Language thus links what would otherwise be essentially private experiences (as Locke is standardly parodied, Lockian 'ideas' are thought of as mental contents).

This is probably not fair to Locke. Everyone is unfair to Locke, and it is not really fair to suppose that by 'ideas' he did mean mental images. But it is (especially as a parody) fair to another theory that had a curious prominence at the start of this century, and which still dominated much literary thinking by mid-century when all the dominant arguments in philosophy were against it. This is the theory of *Imagism* in English (as opposed to French) literature as it emerged from the thoughts first

of T. E. Hulme, then of Ezra Pound, then of a whole host of so-called New Critics[12] (in England associated with *Scrutiny*).[13] The central doctrine (the rhetoric was Hulme's) was a preference for the linguistically 'concrete' over the 'abstract'.

The failure of literary critics and philosophers to share understanding of the underlying issues here is perhaps the central point of rot at the heart of 'Anglo-Saxon' theories of communication in this century. The 'literary' use of the contrast between 'concrete' and 'abstract' belongs within what a more self-confident age would still happily call 'Rhetoric', that is to say the study of how the use or misuse of communication may enlighten or corrupt our common capacity to imaginatively respond to one another and to the world around us. It is inevitably a moral theory, for it is about the unearthing of benefit or harm implicit in our use of communication. Unfortunately 'rhetoric' has come to mean something exclusively negative. The fault lies on both sides. On the one hand is the (normally unargued) assumption on the part of many philosophers that what is involved in these matters has little or nothing to do with thought (or with the 'cognitive') – that we can set 'rhetorical' matters aside in some area of the 'merely' 'causal' or are even to do with inevitably high-minded nonsense. On the other hand, those whose concerns are with the arts, crafts and craftiness of imagination have

[12] For an excellent and sympathetic discussion of the imagery of Ezra Pound and its underlying theory (as well as for a huge variety of other good things) see Charles Taylor, *Sources of the Self* (Cambridge University Press, 1994), pp. 472–7. Taylor says of the presence of imaginative content in Pound's imagery: 'It doesn't come to us in the object or image or words presented; it would be better to say that it happens between them. It's as though the words or images set up between them a force field which can capture a more intense energy.'

[13] It seems to have had a slight, if brief, influence on Russell in *An Enquiry into Meaning and Truth*.

in effect been happy enough to accept this and to respond with a kind of sulk against those they see as cold-blooded lovers of logical 'abstractions'. Neither side finds it easy to escape from the grip of their own bad metaphors.

As a way of describing good writing the theory has much to recommend it. Euphemisms tend to be 'abstract' in this negative sense. The outrageous term 'collateral damage' for civilians maimed and killed, flayed or roasted alive by military action not directly intended for this effect, but somehow a result to be tolerated, is only one of the many ways in which policy-makers and others like them seek to deprive us of imagining what they are really talking about, though it may be a peculiarly disgusting case. The culture of this kind of abstraction is all about us, and it is indeed a prime responsibility of imaginative literature to fight against this.

A distinction here between the imaginatively dead use of language and its converse is vital for any under-standing of the morality implicit in the use of language. However, as a theory of meaning it hardly gets off the ground. 'Concrete' words refer to (or are even 'conduits' for) moderately discrete items of experience, the smell of chocolate, the colour of roses, the taste of almond biscuits, or ruder, more exciting items. Clearly, not all words could possibly work this way. 'Abstract' words have no such power. Since all words that mark inferences of logical connections are of this latter sort, then poetry that concentrates concrete sense should eschew such items.

In fact the verse form of Pound's *Cantos*, while it attempts to follow this principle out, does so quite imperfectly, and this being the normal irony of theory in art, the theory was perfectly capable of stimulating

significant, sometimes wonderful, poetry. Imagery seems capable then of making over poetry to the condition of painting or, as was often insisted, the cinema.[14] It is at the same time a drastically limiting doctrine, for, as its opponents quickly pointed out, taken seriously (as it far too often was), it would tend to exclude from even being regarded as seriously imaginative literature any writing that had to do with explanation, argument, speculation or in general discursive thought, for the key words in such writing – 'if', 'so', 'because', 'therefore', in fact all the logical and grammatical connectives – must inevitably be classified as 'abstract'. Language as pictures, conceived in this way and if taken seriously as an ideal, requires a profound anti-intellectualism.[15] No topic of rhetoric is automatically concerned with the 'non-cognitive': it is rather that the effects of imagery must presuppose non-imagistic understanding.

We do not have to be fully paid-up Wittgensteinians to see that an 'imagist' theory is a most unsatisfactory theory of meaning. In fact it is best not regarded as a theory of meaning at all. It fails to account for the possibility of communication. The concept of mental imagery is notoriously tricky[16] but that apart, under-standing does not require – *could* not require – that we somehow reconstitute a speaker's mental imagery. Certainly what you say or I read may be connected with

[14] The theme in modernist art of making over one art – one system of communication – to aspire to the conditions of another can hardly be overstated. It seems, paradoxically, to parallel a search for the 'pure' conditions of poetry, painting, music. Underlying both is a constant search for the conditions of significance as a topic of art.

[15] For a particularly vigourous statement of this see Donald Davie, *Articulate Energy*, reprinted with a postscript (London: Routledge and Kegan Paul, 1976).

[16] For classic statements of the difficulties see Ryle, *Concept of Mind, op. cit.*, and Daniel Dennett, 'Two Approaches to Mental Images' in *Brainstorms* (Brighton: Harvester Press, 1985), pp.174–90.

what we may both imagine or visualize, but this can only be the outcome of meaning not a condition of it. If the very idea of a word's meaning depended on that of the 'inner experience' being relevantly the same for both speaker and hearer (so 'red' to you doesn't 'mean' the sound of a trumpet to me)[17] we can have no concept of their having the same experience: this conduit theory becomes notoriously self-undermining. 'Receiving' words remains, irreducibly, a matter of understanding, of knowing what words mean in a language – a 'cognitive' matter of construing linguistic rules.

Yet, for all that, the thought behind the literary distinction between 'abstract' and 'concrete' – the demand for vividness of imagery – is far from vacuous. Reports (whether in imaginative literature or anywhere else) *can* be 'imagistically' empty or vivid, and can indeed be in this sense dully 'abstract' or vividly 'concrete'. Whether we can or cannot easily imagine for ourselves what is being talked or written about by another as if we were experiencing it ourselves is quite a different matter from what would follow an attempt to define the *meaning*, or to classify the category of linguistic use, such talk or writing belongs to. But then it is not a key to how to get a grip on metaphor. Though much metaphor is at the same time powerful imagery, frequently the most imagistically vivid examples are powerful just because they are *not* metaphorical at all. Ezra Pound quotes a line from a poem by Thomas Hardy concerning a drowning: 'And they found him in the morning with the crabs upon his face.' Bald fact, no metaphor, not even simile, can for this reason be imagistically overwhelming to any who can imagine the situation. Yet someone might be able to understand the

[17] See Locke, *Essay Concerning Human Understanding*, book 3, chap. 4, section 11.

words yet fail to imagine – to visualize – the horror. That is their fault, not any fault in the significance of the words or even of their understanding of them, though it may be a fault of the selection of words used. When Othello says to the guard 'Put up your bright swords else the dew shall rust them', the imagistic vividness of the line depends on two things not in the least metaphorical: that we guess that it is the shininess of the swords that he is accusing the guard of caring most about, and that we are virtually forced to imagine the scene.

Only one topic of rhetoric is metaphor. Imagery and metaphor, while they may constantly interact, are very different topics. If a causal theory had a place it would apply not to metaphor but to imagery.

How Does Metaphor Deviate?

Why metaphor? It is tempting to think that a tidy way with metaphor would be to ask what the function of metaphor is and then in terms of an answer to that, how it is that it achieves that function. But this assumes that we know already what it is to have located metaphor. Surely nothing could be simpler. Metaphor is non-literal. Could this concept be applied outside the domain of language? Is non-literal merely a form of abnormality?

Here it is important to avoid two traps for the unwary. One is the misuse of the idea of the 'arbitrary sign'. The second, more subtle, is to fail to see the importance of a metaphor's scale. The two are closely linked.

Romeo, we all know, says of Juliet that she is the sun. In fact we really know nothing of the sort. What Romeo says concerning Juliet is deplorably over-quoted by philosophers, looking, presumably, for a brief, standardly recognizable example. In fact it is not brief at all, and to make it seem so is to make a line of a play

jewelled by the most controlled use of metaphor seem dull. That is not just a philosophers' but a literary sin. It misconstrues metaphor. So let's start by attempting to take just this example seriously.

A general reason often put forward, or assumed, for supposing that the distinction between the literal and the metaphorical is irreducibly linguistic is that it depends for its sense on the idea of adopting a 'deviant' use of words, one that departs from the rules of standard usage, or which appropriates standard words to non-standard concepts. Both ways of putting the matter presuppose an idea of rules or conventions of meaning that could not fit our grasp of pictorial communication. In this sense it is indeed a matter of 'convention', that is of 'arbitrary convention', that we use the shape of the morpheme 'sun' or the corresponding phonetic shape to refer to the sun. A painted sun however as a yellow disc is no arbitrary convention.

Metaphor is certainly not sign-deviance. Indeed it is an 'arbitrary' convention – a convention of English – that the morpheme 'sun' is used to refer to the sun, but when the sun is referred to metaphorically *that* convention is not breached. If Romeo had said 'Juliet is the nus', or the more fully dyslexic, 'Lujlet si the nus', some editor would soon enough correct the dyslexia to enable us to see the conventional spelling as metaphorical or otherwise. If we adopted the 'convention' that henceforth we should write or say 'sun' as 'nus' then 'But soft what light through yonder window breaks? It is the aest and Juliet is the nus. Arise fair nus and kill the envious moon' would express precisely the same metaphor, something we would easily recognize by nus-down by which time we would have become used to the new spelling. Nothing follows about metaphor.

If metaphor is not *lexically* deviant, is it *semantically* deviant? If Romeo says of Juliet that she is the sun, even though he obviously does not think that she is that familiar yellow disc, nor that she is a hot planet, he is not abandoning a 'normal use' of words. Perhaps he is departing from how in their normal use we should understand them as referring to the world? The sun's being depicted by a yellow disc is not a matter of *any* convention, any more than it is that the sun looks like a yellow disc, or that it sometimes does. That is a matter of fact or, if we like, of belief, or perhaps of how we picture it to ourselves, at all events sometimes. Perhaps that the sun is 'conventionally' thought of as a yellow disc is a 'depictive' convention? Then what pictures can tell us about conventions is that all sorts of important conventions are by no means arbitrary. One way of taking the expression 'what the words' mean can be (certainly in cases like this) 'how we picture' what the words refer to and when Romeo refers to Juliet as the sun what he 'deviates' from is *more* like that. The sun is normally thought of as an astronomical object rather a long way away and rather hot, and that is certainly not how he thinks of Juliet – even metaphorically. Neither does he think of her as a yellow disk – even metaphorically. Yet his words mean what they do, and to do that they must mean what they would do if he were to say them on any other occasion. So *what* deviates? Perhaps his thought *is* a departure from how we 'conventionally' *think* of the sun. His thought is about Juliet. Is there *any* way he 'conventionally' thinks of Juliet?

THE SCALE OF METAPHOR
The light in the east is the light at a forbidden window after a late party, but it is Juliet's window, the window of the one he is seeking, she who had earlier taught the

very torches to burn bright, wooed and won in a sonnet-duet in which she was the shrine, he the pilgrim. His previous love, confused and blind, and still thought to be so by Benvolio, has been transformed as it alters its object so that he 'ne'er saw true beauty till this night'...and so on. This play is saturated with hyperbolic images of light and of what the heavenly bodies of light stand for. Romeo's next words, 'Arise fair sun and kill the envious moon' while referring in one direction to the coming dawn of 'jocund day' which will 'stand tip toe on the misty fruit tree tops' at the same time points in another direction to a metaphor whose scope is virtually the whole play. Romeo does not merely, thus not really, refer to Juliet as the sun and no philosopher should be excused from acknowledging this on the quite spurious grounds that to do so would be to get side-tracked into 'literary criticism'. Romeo may utter the 'sentence form' which indicates the metaphor he is expressing, but the expression of his metaphor cannot be as simply located. Romeo 'says' 'Juliet is the sun' only in the limited sense in which these are the words he utters.

Identifying his metaphor is a question about what thought – what kind of thought – we can ascribe to him. To answer this we need to take account of the whole work of which it is a part, or at least the first two-thirds of the play. It is essential to how literary metaphor – indeed all metaphor – works that it must be embedded in contexts at least as wide as this.

A primary question we need to ask, therefore, is: *How wide is a metaphor's scope?* How long is a piece of string? The question is particular, not general. Only a very dull philosopher – dull to the point of perversity in reading – could, for instance, suppose that when Donne says 'No man is an island' he is uttering an obvious

truth, as if he were saying 'no man is a banana'. For what he tells us is that no man is an island 'entire and whole unto himself' and to obsessive individualists that may be precisely how things often enough are.[18] If Donne tells us that any passing bell must toll for us so that to seek to know who in particular it tolls for is to be trivial-minded, metaphor or no it matters that we might take him seriously. To identify any metaphor is to be able to estimate its scale. This is how the words of any language living enough to be capable of sustaining literature, may be used anyway in their own right. Outside artificially restricted dialects it is in the nature of words to reverberate. Imposed restrictions have rigour but most often the rigor of being dead (the words are really the same). This may be very useful, to be sure, but being dead simply means that words are deprived of metaphorical possibilities. Reverberation need not imply imprecision.

When William Blake writes of the 'hapless soldier's sigh [that] runs in blood down palace walls', the first thing that makes us suppose that this is a metaphor is that sighs are not the sort of thing that could in principle be located as a moving stain on a wall. In fact the scope of each metaphor in *London* is virtually the whole poem. The more close-knit a poem is the more that is likely to be so. Then each metaphor within such a work will interconnect with each other.[19] At the same time to take a *whole* utterance as *metaphorical* (and here the scale of the metaphor's supposed scope begins to matter a great deal, since it comes very close to identifying the

[18] Of course, even there, one might add something further to the denial of male bananahood which could be very far from trivial.

[19] It is this which lies at the core of Empson's account: it is however, I think, misleading to think of this as a somewhat mechanical 'interaction' theory of metaphor. In fact the strange obsession for finding labels for theories of metaphor is a path to madness.

work as a whole) presupposes that we attend to the (supposed) *literal* sense of the *individual* words in it. This is essentially a matter of understanding. If so and if what is to be understood is meanings, that speakers and writers take seriously the object of such understanding must have to do with beliefs. The only question is then how beliefs come in, for they will no more come into the story of metaphor in ordinary ways than metaphor is ordinary. Meaning inevitably connects with belief, but far from seamlessly: one may for example have firm beliefs, half beliefs, not quite conscious beliefs. Such things all have their connections with meaning, but no direct or exact counterparts.

METAPHOR AND BELIEF
Certainly no harm is done by referring to some sense of particular words as being 'metaphorical' if we wish to do so. In this way 'metaphorical' carries much of the force of 'secondary', as opposed to the 'primary' sense of a word, in a dictionary. But this concerns the history of the language within which such understanding takes place, the history of change of beliefs, half-beliefs and speculations of the language's speakers. That history matters for metaphor, and metaphor matters for that history.

It understates the matter to suppose merely that not being clear about sense will bar us to rightly diagnosing metaphor. A far more serious barrier is being unsure of beliefs – the particular ways of believing and half-believing that metaphor-users are engaging in. Renaissance metaphor (not only Shakespeare's) is notoriously rich and frequently notoriously difficult to identify because Renaissance beliefs are, even we may suppose, to those who held them. When beliefs are uncertain metaphors will be as well. Timon's reference

to the sun as a 'god, kissing carrion' may strike us as a metaphor, but it is not quite certain that it should. It must be for us. In a seventeenth-century context it may incorporate a not-yet-defunct form of astrological vitalism (whereby the divine heat of the sun really does engender in carrion by the sensuous touch of the sun's beams – really, not metaphorically a *kind* of kiss – lowly creatures such as worms and maggots). This was a common, perhaps slightly insecure, belief at the time of Shakespeare's giving that line to his character. Francis Bacon seems never to doubt it. By the same token the use of defunct, if still poignant, and perhaps not fully eroded, beliefs belonging to past myths belongs equally to metaphor. To say nowadays that 'Venus plucked me by the hair' as a report of a passing seduction, is, for us, metaphor, was not presumably, or just possibly not, for Homer. The Christian Renaissance, tangled and uncertain as its beliefs were, really did not believe in the Greek gods. Most of its visual art and literature superficially looks as if this were not so. The use of such mythology, even in pictures and whole stories, is close enough to metaphor, for metaphor is itself close enough to whole stories.

When Romeo 'says' what he does perhaps nothing is asserted, but much is thought. Thinking, let alone imagining, is wider than assertion, because we can do more with beliefs than simply instruct others to share them. Romeo's hyperbole is, as Juliet fears, very nearly wanton (as much of Shakespearean imagery is). His image of Juliet's 'eyes...in heaven...[which]...through the airy region stream so bright / That birds would sing and think it were not light' is, if we read it wrongly, insanity. As he is himself reminded, it very nearly is insanity. In fact, however, his hyperbole takes off from another wild, but fitting, fantasy in honour of his

thought of Juliet as a queen of heaven. This fantasy cannot be quite peeled off from the narrative which encloses it. For Romeo's thought – a thought that both captures him and which he cannot quite believe – is, if we track its context, that Juliet just might be a sort of Beatrice, a corporeal embodiment of the form of the Good, personified in terms of light. These are standard Renaissance metaphors – or perhaps to some simply strange beliefs. To Dante, certainly to anyone who really believed in a type of Neoplatonic mysticism, this would be no metaphor, however strange a belief it may be to us. For Romeo this is how he *thinks* of Juliet, not what he *believes* of her: that a fourteen-year-old girl might be at the same time something quite other. (Beatrice was, of course, even younger.) It is this that bewitches him. Romeo, like any lovesick youth, is confused, but unlike just any lovesick youth of any time, his confusion takes a very precisely late Renaissance form.[20] He is caught in half-belief, not just between contrary moods (which is how we first meet him, lovesick with Rosalind) but between contrary conceptions of how things *could* be – if only.... There is nothing vague about this and it is not merely a matter of 'effects' on us, vague or otherwise. His metaphor is firmly focused between these two contrary poles.

It would be a gross misunderstanding of even that hyperbole to attempt to follow out all its possible consequences. To follow the form of the fantasy – as to understand any fiction – is also to know how to hold back. This is, presumably, why Davidson thinks of the application of metaphorical attention-drawing as 'indeterminate', but 'indeterminateness' is not itself a

[20] The specific context of belief here is part of that process of emergence from the complex traditions of Medieval Romantic Love. See C. S. Lewis, *The Allegory of Love* (Oxford University Press, 1936) and Donald Schon, *Displacement of Concepts* (London: Tavistock Publications, 1963).

clear idea.

The metaphorical occurs when what is non-deviantly *said and meant* deviates from *belief*. This is why the problem of the scale of metaphor matters. Beliefs range and interconnect, constitute in Quine's metaphor a web.[21] Our interconnected meanings certainly exhibit the shape of that web, but meaning and believing are manifestly not the same. In short, metaphor emerges as a kind of fiction. We have no more reason to believe with Hobbes that metaphor is or need be a kind of deceit than we have for believing with Plato that fiction is a kind of lying.

If metaphor is fiction with belief, how might it contrast with what we normally think of as fiction, with story-telling, narrative fiction? The boundaries are, and should be, slightly hazy. It is almost a matter of scale. A short answer is that what we normally call fiction – novels, plays, stories in general – is fiction with *narrative*, whereas metaphor (when it departs from simile), including the use of myth derived from religious traditions we do not accept, is fiction that negotiates non-narrational, normally *categorial, beliefs*. Narratives deal with consequences; metaphor, however much it may be a component of story-telling, deals with something deeper. In that sort of metaphor which cannot be reduced to simile we are, as Goodman insists,[22] thinking – and inviting others to think – beyond the range of our own conceptual boundaries. Metaphor, as he puts it, commits a 'deliberate category mistake'. In broad terms categorial divisions are easier to define than

[21] W. V. O. Quine and J. S. Ullian, *The Web of Belief* (New York: Random House, 1978).

[22] *Languages of Art, op. cit.* Goodman simply refers us to Ryle's *Concept of Mind* for the 'idea of a category mistake'. It is of course as old as Aristotle.

to firmly locate. For example, to call a number or a day of the week blue involves a misplaced category since it is not that either are some other colour, but that neither are any colour at all. To such things the very idea of (the category of) colour fails to apply. So to say of something that it is so-and-so, where either being or failing to be so-and-so would be equally absurd, is to break a rule of category division. But what are we to say of a 'deliberate mistake'? Is that not to break a similar rule? So isn't Goodman's own definition of metaphor itself metaphorical in its own terms? Not only that, it is not always obvious, and it may matter that it is not obvious when we have broken such a rule. For instance when we call a pudding, a young girl or a tune all sweet, which should we suppose is the 'literal' use of the word? Why should we, for instance, suppose that the literal is located in pudding-talk rather than in tune-talk? Or perhaps the word 'sweet' is, like the word 'interesting', common to whole ranges of categories? If so, a sweet tune then just has the same property as a sweet pudding or a sweet personality. Then the here appropriate sense of 'sweet' as applied to puddings does not refer to a flavour, but rather to a quality of flavours, like being delightful applies in the same way to tunes and people.[23] There may be no 'right' answer here. If so the conclusion we should draw is that both our sense of our own categories (our own 'conceptual structures') is less reliable than we, and many philosophers, often suppose and at the same time far more liable to shift and change

[23] See J. O. Urmson's much too neglected paper 'Representation in Music', in Vesey (ed.), *Philosophy and the Arts, op. cit.*, pp. 132–47, which effectively explains the possibility of a music portrait such as the Enigma Variations in these terms. One implication of Urmson's observations is that the philosophical device of solving philosophical conundrums (such as the categorial divisions between the mental and the material), by direct appeal to our intuitions of what makes (literal) sense, must be far more hazardous than it was common to suppose.

than we may like to think. Then the very boundary between the metaphorical and the literal will shift and shape along with this. This indeed seems to be the way things are.

The consequence is that while certain narratives may become *stale* by familiarity or imaginative weakness, metaphors by their very nature are liable to *die*. No theory of metaphor can be adequate which does not provide an account of how and why metaphors die. Metaphor dies in two ways: by becoming cliché and by conceptual change. Lazarus-like, however, even dead metaphor is equally liable to resurrection.

THE LIFE AND DEATH OF METAPHOR
Metaphor involves us in saying, as simile need not, what we *know* we do not *believe*, however our wishes may wander. Metaphor enters when our wandering wishes about what we believe play a part in our thinking. This is its function. How may we explain it?

Think, first, in the simplest, most naïve, way, of language as being rule-governed. What words mean, and how they may be understood, rests on this. Rules of meaning are of two sorts: word-to-word rules and word-to-world rules. 'Red' has a word-to-world rule in that it picks out one feature of the world rather than another (red items rather than green ones) and a word-to-word rule in that it may be replaced by or conjoined with one word (or set of words) or another by a synonym or partial synonym together with a qualification, such that scarlet is a sort of red. That red is a kind of colour is, if analytic, an aspect of a complex of word-to-word rules which constitutes our conceptual beliefs – categorial – concerning what kind of things there are – our 'deep' word-to-world rules. It is this last sort of 'rule' that metaphor most manifestly flouts. If

we, like Quine, believe that the distinction between analytic and synthetic is never hard and fast, we will never take the distinction between such rules to be fully determinate (and equally be resistant to my distinction between metaphor as a phenomenon of meaning and a phenomenon of belief). Perhaps we will think this *only* of metaphor. If we are (strict) Aristotelians – possibly (strict) Kantians – we will think of word-world rules at a *high* (categorial) level as immutable, since neither Aristotle nor Kant believes that the higher level categories of our thinking can be violated. The absorption of metaphor within language will then never involve category change. Metaphor as a merely 'rhetorical' variant of simile – or a kind of nonsense – becomes, then, an unavoidable doctrine for all figures of speech.

It is easy to suppose radical metaphor that is reluctant to reduce to simile to be far more radically wanton than mere indeterminateness of sense. For to say a thought may really be green, as opposed to being a thought *of* green, or that someone may be both a young girl and the Neoplatonic sun, is to break both sorts of rules. Since the rules of language are (more or less) rules of inference this is to invoke, if not to commit, a contradiction. Contradictions in terms can easily enough be spelt out as straightforward contradictions. (If a mood or thought of any sort, then not a material body, thus not extended; if coloured extended, so both extended and not extended.) So, since from a contradiction anything follows, then nothing at all of consequence. In short, if the words in a language are governed both by word-word rules and by word-world rules, breaking the former we achieve an 'internal' absurdity, if the latter a 'natural' absurdity. Then, even if 'fictional', metaphor loses all sense, all 'cognitive content'.

INTENTIONAL SPEECH (AND MENTAL) ACTS

This is a horrendous price to pay (and takes us back to where we started). The problem of metaphor is how to avoid paying it. One way is to insist that normal linguistic rule-following is suspended, but it cannot be. An alternative is to reconsider what it is to 'make use of' our grasp of the 'rules' of language. The core test of metaphor is what sorts of beliefs and corresponding intentions, wishes, or conceptual fears and hopes, the speaker or writer has and wishes us to share.

We may turn to an equally simplified idea. To be prepared to assert a proposition via a sentence is to be prepared to, to intend to, change another's state of belief. (To assert a proposition to oneself is to reinforce such a state of belief). Thus to assert – or to be prepared to assert – is to have a certain sort of intention concerning another's epistemic or doxastic situation. But if the sentence in question either states or implies a contradiction – as it seems to in a live metaphor – then one may (so long as one is aware of that fact) no more intend to assert the sentence in question, no more assert it intentionally, than one may intend to be in two places at once or intentionally be in two places at once. This is equivalent to saying that metaphor of this sort makes no factual claims.

However, we may *wish* to be – wish that we could be – in two places at once. While one cannot, even with the greatest effort of will, intend to believe seven impossible things before breakfast, nor, by the same token, intend any impossible acts, one may with very little effort of will at all *wish* all sorts of impossible things and wish that (if only…) one might do all sorts of such things. For many of us this is the characteristic pre-breakfast state.

So, think of the mental verb that governs the thought

of metaphor not as *intention* but as *wish*. While it is
logically impossible to have intentions to achieve what
one also believes cannot come about, or simply won't
come about (since if so it simply will not count as an
intention), wishes are manifestly not so restricted. They
would have little point if they were. For all that, they
may be as precise as intentions.

Wishes, or longings, for the impossible are all too
possible. Romeo's love for Juliet is both (to quote
another poet) for 'an object strange and high begotten
on despair upon impossibility'. It is also a love for a real
person of flesh and blood and (what he never notices) of
quite astonishing courage and realism, and for someone
whose return of love is by no means impossible. He
can't notice that because he cannot settle for that. It is
easy to think of wishful thinking as not really thinking
at all. But that stern doctrine is absurd. Of course if
wishes were horses beggars would indeed ride. Wishes
being wishes and seen to be, beggars at all events, do
come to realize what they cannot do. Our wishes,
precisely expressed in all their absurdity, make us realize
what beggars we are. Our wishes make us realize what
cannot be, for what we wish and cannot intend we may
see is beyond us, and indeed, conceptually beyond us,
impossibly so. Metaphor of this sort – live metaphor
that cannot be reduced to mere simile – shows to us the
limits of our language – of what can be asserted.

What is the point in apparently (if not in fact, but
fictional) asserting an impossibility? Perhaps not for
plans and policies, even possibilities of thought and
belief, but rather for showing us, and thus enabling us,
to explore the limits of the thinkable. Only when we are
aware of such limits can we have a hope of enlarging on
them – transcending them – in conscious and deliberate
ways. If the function of metaphor that *can* be reduced

to simile is to extend our varieties of classification, that of metaphor that *cannot* be so construed is to present us with a perception of the limits of our very conceptions of things. These are primary cognitive activities that must lie at the heart of the very possibility of language. By the same token they lie at the heart of the possibility of thought about the world and its communication to others. The philosophical bias which would place the metaphorical beyond the limits of the cognitive reverses the order of things.

Then, since the richest place of metaphor is within the resources of imaginative literature, where we learn how to depart from the merely prosaic, it follows that the possibility of such literature lies also at the heart of the possibility of language itself.

THE PROCESSES OF METAPHORICAL DECAY
Metaphor is as much, or more, how we awake from our cognitive dreams, than the 'dreamwork' of language. Good metaphor always is. Since the role of metaphor is awareness of the limits of language, the role of metaphor is by the same token the adjustment of language's limits. Metaphors are essentially liable to die, firstly and most simply by becoming cliché (really the constant enlargement of our literal vocabulary).

We can do three things with a metaphor. The first is to do nothing, to stick with the longing – the recognition that the wish with words cannot be more than that. It is enough to be presented with the wish, the fear or the startled thought, to keep the metaphor alive. To tell a story as non-fictional commits one to the intention that it be believed, and hence to the belief that it is at least possible, whereas to relate a fiction may frequently be to relate the impossible merely as plausible. Much the same applies to the use of metaphor. If the object of an

intention to achieve belief is a conception of the possible; the object of a wish or startled thought may equally be a realization of an impossibility. The second thing we may do is to reduce the metaphor to cliché (really to alter the meaning of the words in a frozen context so that they now lose their original literal sense which gave rise to the metaphor, and adopt another). We adjust the 'word-word rules'. The third is to alter our beliefs about the world or concerning our deep conceptions of it. Either way what was once a metaphor may now no longer be.

It is important that we may not always know ourselves whether we still have metaphor or not. Correspondingly, just as change in radical belief can be tracked by the detritus of dead metaphor, our own uncertainty concerning what we *realize* we *do* believe (our opinions)[24] can render any dead metaphor liable to resurrection. Indeed it would be fair to say that it is this fact alone which constitutes our capacity to suffer what Wittgenstein called 'the bewitchment of language'. But this is not the fault of metaphor, but of a failure of doxastic insight which good metaphor can remedy. This is where our use of language as art (imaginative literature) joins often very reluctant hands with that exploration of language which is philosophy. To say that Lucy has a heart of gold is no longer a metaphor any more than it is (now) metaphorical to say that she shows kindness to all. The difference is merely that the first expression wears the heart of its history on its sleeve while the second disguises it. (Kind did once mean kin – so to be kind was to pretend kin – and Shakespeare could pun illuminatingly, as we cannot, with 'A little less than kin and more than kind'.) '...Has a heart of gold'

[24] See Daniel Dennett's illuminating discussion of this, 'How to Change Your Mind', in *Brainstorms, op. cit.* (pp. 300–309).

is now a single predicate more or less equivalent to 'very generous'. Fred does shamble, an ordinary if ungainly gait. This is no longer a metaphor even if it once was. We do not any more think of cattle going to their death.

It is as easy to be over-impressed by the detritus of dead metaphor within our language as it is to disregard it. Books such as Lakoff and Johnson's *Metaphors We Live By*, or Raymond Williams' *Keywords*, have sensitized us to the historical reverberations of much of what we ordinarily say.[25] At some point in the history of virtually any word we may find a period of reaching for strange simile or metaphorical tension – often both interacting with each other. It neither follows from this (and it would in fact be an absurdity) that there was some pre-history of language in which all was metaphor, nor does it follow that what was once metaphor must inevitably retain some remaining spark of life. Most often the words have frozen round an uncontroversial thought. How far this is so or not has to be a matter of accessing our own beliefs, the beliefs inherent in the way of life of our dialect, and how strongly, if unreflectingly, these beliefs are held.

Philosophy exists because we do not always find it easy to know what our beliefs are, but we should not for that or any other reason allow ourselves to be bullied into supposing that we have beliefs, or half-beliefs, that we do not. Our clichés can only provide partial evidence for how we live and for what we live by, for it is the nature of cliché to disguise the difference between death and dormancy. Kant, and many philosophers after him, for example, have illuminated our thinking by pointing

[25] George Lakoff and Mark Johnson, *Metaphors We Live By* (Chicago University Press, 1980), Raymond Williams, *Keywords, A Vocabulary of Culture and Society*, revised ed. (London: Fontana, 1983).

out how metaphorical our talk of the 'inner' or 'external' world really is when we wish to contrast the mental with the material. The mental is not inside us as our livers are beneath our skin: we think we have clear beliefs where what we actually have is the unresolved content of metaphor. Bacon, that apostle of the experimental method, and of our supposed rightful power over nature, notoriously talks of 'putting nature to the test'. It matters that he was a lawyer for whom putting a witness to the test really did mean torture, and the unconscious ideology that we may still inherit from the Baconian tradition certainly requires bringing to light at the present day.

Yet it would absurdly force the issue to insist that all contemporary uses of the idea of an experimental test are in any way direct indications that all who say such things are similarly ideologically committed. Raymond Williams offers a similar example, pointing out that an early sense of the word 'interest' is the economic one, while the psychological sense of having or taking an interest in something falls into place by late simile. He suggests then that even our concept of something's being interesting may be unconsciously saturated by a commercial or capitalist ideology. This may be so but the evidence here is not impressive. The words give every sign of having diverged too far. On the other hand, they may yet provide evidence of a possibility of revival of a metaphor, as opposed to a revivification of one which is inherent in the language. Indeed in these Gradgrindish times it seems to be happening: people have begun to adopt the new cliché of 'buying into' an argument. A proper response is to weep.

The third thing is to adjust the word-world rules. In other words to change the way we believe things *are* or *could be*. The distinction here is obviously important,

if notoriously elusive. If, like Aristotle or Kant, we believe, that once made clear, the categories of things will remain more or less fixed, the second type of adjustment will be rare and would always be the mere correction of error. Yet the assimilation of metaphor is frequently to engage in conceptual change. Sometimes metaphors occur when previously the thought had been literal. When they do so it is in response to the pressure of other wished-against impossibilities. To be the support of the world (like Atlas's shoulders) was once something that something had to be, even if we knew not what, since otherwise everything would carry on down, down being an infinite line that extends the string of a bob. Since the fifth or perhaps the fourth century BC, among those who inherit the education of the Greeks, to be the support of the world is not to be what something must be, since the concept of down changed first to the limited centre of everything then to the centre of whatever gravitational field we may find ourselves in. Similarly, the Homeric 'metaphor' that when overcome by passion Venus plucks us by the hair[26] – really *does* take us away from ourselves – need not have been much of a metaphor. It may have at most been simile, since that may have been very close to what was really believed to happen, that gods do actually deprive us of our autonomy of action. Perhaps we may never know which, lacking enough further data concerning what was believed. To us it must be metaphor or cliché. Sometimes it is the other way about. We no longer think of currents having to be features of flowing liquid (electricity) but, as Kuhn pointed out, that was once how electricity was conceived.[27] How else could it have

[26] An example suggested by Adam Morton.

[27] Thomas S. Kuhn, *The Structure of Scientific Revolutions*, 2nd ed. (Chicago University Press, 1970).

been indeed? Then, first, electric current becomes a usable contradiction in terms (a metaphor) when electricity is no longer thought to be a liquid, and later not metaphorical at all.

In our context an almost perfect case of conceptual extension via metaphor is our capacity to refer to the 'expressive' properties of drawing – of a line being relaxed, nervous or hesitant – as qualities which drawn lines have in their own right. Even if the origin of such concepts is metaphorical its established currency is now literal. Without it we would simply lack normal descriptions of pictorial qualities.[28]

Too much indulgence in metaphor can carry a price, that of being uncertain of what we do in fact believe. Caught between contrary doxastic wishes, we may be unsure of whether what we say is a delightful idea or an opinion we really hold. Too little metaphor will, paradoxically, produce a similar effect, that of our never exploring the limits of our beliefs for fear of being tempted beyond them.

Whether the adjustment of metaphor results in cliché, new classification or deep conceptual change, an ahistoric account of metaphor, one that is not essentially part of the history of the embodiment of thought in language, must inevitably be inadequate.

PICTORIAL METAPHOR? SEVEN CONDITIONS FOR THE ANALOGY
The question of the possibility of pictorial metaphor still remains. Not only is this an important question for understanding pictures it can be a convenient way of summarizing the status of metaphor in language. What is it that we have to extrapolate from language and literature if we wish to apply the concept of the pictorial

[28] See note above to Goodman, for whom these terms remain metaphorical.

to visual art?

The following seven conditions would have to be met should a serious candidate for a pictorial analogue to linguistic metaphor present itself. Should they be met, such a candidate's claims would, I suggest, be overwhelming.

1. It cannot be simple visual imagery, or the mere cause of such. In a way all pictures achieve that. A concept of metaphor that applied to all picturing would hardly be useful. (In effect this is the unfortunate, if unintended, consequence of Davidsonian rhetoric.)

2. As Wollheim notes, pictorial metaphor can't be merely a matter of illustrating linguistic metaphor. He instances Blake's *River of Life*, but a great deal of political cartoons get by just on this trick. The puzzle they usually present is to recall the appropriate linguistic phrase in order to make sense of the picture. To be a significant concept it should apply in its own right to pictures.

3. If to significantly parallel the concept of metaphor elsewhere, pictorial metaphor should address belief, assume knowledge, and invite a wish or a speculation about a departure from its limitations.

4. All the above conditions should be met without an account of depiction relying on too strong an analogy with the linguistic, in particular with the ways in which linguistic rules operate.

5. Metaphor should not be tied to specific content.

6. Pictorial metaphor, even though it may start there, as linguistic metaphors do, cannot simply be merely a matter of depictive ambiguity.

7. If pictorial metaphor is to be anything like metaphor in language there needs to be a corresponding historical topic of metaphorical change, on the one hand towards cliché, on the other towards something like the

pictorial equivalent of conceptual change, of how we·
conceive of what we depict.

Because metaphor is a matter of categorial belief – or,
if preferred, of reflection contrary to beliefs of this sort
– the fact that pictures lack the 'grammatical structure'
of sentences need be no barrier to metaphor. In fact,
because both pictures and the world they depict are
each visual, pictures tend to operate metaphorically at
two interacting levels. Consider the concept of 'tactile
qualities' which we have to see as a barely metaphorical
concept within the description of art. 'Strictly' the
tactile should not belong to the visual, except as it
derives from how what is seen, whether picture, or what
is depicted, may be touched. In fact such 'strict' literal-
mindedness loses sight of the concept. 'Touch' in this
sense is no longer any more securely related to the
merely visual; it has been re-secured by pictures via the
incorporation of qualities of 'facture' within our
conceptual scheme of what depiction is.

At the same time what is depicted can be incorporated
within the metaphorical processes of representation. In
the chapter concerned with pictorial 'metaphoricity' in
Painting as an Art, Wollheim concentrates on a variety
of what he takes to be genuinely pictorial metaphor,
where paintings of buildings can at the same time be
seen in terms of their presenting their surfaces to us as
a type of skin: they become for us, via the power of the
picture, eroticized. While, as elsewhere, puns may invite
metaphor, this is quite different from cases where a
picture is ambiguous. These are manifestly pictures of
buildings and of nothing else. To suppose that buildings
are in fact erotic objects would be as contrary to our
moral categories as to suppose that people or bricks
were edible – either morally or materially. Wollheim's
psychoanalytic leanings incline him to the suggestion

that such eroticization is the normal force of pictorial metaphor. It may certainly be very common, but there is no reason for supposing that pictorial metaphor need be confined to this.

In fact any practice that incorporates belief is thereby capable of its own type of metaphor. Danto's claim that all art involves or invokes metaphor is in this sense plausible enough. Consider for example the bare plot of Copelia, a manifestly light-hearted work, by no means deep or difficult, yet which is perhaps the definitive ironic comment on classical ballet and its implications for our conception of what it is to be human. In it a dancer, trained to the limit and choreographed to that point of obedience that is characteristic of this dance tradition, acts the part of a doll who comes to life as a real girl – yet remains a doll (in reality acted by a young woman). In no way are we confused by this. The story and presentation of the work is conventionally straightforward. Because of this, at each turn of the ballet we think of the dancer and the character portrayed (what happens applies indifferently to whether it is fact or fiction) in ways that we 'know' are not so. We are thus first presented with the limits of our normal thinking and then invited by the work to think beyond them, beyond the frame of our assumptions. In this way the whole work is a metaphor about the limits of human autonomy.

What might parallel the life and death of linguistic metaphor in non-linguistic contexts? The parallel need not be exact, if only because representational systems outside language are far less historically systematic than language is, but it ought not to be absent altogether. In fact it is not. What we loosely call styles of pictorial art incorporate among other things quite radical variants in what we conceive of as depictable and of how depiction

works to render the real. An obvious – perhaps over-obvious – example is Picasso's later 'softer' cubism, where figures are drawn as from multiple viewpoints. Surprisingly few people now regard his drawing as depicting people with distorted faces. His portrait of Dora Marr and the paintings and drawings of weeping women that make up the context of Guernica, transmit their content to us far more naturally and easily than they seem to have done to those who saw them first. Two things seem to have happened which it is as well to distinguish. On the one hand, and to some extent, we have become used to a certain sort of pictorial cliché. But far more significantly we have adapted our view of what can be visualized. I argued in 'Representation and Conceptual Change'[29] that what is happening in such drawing and painting is something which shifts our conception of weeping, of outraged grief, so that what results as a consequence of how we struggle to construe the lines of the drawing enables us to recognize in the picture a structural analogue not merely of an appearance but of an experience. John Berger[30] put it that: 'What has happened to the bodies *in being painted* is the imaginative equivalent of what has happened to them in sensation in the flesh.' That is, if we like the germ of visual metaphor: its consequence as the metaphor becomes incorporated into our visual thinking (our sense of the naturally recognizable) is more radical than that, at least the beginning of a shift in our conception of grief, so that we learn it is not mere sadness but can be, more radically, a form of disinte-gration. The result is a change in how we conceive of grief, not merely (if the idea has sense at all) the

[29] *Op. cit.* The passage here is recyled from my earlier paper.

[30] John Berger, *The Success and Failure of Picasso* (Harmondsworth: Penguin Books, 1965).

appearance of grief.

Such processes are in fact all about us. That we may think of them as less dramatic may simply mean that they have become more deeply assimilated. Rembrandt's (or Cézanne's) searching gaze is not mere looking; it is probing, constructing, building with a brush that draws; so much a form of making that we cannot separate from attending. Our grasp of how to construe the paint becomes at the same time a shift in our concepts of what attending is, or can be. The looks of things, even our conception of what a look is, are constantly constructed and reconstructed, by the metaphors of the pictorial. Such pictures belong to the process of our own conceptual change as much as the metaphors of science and literature. It is not implausible to think of the development of Renaissance perspective as a conceptual shift of this kind, a shift towards an entrenched concept of a new kind of visual objectivity, one from which we may have begun to move away. If so, it belongs to a larger set of concepts of the public possibilities of individual imagination, that we most often associate with the development of literature, normally associated with the representation of narrative. To this we will now turn.

Chapter Four
FICTIONAL FRAMES

Beyond Truth and Falsehood?

FICTIONAL PRETENCE

So far we have taken fiction for granted. Yet manifestly, the whole topic of 'representational' art, of what Aristotle called mimesis, can easily be seen, as Aristotle's *Poetics* is often regarded, as being almost entirely about fiction. Early in the *Poetics*[1] Aristotle reminds us of two 'natural' facts. The first is that it is a basic characteristic of humans that they delight in 'mimesis' (that is imitation or representation either of what is or of what might be) – delight thereby in fiction. The second is what can still seem to be a deep psychological paradox at the heart of that delight. This is that even when, or especially when, we admire a representation (it might be a painting or a statue, but could equally well be a narrative) of what we would normally regard as disgusting or horrifying for the 'exactness' of its imitation, our response to it, while it must draw on such a normal reaction, will be totally different. In the best cases it will one of admiration and a certain kind of deep delight, even if it is a delight that is deeply connected with our capacity for pity and terror. A statue of a dying slave, or a dead victim (Michelangelo's *Pieta*) or of a sea monster crushing a father and his

[1] *Poetics*, V.

149

sons to death (*Laokoon*), a painting of a rape or a flaying (Titian's *Rape of Lucrece* or the *Flaying of Marsyas*), the depiction in drama of desperate torture (the blinding of Gloucester in *King Lear*) or any of the more ghastly events in drama, all provide incontestable evidence for this.

Such cases are the truisms of representational art; they present the foundation facts which, however puzzling, we cannot deny if we are to begin to take such art seriously. They are not confined to tragedy, though they appear somewhat differently in comedy and very differently in farce. The problem (still) is to find a reasonable theory to explain or understand them. Moreover, a moment's reflection should show that no such theory could be confined to art. It certainly could not be confined to fine, high or serious art. For, as Aristotle is at pains to point out, delight of this sort is a kind of human universal that seems to set us apart from other, otherwise intelligent, animals.

Very young children delight in this sort of fiction, and delight in trusting us and the fact that it is only a game – a game of pretend in which we say 'I'm coming to *get* you!', that we are big growly bears coming to eat them all up, that we will do *frightful* things to them. The pretence (normally healthy, and it is significant that such delight in fiction is constitutive of a central concept of psychological health) produces delight and laughter, not terror. Here also, however, the delight is essentially connected with the game being a fiction about terror. The subject matter matters. Children need to have it explained to them, for the sake of their safety, that puppies, while excellent and intelligent companions and playmates, are unable to grasp such distinctions. To pretend to be aggressive to a puppy or a pony can bewilder it dangerously: 'It doesn't understand the game,

like you do, doesn't know how to pretend.' If the point of the pretence is lost it becomes something different and dangerous, a deceptive tease. Nothing could more dramatically indicate how deeply what lies at the heart of art is embedded in the facts of what it is to be *us*: our capacity for fiction; and that capacity is in there right at the start.

To see why this is, consider two further facts about ourselves. Consider the differences that children have to find out between themselves and puppies. We may fairly readily find out about the moods of dogs, at least to the extent that when they wag their tails they are happy. Dogs can look puzzled, enquiring, expectant as well as dismal, frightened and something very like ashamed. To be sure, this all may be an anthropo-morphic fantasy, but, if it is, it is one that enables us to get along pretty well with dogs. Perhaps we might go a bit further. Most dog owners are reasonably confident that dogs can be, up to a point, deceptive, can wag their tails to reassure us as if they are pleased, as well as to directly evince delight. One is that a dog might not merely wag its tail to show (perhaps even falsely) that it was pleased, but wag its tail to show how another dog, not this one, might feel if.... The other is to recognize the same type of conditional thought in another dog or in us. While we may train dogs and other animals to perform for us, in fact no dog, certainly no horse, can act as an actor – even a child actor – can.

Second, the gulf that exists between language-users such as us and animals without language. It is a dramatic feature of language that grasping the sense of one sentence generates the grasp of an indefinite range of sentences of that same form. So if someone, a child, can be got to understand a sentence such as 'Daddy went shopping', not only can they *directly* go on to

understand the sentence 'Mummy went shopping', but, astonishingly, 'Kitty (the pussy cat) went shopping', despite the fact that they may be quite sure that shopping is something that little cats do not, even *could* not, do. Similarly, if we can grasp the sense of the sentence 'I was happy when I went shopping', we can grasp the sense of the sentence 'Kitty was happy when she went shopping' without there being any question of having to work out just what sort of pleasure a cat might get out of a visit to Woolworth's. That question might arise later, but the conditions for it belong to the sentence-understanding right there at the start. Similarly, a way of telling a child why one should not pull the kitten's tail is to ask 'How would you like it?'. It should surprise us more than it does that the direct rebuttal: 'No idea, I'm not a cat and anyway I don't have a tail' is not standard. Stories about animals, strange fictions, illuminating fantasy, seem to be guaranteed by the nature of language-learning itself.

MAKING IMPOSSIBILITIES PLAUSIBLE
If we put these two speculative thoughts together we might speculate about a third. This would be a modification of an observation of Aristotle's. 'With respect to poetry' (which includes drama) he says, 'impossibilities, rendered probable, are preferable to things improbable, though possible.'[2] In other words, what is most preferable is the capacity of fiction to render impossibilities *plausible* – seeming probable to us. However 'objective' the sense of 'possibility' here, the kind of 'probability' involved is obviously 'subjective' in the sense that it has to do with how we can make imaginative sense of what we are told. One way of regarding the issue of fiction is thus how to negotiate the inter-

[2] *Poetics*, VI.

locking implications of these notoriously tricky words. A delight in the indefinite extensiveness of fiction, its capacity for exploring the plausibility of the impossible – far beyond the range of the normally accepted – also belongs there at the start. This is very close indeed to placing the possibility of art at the core of what it is to be human.

There are a number of well-known Aristotelian slogans about what makes us *us*: that man is the only animal that is rational (or equivalently, the only animal of whom it makes sense to say that he is occasionally irrational), that man is a political animal, and the animal that laughs, has a genuine sense of humour. Taken together, they suggest a picture of what we take to be the core of humanity: that we can formulate and have opinions about our own beliefs and desires, that we must do so socially, that we delight in (celebrate) the possibility of representation and have a sense of the tragic and of the absurd. That which, above all, art *celebrates*, in painting, poetry, perhaps above all in the public celebrations of drama, is precisely our own sense of what it is to be the sorts of beings we are. Since Aristotle's first question in ethics is what is the good life for humans, such awareness is a necessary, if rather manifestly not a sufficient condition of the possibility of morality at all. For Kant too, it is our capacity for aesthetic delight which virtually defines us as human, as beings 'at once rational and animal'.[3]

A cooler way with the problem here is to locate it on the issue of the nature of fiction. It is a truism of philosophical history that Aristotle's argument is designed to defend 'the poets', painters, sculptors, perhaps above all dramatists and story-tellers, from the charge of telling

[3] Immanuel Kant, *Critique of Judgment*, book 1, First Moment, section 5, trans. J. C. Meredith (Oxford: Clarendon Press, 1961).

lies. Either, on a certain, perhaps unfair, reading of Plato, such people deal merely with images, shadows, of things rather than with reality itself or, worse, they say about what is, what is not, perhaps even could not be, true. But put like this the debate seems foolish, for the rebuttal seems too easy. For on the one hand, we merely have to point out that unless 'images' of things are offered to us as instances of them, there is no deceit, on the other that since what is fictional makes no show of being true, it cannot thereby mislead us with falsehood. Only bad art or art very badly understood could possibly fail in this way. However we may admire the 'realism' of a sculpture or a painting *trompe-l'oeil*, deception is rarely what is involved, and however we may admire the verisimilitude of a narrative it is no more part of that idea that we should mistake it for fact than it is part of the very idea of playing bears that children should suppose us to *be* bears.

Perhaps Plato's fear of poets is strictly comparable with an unhappy child's fear of pretend games; a systematic misunderstanding of what has to be trusted in fiction – like a frightened puppy. However, then the issue is not so foolish, for we may now ask whether the error to be corrected is a conceptual matter to be cured by explanation, or a moral fear to be treated by comfort and reassurance. What makes the matter deep is that it can be systematically unclear how we might peel these two sorts of confusion apart. For the problem of fiction versus untruth is the problem of misplaced literalism. In pictorial contexts this is, as we have seen, the problem of wrongly identifying the properties of representations with what they represent, in infantile cases the problem of fantasy (such as believing that Teddy really does supply uncritical love because he really is cuddly), and in religious contexts the problem of idolatry.

FROM 'fiction' TO 'Fiction'

Then, the problem of fiction is how to identify and avoid corresponding error. It is very far from the simple error of confusing fiction with fact. Its cure, as in other cases, is to take fiction seriously as *art*. This needs explaining. How may we travel from the 'logical' concept of 'fiction' to the idea of 'Fiction' as literary art?[4]

Surely fiction is easy enough to define. An utterance is fictional, surely, if it is neither true nor false but may yet have the grammatical form of an assertion which normally would be taken that way. 'If you walk on my nice clean floor I shall boil you in oil', 'Rapunzel let down her hair', 'Holmes solved the murder', 'Peter Rabbit was afraid of Mr MacGregor', 'King Lear went mad on the heath', are thus neither true nor false, but fictional. We are familiar with the comfortable triad 'true', 'false', 'fictional' (or 'neither true nor false'). Unfortunately it is not as simple as that. Certain libraries standardly classify books into fiction and non-fiction. How convenient it would be if they could classify them as fictional, true and false. A third of such books would not require reading. Sadly, however, the distinction between true and false is quite unlike that between fiction and the rest. A tempting explanation might be that the former distinction has to do with the 'connection' between books and the world, the false failing to fit what is, while in the case of fiction there is no question of their aiming to fit at all. We have only to state that temptation to see that we should resist it.

A common philosophical ploy can be to explain this in terms of pretence. The sentences in question have all the grammatical features of a sentence used to assert

[4] See Peter Lamarque, *Truth, Fiction and Literature* (Oxford: Clarendon Press, 1996).

something, but such features may be made use of not merely to assert, but to pretend to assert. Thus if one says to a child 'I'm a great big growly bear' one is not actually asserting, intending to convey a fact, merely pretending to do so. This – while in a way true – is unhelpful. For there are two concepts of 'pretence' here, that which involves fiction and that which involves deceit. It is perfectly possible to pretend to assert while not fictionally, but as a genuine form of deceit. Someone might require that you tell something to someone else, say tell the policeman where the fugitive ran off. Not wishing to do so, you go over to talk to the constable, make every show to the interested bystander of telling something to the policeman, while in fact asking the time in an anxious manner. That is certainly pretending to assert, but certainly not engaging in fiction. Or one might say the appropriate sentences very loudly and clearly, fully aware that the audience cannot speak the appropriate language. In short, for 'pretending to assert' to fit the case, pretending has to be that *non-deceptive* pretence that fully relies on the audience understanding what is said. So simply to call fiction pretend assertion assumes just what it seeks to explain. Then fictional pretence becomes something like a basic category not to be explained in terms of any other variety of pretence.

That fiction is using a sentence to say what is neither true nor false will not do for two further, and connected, reasons. Firstly, all sorts of utterances (of the appropriate grammatical form) may be produced for quite other purposes than that of telling the truth without being fictional. In a lecture on logic and grammar someone might quote the sentence 'Socrates was bald' as an instance of a subject-predicate sentence without any question of it being *either* fictional *or* non-fictional.

Secondly, to take fiction seriously is to care a great deal about some sort of 'fit' fiction has with what we take to be the real world. Just as, as Aristotle observes, we may admire the realism of a sculpture or a story without thinking it other than fictional, so a standard and basic objection to a story must be that it is sentimental, that its characters are unconvincing, that it radically distorts motivation, and so on. It is a fact about stories that they can be so criticized just as it is a fact about pictures that they may be badly drawn, however imaginary what they depict may be. Both facts have to do with a kind of fit to the world; both apply to fiction. Yet, equally, and more confusingly, the fit is far subtler than any mere match could possibly be. Aristotle really does mean that stories which make the impossible plausible are preferable in terms of our finding out something important about the actual, non-fictional, world. Stories, unlike pictures, explicitly, and implicitly, explore possibilities, impossibilities and plausibilities. The core topic of linguistic fiction is stories and story-telling.

STORIES
A story, fictional or otherwise, is a relatively complex sort of thing, more complex than bald narrative. The very idea of a story sits at the centre of what can seem to be inevitably conflicting values. It is an interesting question what the minimal complexity of a story might be. (Compare a similar question concerning the minimal complexity of pictures.) The answer seems to be that it tells of a sequence of events that lead to a certain consequence. It is part of what a story is that it may be judged to be likely, plausible, tall, fantastic, or merely dully predictable. One thing happened, then another and the outcome was so and so – a mere list of events, real or imaginary, won't do. When children are set the

exercise of writing stories, they are told at the start that a succession of '...and then's' is not enough: there eventually needs to be a reason why what happened did happen. The reason need not be narrowly causal beyond the fact that someone being told the story has reason to expect a certain outcome, even, or especially if, that expectation is caught out, surprised, in all sorts of ways. So Jack and Jill went up the hill (for a reason which was) to fetch a pail of water, then Jack fell down and broke his crown (so now we know why) and Jill came tumbling after (well, maybe she would).

Not all historical (non-fictional) records, however well sequenced, make up stories. Significantly, for this reason many historians tend to distrust stories. If historical reports fail in this way we pay the price of not being able to make a certain sort of sense of the narrative. That may simply be the way the world is. It can be a gross dereliction of a historian's duty to the facts as they may be known to import overt or tacit explanations in default of knowledge. History, whether on the grand scale or on the small scale of our own personal biographies and autobiographies, is constantly in tension between two values.

Ezra Pound has a delightful line in a later Canto: 'And even I can remember when historians left gaps in their manuscripts. I mean for what they did not know.' What we do not know may be just what would make sense of a senseless world. But if, as Socrates insisted, 'the unexamined life is not worth living' one reason is that lives we cannot understand, cannot make sense of as stories, are, especially if our own, deeply and radically unsatisfactory. If we cannot compare lives in these terms we have no resource for negotiating one another's explanations and values. But if we merely devise story-telling intelligibility we may suffer a drastic drift from

truth.

Worse, since we tend to remember not just what we recall, but what we can put together in intelligible ways (*remember*, rather than merely call-back), memory itself is liable to be caught in the same trap. Aristotle puzzled over Solon's dictum 'call no man happy until he is dead'.[5] We are hardly happy *when* we are dead; the point is that only at the end and looking back could we make the judgement. Kierkegaard's corresponding dictum that we live our lives forward but understand them backwards[6] implies this same dilemma of awareness. Any experience of what it is to attempt to make sense even of those brief episodes of our lives that matter most to us will teach us the same thing.

Making sense of things is not enough. The sense made ought not to be spurious significance: to be relevant it has to be something not that we fantasize but *realize*. To realize something is to bring to awareness what we already dimly, unrealizingly, know, to revivify what lay buried, repair what is lost in confusion, inattention or self-imperception.

It is here that frank fiction may come to the aid of elusive fact. For if we import into our narrative of events, not what we are sure of, but what we may suppose as a way of getting the telling of the story to work, making sense need no longer be at war with caution before truth. How, then, may fiction in story-telling declare itself? Children learn to understand 'Once upon a time', 'It's only a story'. What do they thereby grasp? On the face of it something about the whole of the story from start to finish, since it is the whole story that is fictional. On the other hand, it is equally obvious

[5]　*Nicomachean Ethics*, Book 1.

[6]　*The Journals of Søren Kierkegaard*, trans. Alexander Dru (London: Oxford University Press, 1938).

that the detailed application of this understanding cannot apply to every bit of the story. For it is a logical truth that not all of a fictional story could be fictional. If it were, we would have no way of telling, because no way of following, the story. All we would have would be a meaningless unlocatable list of empty names. Moreover, the pay-off is always non-fictional. If Holmes was a fictional character, or if Lear (let alone Cordelia, her sisters, Kent and Gloucester and all the other persons in the play) is fictional, then whatever they are said to have done was fictional too. Yet it is part of what it is to understand the stories of Holmes and Watson that they lived in London at a certain date, where the circumstances, manners and motivations of people were as we take them to have been then. A minimal condition is that Holmes and Watson are men as men are, then beyond that Victorian gentlemen as we suppose *they* were. What engages us – what the stories make us confront – is just how we might detect and decode events from evidence. Correspondingly, what we value in *King Lear* is how the play addresses – forces us to address – quite *non-fictional* assumptions about old age, human cruelty, courage and so on, as well as make unquestioned assumptions concerning the wetness of rain and the destructive forces of nature. So we have a question concerning the real world, concerning, among other things, how far we are essentially just 'bare forked animals' when all's told.

We could tell a story about how everyone one after another transmogrified into rhinoceroses and have no doubt that that is fictional, but making sense of how they did so, and of their behaviour and attitudes, forces us to accept and confront some totally non-fictional assumptions. In Ionesco's play these are about moral cowardice in the face of embarrassment, the need to be

part of a crowd, however awful – assumptions deeply
relevant to our understanding of any terrible breakdown
in the moral and social order, such as the rise of the Nazi
Party. The impossible becomes thus all too plausible.

It is a logical fact about stories as fiction that their pay-
off – what their plausibility confronts – is non-fictional.
In no way is this restricted to 'serious' or 'significant'
Fiction as Imaginative Literature. Rather, what makes
fiction serious in different ways is how this logical debt
to intelligibility may be negotiated.

THE UNSPOKEN CONTRACT BETWEEN THE TELLER AND
THE TOLD: POSSIBLE WORLDS AND IMPOSSIBLE STORIES
There are two issues here, one rather dryly philo-
sophical, the other less dryly concerned with the
'contract' a story makes between the teller and the told.
In fact they are the same problem from contrasting
points of view. The dry problem is this. Suppose we met
someone outside a pub wearing a deer-stalker, clearly on
drugs, inclined to describe rather wild flights of inference
as 'elementary' and with a friend called Watson. The
one thing we could be sure of would be that he was not
Sherlock Holmes, since fictional people cannot sit
outside real pubs. But the fictional Holmes lives in
Baker Street in London. So by that argument the
London of the Holmes stories is fictional too, and we
can continue the same move indefinitely. Fictional
people cannot be made wet by real rain, confused by real
fog, and so on. So the entire furniture of the story is
fictional. But we would fail to follow the story unless
this were not so. Perhaps we might say that, with
respect to the rain, the fictional stuff that wets the
fictional Holmes is *just like* the real stuff that wets the
real us. But what is just like rain is just like rain *is*. Are
the likenesses fictional or non-fictional? They might, of

course, be fictional. In science fiction rain might not wet (fictional) people as we normally suppose it does (real people). But that would be a different story, even a different *type* of story, and in any case the process of fictionalization must eventually come to a stop. It is partly where it does stop that determines what understanding stories is. It involves knowing what type of story we are being told.

One way of putting the matter is to say that in the second sort of story we are presented with a different kind of possible world from the first and that what marks out the different worlds from each other (including our own) is that some items re-occur (and have the same labels) in more than one world, others in just one, some indeed (these would be the necessary truths) in all. This is an attractive device and works well in all sorts of philosophical contexts.[7] Since we might more or less use this device to estimate the distance of various possible worlds from one another, a more or less 'realistic' story would be about a 'closer' world to 'ours', a fantastic one, a more 'distant' one. One advantage this could provide might be that we would recognize fantasy as those 'worlds' where the common ground was most attenuated: a question this might pose for the fictional reader would then be how much 'common material' was really required to make sense of such widely spaced possibilities. A necessary truth is then one that carries over to remotely different possibilities since without it they would be unintelligible. One difficulty, however, is that if we take all possible stories as the full range of possible worlds (a 'multiverse' of possible worlds), since many such stories (such as Lewis Carroll's) even suspend what we

[7] Cf. David Lewis, *Counterfactuals* (Oxford: Blackwells, 1973) and S. Kripke, *Naming and Necessity* (Oxford: Blackwells, 1980).

normally take to be necessary truths, we are either forced to say that the idea of a necessary truth becomes infinitely elastic, or that the multiverse includes impossible worlds as well as possible ones.[8]

However, from the point of view of what it is to understand fictional stories – indeed other sorts of fiction – this is at the very least an odd way of putting it. In this terminology it would not be easy to capture the idea (endorsed in the previous chapter) that metaphor is a kind of fiction, since, if so, metaphor must be seen as contemplating the thought that things are other than (it seems) they *could* be, rather than the thought that they are other than they are *in fact*. However, the real difficulty for this way of putting the matter is that it loses focus on what happens when we are told a story: in effect it makes assumptions about our assumptions as readers, as story-followers, that are extremely implausible.

For it is as if the picture of a reader's understanding of a story emerged like this. Today I had an egg for breakfast. I might not have done and if I hadn't perhaps everything would have remained much as it was except for the fact that I failed to eat an egg. To be sure all sorts of other alterations might hang on this unknown to me. But I am in no position to know this and can safely assume that in the variant the 'world' will safely look after itself in my absence. All variants are, as it were, 'whole worlds'. Fictions really are not like that, even if philosophers' fictions are. To see why, it is best to return

[8] Cf. Nicholas Wolterstorff, *Works and Worlds of Art, op. cit.*, who takes very much this view. In many ways it provides him with positive advantages in saying much of the illuminating things he has to say about the arts, especially the art of fiction, for example in part three. His account of the 'non-comprehensiveness of a work's worlds' (pp. 131ff.) accords very closely with what I am sketching here. In my view much of what has to be said requires a simpler apparatus than he provides.

to the alternative perspective.

The idea that not all of a fiction can be fictional can be most simply (but rather misleadingly) put by saying that 'once upon a time' really means something very like 'suppose'. Suppose there were the following: Holmes, Watson, etc., and that the following events occurred, or that there was Lear, Cordelia, Goneril, Regan, etc., and the following events occurred. We could call this the fictional 'introduction'. More or less this answers the question what (fictionally) the story is about. Here 'about' does not mean what in the real world the story refers to but what has been specifically invented by the author. 'Then...' (and so the story goes on). That what is fictional in the story is simply what the reader has to suppose, is tacitly asked to suppose, differently from 'normal' belief – even as in science fiction the 'laws of nature' – might fit the idea of 'possible worlds' quite well. But this reduces the kind of background interest the reader has to simply asking what would be likely if...so and so were different.

So, different from what? Well, certainly not from how, should it be possible to know this, everything actually is, or even possibly might be, but simply from how the story-teller or the told believes things are, or might possibly be. Often enough story-tellers and readers or audiences may differ about this. In the case of old stories this may matter for how we are to understand them. In *Beowulf*, Grendel's mother lives at the bottom of a lake. Is this a fictional 'introduction' or did the story-tellers really believe that such things were, or at least might be? Even quite modern stories may involve something of this problem. A short story by George Eliot tells of someone revived by blood transfusion. This seems quite unfantastic to us, and we have to remind ourselves that it was almost certainly intended

to be as wild a variant on reality as the events in Frankenstein. To see what it is that a story asks of us – as told by the teller – certainly requires that we can distinguish between the fictional 'introductions' and the merely different beliefs that the story-teller may have. It is often, if quite subtly, difficult to construe a story when we are confused by this, especially where the story-teller's differences from us seem to be concerned with such things as the psychological 'laws' of human behaviour. The result can be that we may be somewhat unsure what it is that we are supposed to be surprised by or to take for granted in the outcome. Just as what words are to count as metaphor must depend on the history of beliefs, so will what is to count as fiction. This should not be surprising: both depend on the negotiation of belief.

FICTIONAL FRAMES
There is however a larger problem, already touched on. Not all of a fiction *can* be fictional in the *same* way. Think of a soliloquy. When Hamlet 'lets us know what he is thinking' by the conventions of a soliloquy, so that he tells us thoughts that the other characters in the play could have no knowledge of, it would obviously be a gross misunderstanding of the play to suppose that it tells a story in which the other characters go suddenly deaf, any more than a play which (fictionally) takes place within a dungeon but where the audience can see all that is going on on the stage is a story about a room with a mysteriously transparent third wall.

Nonetheless there is indeed something fictional here, but not a fiction 'within' the story, rather the fiction 'frames' the story. We might reasonably suppose that the sort of thoughts, waverings and strange intentions, hopes and fears, that Hamlet expresses were the sort of

things that are unknown to anyone else. Perhaps not even to Hamlet if, as is likely, he fails to realize his own state of mind. We have no problem with the idea that what he says is inaudible to the other people in Elsinor. A far more interesting question is whether his soliloquies are audible to Hamlet. Then who speaks the lines? Clearly the actor 'as' Hamlet, but not 'as' Hamlet speaking audibly, even though the actor is audible to us. (Who sees the ghost seems to be an option to be explored differently in each production: it might well be Hamlet but not the audience.) More simply, what happens in a dungeon happens in a place that nobody could enter or see into. For all that, a story about such things could only make sense supposing that we do know what happens. Then, the assumption that the story can be told is itself a fiction, but not a fiction which the story is (fictionally) 'about'. Such assumptions are the fictional 'frame' of the story. A fictional frame is, then, what we as readers have to fictionally assume in order to make sense both of what is fictionally introduced and also what happens in terms of that. It is, however, equally a matter of what as readers we do *not* have to assume.

In fact, of course, framing, while *manifest* in fiction, is not *confined* to fiction. Any narrational attempt to make sense of either an imagined reality or a remembered or researched one requires framing, just as any pictorial attempt to make visual sense of the world requires the systematic selections of modelling, and as any attempt to grasp the force of another's metaphor requires an appropriate feeling for that metaphor's scope. Narrative framing, the processes of pictorial salience, metaphorical scaling, are each different because pictures, metaphors and stories are different. How we explore their several outcomes and interactions is what

constitutes our exploration of the artifice of under-standing, whether of the real or the imagined. It is also what gives rise to our sense that the distinction between the way things are and the way things are imagined can be so elusive to our grasp. None of this warrants abandoning truth as a primary concept. It is these facts of framing, not some obscurity in the idea of a boundary between the true and the false that makes even the most non-fictional narrative a matter of artifice. Anxieties about the obscurity of the borderline between truth and un-truth – even radical doubts about truth – derive at root from a failure to note the difference between a story's frame and its fictional or non-fictional content.

Testing Possibilities

A persistent myth among philosophers is that one may test possibility by story-telling, even to the extent that it is frequently uncritically assumed that so long as one can tell a convincing story about some imagined situation then, at least, it is 'conceptually' possible.[9] Indeed, it is then assumed that such a test examines the key concepts within the story for what they really are. The influence for this idea is that of a 'thought experiment' in science. However, in general it is really not very clear just what 'conceptually possible' could mean beyond the idea that a certain plausible, convincing, story can be told.

It is far nearer the truth of the matter that virtually any story may be made convincing so long as you tell it

[9] Derek Parfitt, *Reasons and Persons* (Oxford: Clarendon Press, 1984); Kathleen V. Wilkes, *Real People: Personal Identity Without Thought Experiments* (Oxford: Clarendon Press, 1988). Wilkes's criticism of Parfitt's deeply influential book is, as her title indicates, that it uses the wrong tools (those of short, radically bizarre, stories) to explore his topic. In my view the issue that divides these two important books is more important than either of them taken singly or even together. We are still a long way from getting it properly into focus.

sparsely enough, and so long as it is received sparsely enough. Stories make sense so long as we learn to hold our questions back. What convinces is sparse telling. It is easy to think of this as a passive matter on the listener's or reader's part. In fact the imagination of appropriate uptake is far more active than that. Coleridge's famous dictum about the 'willing suspension of disbelief' is only part of the matter. We do not merely suspend a scepticism that would be proper to non-fiction, rather as readers or hearers we actively select relevant from irrelevant beliefs, in short make fictional frames from our own stock of belief. The story-teller's fiction is met by an appropriate story-receiver's fiction. Being sparse is not telling short, and need not be selling short either.

The connection, or lack of it, between what is possible and what can be imagined is pervasively puzzling. On the one hand much of what we know to be possible is, since actual, what was in the past unimaginable by anyone. On the other hand we might wonder how we could even address the idea of possibility via any other route than that of imaginability. How different are fictions in 'art' different in this respect from 'fictions' in science?

THOUGHT EXPERIMENTS
It is a truism of the theory of science that 'thought experiments' test possibilities in the non-fictional world of scientific enquiry – *this world*. What makes them *thought* experiments is that we work with them on what we know or believe about the world, and come to *realize* – make manifest to deliberate, conscious attention – what we may already suppose unawares. What makes them *experiments* is that they are *instruments* of thought, since to do this requires an elaborate and active

process of construction in story-making.

However, even, or especially, 'thought experiments' are normally and spectacularly sparse. Mostly, their being sparse is honoured by the philosophically resonant concept of idealization: idealization directs us towards mathematical, or at least conceptual abstractions, thus teaches us what is truly conceivable behind the veil of the merely imaginable. (The distinction is Descartes'.[10] His example is powerful. A figure with 1001 sides is conceivable just so long as a different one with 1000 sides is, since we can always think of adding 1 to any number, but we can't imagine the difference. Here he seems to mean by 'imagine' 'visualize'. But what stories invite us to imagine must be wider than that.) More correctly, however, they construct these concepts as they establish their plausibility.

A classic thought experiment in the history of science probably deriving from Buridan[11] begins with the speculation of what would happen where a cannon-ball is dropped from the moon through a hole right through the earth. According to classical (medieval) Aristotelian physics the final rest-point for any heavy object must be the centre of the earth – the gravitational centre of the Universe. Since heavy bodies fall because they seek their rest-point, in effect half-way through the hole there will be no reason why they should continue, so there they will come to rest. Would the earth above us, were we to be at the centre, have no weight, no tendency to press down further? Aristotelian assumptions would seem to imply this. (Presumably any further balls or pebbles will simply pile up on top of them, unable to get through the underlying support.) But thinking of this

[10] Descartes, *Meditation VI*.

[11] I am grateful to Andrew Pyle for his assistance here. See his *Atomism and its Critics* (Bristol: Thoemmes Press, 1995).

case it is clear that the stone will have at this point acquired maximum impetus from the fall and be travelling at top speed. Then since the impetus acquired in this way will have to be 'used up', the stone will continue against the natural tendency of gravity eventually to fall back (from somewhere up in the sky on the other side of the earth) and repeat the process, losing some impetus each time until finally coming to rest.

However this story may be thought of as a version of another one, where a round pebble falls to the centre of a hemispherical bowl, oscillates and then finally comes to rest. And that again is a version of a further story where the restraint of the bowl is replaced by the restraint of a string suspended at a fixed point. This is then a pendulum. 'Half' the story then provides an inclined plane down which the falling body runs, and that half is again a version of 'half' of the original story of the vertically falling body. Connecting these stories together occupies the central section on falling bodies in the *Second Day* of Galileo's *Dialogue Concerning the Two Chief World Systems*.[12] Much of the discussion, normally overlooked as literary padding by those who simply wish to extract Galileo's physics of impetus from the text, concerns the degree to which the original idea is an absurd fantasy. Because we are dealing with an episode in the history of science we tend to think it merely naïve that the speculation concerns an impossible story. But it is this fact which makes it a crucial step in the framing of the abstract constructions of dynamics. We have to suppose Divine power or Angels to start the whole thing off (tacitly also, presumably, to dig the hole), there are inevitable problems in the matter either

[12] Galilei, *Dialogue Concerning the Two Chief World Systems*, trans. Stillman Drake (University of California Press, 1962), pp. 221 ff.

of a turning earth or in a rotating lunar orbit; there is the matter of how long it would take to fall, perhaps six days, by which time turning will have spoiled the original idea and so on. By the time Galileo has made his analogies, however, their effect is that the cannon-ball has been reduced in thought to a mere point which identifies any falling body. This is very close to a Newtonian point-mass but at this stage it is merely implicit in the story's framing. Since at this stage of the story-telling no concept of universal gravitation has come into the picture, significantly no problem of how the cannon ball is released from the moon in the first place comes into play.

Should we think of this as irrelevant to the story's implausibility as the question of who paid for the cannon-ball, or as simply not arising within the assumptions of the story-teller? Good history of science suggests the latter. For something like this we have to await a different story: Kepler's *Somnium* or *Dream*[13] in which our hero actually gets shot off to the moon in a vehicle, experiences a calculated point on the way at which the two gravitational pulls between earth and moon cancel out and is then able to describe how the view of the heavens would look to an observer from such a strange viewpoint. Kepler's story, unlike Galileo's, does, however, contain a decent enough amount of circumstantial detail about how the expedition is set up and even the political and social background to the events to make it far more like a recognizable ancestry of Jules Verne. Angels won't do, though Kepler did place them on the sun to be at the best position to appreciate the dynamic (musical) harmony of the heavens. (Compare

[13] Johannes Kepler, *Kepler's Somnium: The Dream, A Posthumous Work on Lunar Astronomy*, trans. with a commentary by Edward Rosen (Madison: University of Wisconson Press, 1967).

the idea of the ideal point from which to see a perspective construction.) Possibly for that reason it is given far less credit in the history of 'thought experiments' than Galileo's, yet it is a serious pre-Newtonian 'thought experiment' concerned with, among other things, the 'conceptual issue' of weight as it may vary in a space occupied by heavenly bodies that may in turn be 'visualized' as from different points of view.

Kepler's story functions as if the experiments in varying viewpoints inherent in seventeenth-century Dutch painting were brought into the service of seventeenth-century disputes about the causes of motion.[14] However both stories 'make the impossible plausible'. What is *impossible* is concerned with the world (or what we suppose the world to be) as we normally and widely think of it; what is established by a successful attempt at *plausibility* in story-telling is possibility in the *same world regarded sparsely*. If successful, the thought experiments enable us to realize what, under such restrictions, the possibilities of the world may, as we suppose, really be.

The sparseness of the story frames, narrows, focuses how we may in various ways attend to the world we have or think we have: this one not some alternative, if possible, world. The frame of Galileo's story directs us towards a vividly restricted attention to one (abstractly mathematical) aspect of the world we suppose it might have. If not, science would, we might suppose, have no proper subject matter.

Galileo's thought experiments are in many ways rightly regarded as a paradigm of scientific thought, as conceptually exploring possibility, in ways which contrast profoundly with the fictional imagination of

[14] See Alpers's discussion of this tradition, *op. cit.*

literature.[15] The contrast is genuine enough, but it is important not to make it in the wrong place. For the underlying agenda of the scientific story (its own fictional frame) is to drive a certain sort of limitation – a limitation that leads directly to the conception of idealized mathematical abstractions, the ancestor of Newtonian point-masses. Point-masses, however, 'exist' in the sense that they can play a vital role in how we may conceive of the mechanical world, in much the same way as psychologically 'transparent souls' 'exist' where we can make sense of soliloquy and its later developments. Both are constructions of artifice, if of artifice with different purposes. Neither is more 'realistic' than the other, any more than a very accurate blueprint of a building is more or less realistic than an intensely observed charcoal study of the same building. Both are aspects of the world.

Writers on the metaphysical assumptions involved in the use of fiction in art (typically Goodman and Wolterstorff)[16] tend to favour talk of many worlds in art. So is there one world for science (for serious thought experiment) and many for (less serious) art? Neither alternative seems very satisfactory. Better to abandon talk of worlds – one is enough – and talk of framing what we suppose.[17]

[15] A persistent critic of this kind of demarcation is Paul K. Feyerabend. See *Against Method*, revised ed. (London: Verso, 1988). Feyerabend can be interpreted – and seems to interpret himself – in a number of ways; on the one hand as an extreme irrationalist, on the other as simply, more modestly and interestingly, rejecting a paradigm of rationality derived from a perception of scientific method of which Galileo was supposedly the hero. One aspect of this issue is what we take 'scientific' story-telling to be.

[16] Goodman, *Ways of World Making*, op. cit. and Wolterstorff, *Works and Worlds of Art*, op. cit.

[17] Note the epigraph to the first chapter of Goodman's *Languages of Art*: 'Art is not a copy of the real world. One of the damn things is enough.' It is important also to note that Goodman's enthusiastic talk of 'countless

FAIRY STORIES AND FANTASIES

When within a story we are told that Rapunzel let down her hair so that the large and handsome woodcutter could climb up it to her tower, we do not, not if we are caught up in the kind of story it is, wonder with appropriate concern about the damage to her scalp. When giants put on seven league boots and stride off into the distance we do not make the perfectly reasonable calculation that since a league is seven miles and a stride takes about half a second the giant achieved escape velocity. It is not clear how far we might concern ourselves with the mechanics of sex with mermaids or the fact that angels lack a sufficiently developed sternum to support wing power. Why should we not worry about the fact that the topography of Milton's *Heaven and Earth* is radically inconsistent? It is, after all, 'only a story'. But we do think that we should worry about the consistency of *Paradise Lost*'s moral theology, certainly about its politics. Being a story – this story, this sort of story – is a subtle matter.

FICTIONAL TEXTS AND NON-FICTIONAL TEXTS

Suppose an examination to test general knowledge of Great Literature. Since it is computer-marked, the candidate is asked to fill in true or false boxes in response to model assertions. There is a kind of insanity in such an examination, which, if taken seriously, would render fiction sterile, yet it can seem sensible enough.

worlds made from nothing by the use of symbols' is both a rejection of the 'given' nature of reality and takes off not from Lewis, but from Ernst Cassirer (see Cassirer, *Language and Myth*, trans. Susanne K. Langer (New York: Dover, 1952, which is a very different style of philosophy, in many ways far more relevant to considerations here. For a useful warning about how not to be carried away by the rhetoric of 'worlds' see Gilbert Ryle, *Dilemmas: The Tarner Lectures, 1953* (Cambridge University Press, 1954).

Question 1 goes: 'King Lear succeeded in giving his kingdom by division to all three of his daughters: T/F?'. (What it seeks to spot is whether the students know about his little difficulty with Cordelia.) A smart alec who strikes out both T and F and writes 'fiction', on the grounds that everything that happens or fails to happen in *King Lear* is fictional, will obviously fail on two grounds. Presumably the right answer is 'F' because of the failure with Cordelia. The question was about the play and the idea behind it is to elicit knowledge of what happens in the play, and 'what happens in the play' is the relevant fiction concerning which we may have true or false beliefs verifiable by consulting the texts.

But what is to count as a text? Certainly not simply what is overtly said. Question 2, then, goes: 'Lear went mad on the heath: T/F?'. Presumably, then, 'F'. In neither of these cases is it directly said in the text but it is reasonable to infer it if we have followed the story. But now suppose that Question 3 goes: 'Hamlet went mad: T/F?'. But here there is a familiar readers' problem: any good student 'ought' to know how to hesitate over this: since Hamlet says that he will 'put an antic disposition on' he must have been only pretending...still, as Pascal reminded us, pretending to something can quite easily lead to actually being it, and if this applies to piety why not to madness? (Oscar Wilde posed the question 'are all the critics of Hamlet mad or merely pretending to be?' which should have closed the matter.) Accordingly, the examiner retreats to firmer ground and asks questions concerning 'facts' about the fiction that can safely be inferred. The problem is, however, what is to count as safe ground?

In a paper that used to be compulsory reading for all serious students of English literature, but which is now

somewhat forgotten, L. C. Knights ironically adopted the title 'How many Children had Lady Macbeth?'.[18] The narrative behind this essay is that Lady Macbeth says in the play 'I have given suck and know how blest it is to nurse the babe that milks me...', from which it is reasonable to conclude that she had had children. So presumably some number of children. Ellen Terry, in considering how to act Lady Macbeth, insisted that it is useful to ask herself how many these might have been, though we are given no indication. Knights' point, which is persuasive enough, is that since we are not told we should not ask. Somehow the question is not 'in' the play. What is in the play is what we are shown by, in a deeply unfortunate slogan, 'the words on the page'. Speculation beyond that misfocuses the work. But 'words on the page' cannot simply be ink-marks (Goodman asks 'black ink on black paper?'). Words, to be words of a text, need to be capable of being understood, and how we understand a word is what inferences we can draw from its use. Much the same must apply to how we understand a text. But in the case of fiction there seem to be strange constraints on this, whether our inferences are deductive or simply well-founded inductions from familiar situations. Suppose the same words that Lady Macbeth used were located in a non-fictional autobiography: then Ellen Terry's question would be a perfectly proper question for any subsequent researchers. If Mr Pickwick took a coach to Rochester is a fact about Pickwick Papers, is it a corresponding fact that Mr Pickwick took a four-wheeled vehicle that would be made redundant by the invention of the motor car? Is it a fact about *King Lear* that since

[18] L. C. Knights, 'How many Children had Lady Macbeth?', reprinted in *Explorations* (London: Chatto and Windus, 1958). It is remarkable how this now somewhat neglected essay makes claims that are frequently associated with a now fashionable postmodernism.

the play takes place in Britain at some time in the past
that it was either before or after the Battle of Agincourt,
or that Kent, Gloucester, and so on, did not ride round
central London on a bicycle? It is not simply that such
'facts' are uninteresting, but rather that they somehow
could not be facts about the fictions in question, even if
they follow from it. They would be (equally uninter-
esting) facts about such people or events if they were
recorded in non-fiction.

In general, what distinguishes a fictional text from a
non-fictional text is how in the former our inferences
'hang-fire'. The words of two texts might be the same
and in the same order, yet if one is fiction, the other non-
fiction, they will still, for this reason, be significantly
different texts.[19] The kind of fiction we have is also
determined by the kinds of ways we withhold them.
Shakespeare is drastically sparse in his story-telling.
Not only do Lady Macbeth's children make no
appearance, especially by inference, but, as Angela
Carter points out in *Wise Children*, a novel above all
about how these issues affect our conception of real
life,[20] *whatever* happened to Mrs Lear? Surely a family
as dysfunctional as that had *some* maternal disaster
behind it? Wrong question, perhaps, but why? It is not
an unilluminating question.

In a 'standard' sort of fairy story the princess and the
woodcutter end up married and (of course) live happily
ever after. A likely story! Here's this hulking brute with
no courtly conversation yoked to a fading spoilt princess
who was given him as a prize for valour. Does no one
ask how the marriage might have worked out? And

[19] See Goodman's discussion of Borges in *Reconceptions, op. cit.*, pp. 61ff.
See Jorge Luis Borges, 'Pierre Menard, Author of the Quixote', in
Labyrinths (New York: New Directions, 1962).

[20] Angela Carter, *Wise Children* (London: Vintage, 1992).

how was it for her when Miranda returned from her enchanted island? We should not conclude from this that fairy stories (or their unknown authors) make sentimental or sexist factual assumptions concerning what might be likely to happen given certain initial events. A type of romantic fiction notoriously does do this and we have every right to regard such stories as imposing intelligibility on us at the price of our adopting, or being encouraged to adopt, false or misleading beliefs. That *is* a form of corruption via fiction. The distinction is subtle but important. For the fairy story case is different. Its stereotyped conclusion is a fiction that frames the fiction within it. It is not that these stories are fictionally 'about' maritally over-successful lovers; they are in this sense 'about' princesses and woodcutters, but rather that these are framing 'genre' assumptions that tellers and told adopt in the negotiation of knowing what *sort* of story is being told.[21]

GENRE GAMES

In literary contexts the term 'genre' often functions as a rather crude classification of types of works or novels by characteristic subject matter, with the implication (as often used in painting) that a 'genre' work is a less serious, inferior variety of work. (So science fiction or the detective story is a 'mere' genre.) It is much better thought of as a variety of 'logical' category concerned with how our use of inferences as readers may or might not 'hang fire'. To mistake a genre is to mistake how to follow, to construe the story. James Thurber's reading of *Macbeth* as a detective story (it was the old man

[21] Jenny Lee has pressed me to say whether estimating a fiction's frame is the same process as estimating a metaphor's scope. They are clearly related tasks, but since metaphors are non-narrative fictions their methods will differ correspondingly.

who did it) shows how hilarious this may be.

Fictional writing, even devices of publication, normally establishes genre indicators. The Aristotelian distinctions between tragedy, its four types, comedy, epic, while apparently concerned with characteristic subject matter and formal composition, make far more sense if thought of as genre distinctions which really depend on the kinds of assumptions and expectations which are demanded of the properly informed audience; in effect that is what kinds of inferences should or should not 'hang fire'. In detective stories what is made most salient is what will engage the reader in the detection problem, often to the extent that the reader 'becomes' – adopts the fictional role of – a (not very successful) detective. In stories of fantasy or magic, somewhat differently in science fiction, not only are the normal 'laws of nature' fictionalized, but at the same time we learn what questions not to ask concerning their consequences. This is what it is for the reader to enter a fictional world.

As readers of such stories we fictionally become children of innocent, if wondering, curiosity. If the manner of such story-telling requires, or invites, a sparseness of other sorts of interest, so that by the standards of great and deep fiction the characters seem flat and uninteresting, so that 'we cannot identify with the characters', it may simply be that we have missed the point of that genre. Would if be fair to object to the story of Genesis, of the Myth of Gilgamesh, to the tale told in Spenser's *Faerie Queene*, that in such tales we find it hard to identify with the main characters?

The idea of a reader being able to 'identify' with a story's protagonist, really to feel that the story shows what it 'was like to be' that character is one that peaks late in the history of story, though its potential is there

from the start. All sorts of stories invite no such response on the audience's behalf. How it develops is as much part of the history of radically non-fictional moral theory as of the history of the art of fiction.

THE NOVEL IN THE GREAT TRADITION

If the conventions of the soliloquy or of the theatre provide a fictional frame of 'transparent' walls or of audible thoughts, the framing of the novel took this further towards something very like transparent heads. In none of these cases are they fictions 'about' such possibilities. The rise of the classic Nineteenth-Century Novel (what Leavis includes within the 'Great Tradition',[22] but the list is quite firmly extendable) depends in this sense on very firm framing. It is tempting to see this form of fiction as a natural – virtually inevitable – humanistic replacement for an essentially religious concept of moral justice and (accordingly) good, morally justified, judgement. The impulse behind this type of novel – the truly significant artistic invention of the post-Enlightenment world – is that of the moral necessity of deep human understanding. In the General Confession in the Anglican Prayer Book, God is referred to as the one 'to whom all hearts are open and from whom no secrets are hid'. To a moral theist, such as Milton, who laboured in his 'Great Taskmaster's eye', this could be a source of a sense of an objective moral order or of terror in about equal measure. The absence of such a God is not a matter for unrelieved gloom. But metaphysical privacy has its price. That God does know the morally relevant facts of human motivation, on which depends any consequent facts of true wickedness or stumbling virtue,

[22] F. R. Leavis, *The Great Tradition: George Eliot, Henry James, Joseph Conrad*, new ed. (London: Chatto and Windus, 1960).

at least implies that there is more to the moral life than mere (and hazardous) consequence and also that we mere humans should take care before rushing to judgement. For since what 'God (only) knows' we can't, only in such a final Judgement could a genuine concept of true moral guilt or innocence come into play. Human judges can at best stumblingly imitate this ideal. In the absence of such a God's eye view can there really be justice – even in the purely human world – which does not collapse into mere consequentialism?

POINTS OF VIEW
The Novel, as an art form distinct from mere story-telling – the dominant genre of fiction – can best be seen as an attempt to confront this question. It places the responsibilities of imagination at the moral 'eye-point'.

We may note that to Kant, as much as for Hume, who together focus the central debate that emerges from the moral Enlightenment, the core of morality – what determines whether an action is wicked or virtuous, as opposed to merely unfortunate or convenient for others – lies in the agent's motive. (The big debate of Kant with Hume is over what constitutes such motive.) But for Kant it is vital that we may know only so much – and often not that much – about the true motives of others or even ourselves. There are apparently two ways of responding to this. One is to abandon motivational moral theory for what we may more easily handle, at best a form of consequentialism modified just where we can by what we can reasonably know of motive and intention. Essentially this (especially including the modifications overlooked by countless utilitarians) is the option for J. S. Mill. The other is to hold to the motivational view and to think of a concept of a final

knowledge that defeats the 'opacity of the human heart', as Kant saw it, merely, if powerfully, as a necessary guiding ideal – this does indeed have the effect of limiting our capacity to finally censure others and ourselves, but it does so at the price of systematically postponing moral understanding. This is the real point of Kant's 'moral proof' for the existence of God and, at the same time, of his views on the absurdity of overwhelming human guilt. It matters greatly that the firmest statements of his views on this follow on from his labours to establish the role of imagination in achieving 'true sympathy'.[23] In the novel it is possible to conceive of a third alternative: that of replacing knowledge by the generosity of imagination.

It is thus no exaggeration to think of the novel as the institution that *establishes*, certainly does battle for, this concept within a moral culture. What falls within a canon of definitive Great Works here does not much matter, despite the passions raised by the question. But the central topics of *Middlemarch*,[24] of *Hard Times*, the perception of *Anna Karenina*, the puzzling, cautious, exchanges of Henry James's protagonists, must provide an inevitable starting point.

[23] Kant is often seen as the enemy of sympathy theory and on the evidence of his remarks in the First Moment, section 4 of the *Critique of Judgment*, to the effect that a man who acts well towards others '*because through sympathy he shares all their gratifications*', has no '*moral worth*' of his own. However, at the close of his discussion of aesthetic judgement he refers to the '*propaedutic to all fine art...being a sound education in the humaniora...because* humanity *signifies on the one hand, the universal* feeling of sympathy *and on the other the faculty of being able to* communicate *universally one's inmost self – properties constituting in conjunction the befitting* social spirit *of mankind*' (Kant's emphases) (Part 1, section 60, Appendix: *The Methodology of Taste*). Kant's argument is in effect that, contrary to the tradition to which Hume belongs, such sympathy is both difficult and essentially linked with the possibility of art and culture.

[24] *Middlemarch* is, I would suggest, an essentially Kantian novel in the sense indicated here.

THE COMMON GROUND OF HUMAN VARIETY
In many ways the Novel as a genre stands to modern
puzzles concerning moral psychology in a way that is
almost exactly comparable to how the invention of
perspective stands to Renaissance problems of the visual
perception of the real world. Both are in an important
sense *realist* forms of art, and each makes use of *natural-
istic* devices. The way in which this is so is highly
specific. Both types of communication, whether pictures
or stories, set out to establish and to celebrate the possi-
bility of making individual experience public. They
establish a concept of a public space – a 'politics of
imagination' – for hitherto private experience.

It is no accident that the tradition of perspective
construction in painting emerges when the science of
astronomy and mathematics of optics join forces with
the depiction of the public space of architecture, the
material analogue for an ordered 'polis', and then
becomes able to deploy its powers within the processes
of the negotiation of how the world can be perceived
and conceived from individual points of view ('eye-
points'), that make individual experience 'universally
communicable'. Precisely the same underlying
programme permeates the development of interlocking
psychological 'viewpoints' within the novel. As
perspective establishes and celebrates the possibility of
asking the question: 'What is it *like to see*...from a given
point of view', the novel in this genre does the same for
the question: 'What is it *like to be*...in a given
predicament'.[25] In each case both realism and
naturalism are established as the outcome of the *form* of
representation rather than its criterion of success.

[25] The phrase has achieved virtually technical currency since Thomas Nagel's
'What is it like to be a bat?'. See Thomas Nagel, *Mortal Questions*
(Cambridge University Press, 1979).

While some stories make the impossible plausible, these make the all too plausible, the apparently familiar, reveal possibilities we may never otherwise realize. To be serious they need to be subversive. Where they fail, as naturalistic fiction too often does, is to leave us still engrossed in the comfort of the familiar. Much effort has been spent on the implied distinction between these two terms. It is neither exact nor context-free, but in this context we can think of 'naturalism' as making the fewest possible changes in what is fictionally 'introduced' from how we with least reflection *suppose* things to be; while 'realism' challenges us with wider surprises concerning how we might be lead to recognize the way things 'really' are. Often the two are at odds with one another, but in these cases they pull together. Both forms of representational art establish a concept, a practice, of the 'objectification' of 'subjective' experience. They challenge and change our beliefs concerning what could be an object of experience. They make public within works of art what we might hitherto suppose to be private. Both perspective painting and the novel celebrate a specific humanist ideology: that there can be a common ground for human variety. The search for a clear idea of this is as old as philosophy, and the problem it traditionally presents is that it should be a concept of a common unity that 'undercuts' what can be formulated in clear, linguistically-defined definitions, since it is these which manifestly vary from people to people and from time to time. For Kant, as for others before him, the term for this was '*sensus communis*' which, far from meaning 'common sense' in the rather English sense of that phrase (that is as referring to what every sensible well-brought-up person should take for granted), at least gestures towards what can make even the strangest stories and the least conceptually definable

contents of non-linguistic art communicable. It stands, as it were, at the opposite pole to that occupied by a commonly agreed code of theory or practice.[26] It is thus unavoidably a concept that relates to the roles of art.

The battle fought within literature makes use of a fictional frame of apparently overwhelming simplicity, seemingly as overwhelmingly simple as the devices of perspective drawing. Neither sorts of device are in fact simple. For it is perfectly possible in fiction to let the reader know of the private thoughts, intentions and impulses of a fictional character who might not even herself have been able to articulate them. (The principle is already well established by the convention in epic and drama of the soliloquy.) A paradigm case is *Madame Bovary*. From the 'outside' it is a story of moral disaster. A bored, spoilt young woman marries a decent and caring doctor, wastes her life by betraying him with worthless lovers and finally dies in a despairing suicide. One way of regarding the novel may be that we see the whole thing from her point of view, so can imaginatively connect with her unhappiness, longing for a richer life, sense of betrayal, above all with how far she tries to do her best. We see not what would have been likely if... (there are no surprises there) but what it would have been *like* if.[27] We are shown this by being

[26] See Kant's use of *sensus communis* in the *Critique of Judgment*, especially the 'Fourth Moment of the Analytic of the Beautiful'. For Kant the aesthetic faculty was the power of 'communicating universally without recourse to concepts'. For a powerful and invaluable remedy against the persistent myth that this idea, and its accompanying tradition, is peculiar to Kant, or even to the period of 'common-sense' philosophy that preceded him, often associated with Locke and Shaftesbury, see David Summers, *The Judgement of Sense: Renaissance Naturalism and the Rise of Aesthetics* (Cambridge University Press, 1987).

[27] See Roger Scruton, *Art and Imagination* (London: Methuen, 1974), esp. pp. 98–9. Scruton rightly insists that the question: 'what would be likely if...?' as opposed to 'what would it be like if...' cannot do justice to our understanding of a novel. What he fails to consider is how we may traverse between the two.

shown what we could not see. What also matters is that this is not all we are shown. We don't switch sides: we are given 'both' sides.

THE MORAL CONTENT OF STORY-TELLING

A serious moral objection to stories such as that of Emma Bovary can be that they may radically distort our moral agenda, that to be lead (or seduced) by them to see that from the protagonist's point of view her actions were inevitable, is to regard them as at the same time forgivable. This is a strange, if popular doctrine, the sad second cousin to the Socratic doctrine that virtue is knowledge, that no one can do evil willingly or wittingly. It interprets the cliché that to understand all is to forgive all, as if it implied that what we disapprove of were inevitably unintelligible, and as if what is forgivable was not worth condemning in the first place. The challenge of fiction is however never to *assume* unintelligibility. It is this assumption that ushers in the twin ugly sisters of blind intolerance and irresponsible relativism – the idea, popularized by John Major, that it would be reasonable to try to understand a little less and condemn a little more. Wanton condemnation is hardly better than wanton tolerance, and is certainly more painful.

What can seem to be more puzzling is that understanding can indeed rest on what is itself a kind of fiction.

In *Middlemarch* we are shown facts about her inner life that Dorothea herself could not see. Henry James is the master of this device. In much of Dickens the procedure is more roundabout: not only can the protagonists, like Gradgrind in *Hard Times*, not go beyond the externals of behaviour, but the reader is presented with such externals in such a way that their absurdity,

comedy and horror derives from the fact that they cannot ever be mere externals. (Dickens can easily be thought to be a writer whose topic is the external absurdities of behaviour, as if that 'exterior' life was all, but always his comedy and rage depends on the fact that we know it cannot be all there is – as if not only can Hamlet not hear his own soliloquy, but that he at the same time disguises it from us. Dickens and Henry James are in this respect far closer than is often noticed.) In each case we are introduced to the action via a fictional frame: an assumption concerning the possibility of psychological knowledge that will make sense of the story.

It is important that this is a framing *fiction*; for it is not in fact the case that in normal life we can, however transparently others behave, know what we are shown so readily in novels. However, since it is a *framing* fiction, such novels are no more concerned with a strangely fictional world of 'transparent heads' than a drama performed behind a proscenium arch is concerned with a fictional world of strangely transparent walls. Most novels of this sort contrive to be as straightforwardly 'realistic' about our moral psychology as any drawing room drama behind a proscenium is 'realist' concerning domestic architecture. The framing fiction departs from non-fiction at a different level. But fiction may, if stories are told in a certain way, be about this matter too.

EMBARRASSMENT, FANTASY AND MAGIC: SUBVERTING THE OFFICIAL

Story-telling, like picturing, achieves its greatest power when it pushes to its own limits. The limits are essentially of two kinds. Much of what can distinguish serious stories (including the most light-hearted ones) from unserious stories is the extent to which they can

enlarge the scope of our own moral psychology, together with its tacit sense of decorum. Much of our every day moral experience, for example, sorts itself into what might be termed 'official' and 'unofficial' grief or joy. An 'official' grief, for example a normal bereavement, is one where one may simply have the right to expect sympathy and an attempt at understanding from others. In *Middlemarch*, by contrast, Casaubon's grief is 'unofficial', absurd and unacknowledged, even by himself, though it is part of the normal life of most jobbing academics. It is the simple and absurd disappointment that he is not a great mind. Most academics get by by disguising such grief from students and colleagues. George Eliot forces us to acknowledge it, if only in a fictional character. It is at all events a start. It is trivial that the erotic subject matter of much modern popular and unpopular novels has greatly enlarged the range of 'official' delight. Since decorum may matter, it is not surprizing that not everyone welcomes this, but there is no doubt that our only hope of enlarging the range of our sympathies does lie in fiction. We can be sure, however, that any serious story-telling concerning people must run the risk of being rude or embarrassing in much the same way that any 'thought' experiment concerning abstract possibilities may run the risk of confronting ways of conceiving of reality that are, if plausible, quite impossibly strange.

However, pushing to the limits can also mean something different, can be concerned with the limits of fictional intelligibility itself. This is a subtler matter.

THE LIMITS OF OUR WORLD: THE LIMITS OF THE FRAME

Famously, *Jane Eyre*'s final chapter opens with the line 'Reader, I married him'. Superficially this merely reinforces the novel's fiction that, like *Clarissa* or *Pamela*

and countless other novels, it is a novel of fictional report: that is, the fictional 'introduction' includes the text itself. In a sense almost any fiction, certainly any in the first person, may be said to imply this. But the final sentence extends the implications. If the reader fictionally supposes that it is a report, it is a report from someone to another: then in the reading *both* become fictional. 'I' manifestly has to do with a fictional character, what of 'reader'? Is that not a fictional pseudo-reference too? Yet surely we know who the reader is as well as we could know anything; it is *us*, just about to put the book down as we approach the conclusion, and make a cup of perfectly non-fictional tea.

In fact this is a mistake, and that it is a mistake gives the clue to how the naturalism of the story invites a sense of deeper realism, paradoxically, right on the borders of the absurd. For almost any story taken seriously will implicitly examine the nature of fiction itself. The reader in the act of reading has to adopt both fictional and non-fictional stance.

Much is said, for example, concerning James's novels of the convention of 'the omniscient author'; the deeper, subtler and more pervasive convention has to do with the 'omniscient' or super-knowledgeable reader which can at the same time be tantalizingly hard to sustain. This is why historical novels which show us the thoughts of past people of whom there is no such record, or cinema which shows us views of action that could not have been shot in real life, depart both radically from the constraints of non-fiction and at the same time do so in ways that can be curiously difficult for the audience, imaginatively engaged in the story, to be aware of. For to become aware of that is for the audience, the reader, the told, to be aware of, and be prepared to change, their

own role. To be absorbed in a story, to become to that degree fictional oneself forces the contrast we can then find between that role and our normal non-fictional lives. There is nothing new – nothing especially 'post-modern' in this.

Fiction that targets this fact has to do with appearance and reality, surfaces and depths. Weak versions of the genre leave us unchallenged about this. Jonathan Swift horrifyingly remarked that beauty surely *is* only skin deep: 'The other day I saw a woman flayed and you will never credit how much it altered her person for the worse'. In *Frankenstein*, Mary Shelley tells a, now over-familiar, story of a monster created by an overweening scientific ambition, but what is less familiar is the real horror of the story. Not only is the creature of Frankenstein unloved, but because of the casually serious, high-minded intent of his creator, he is horrify-ingly unlovely, ghastly to look upon. The only one who can respond to the inner life we know he has is a blind revolutionary who cannot see his face. It makes no difference that Frankenstein's project was beyond belief: it is set in what we may be challenged to reflect may be a real possibility about our normal world.

TWO FACES OF FANTASY AND FARCE

'Fantasy' may mean quite different things, two of which widely contrast. That we have the same term for each may be significant, but it lies at the source of many of our confusions over the function of fiction.

In the sense in which fantasy is a form of corruption of belief it is where we find it hard to tell or keep aware of the difference between fact and fiction. (Again recall the Teddy bear.) The naturalistic dramas of soap opera provide a relatively harmless, if dramatic, case. So-called 'factoid' television or film drama, which melds

fact with fiction, like the newspaper tradition of 'true confessions', are more dangerous. Fiction, in which what is introduced as fiction or part of the frame systematically resists our ability to identify their fictional status, may be more dangerous still. Fantasy and farce is the proper antidote to this form of corruption.

To tell a good fantasy in this latter way, a degree of naturalism helps no end. If an ogre pours water over someone, or gets his boots muddy at some point in the story, it had better be real water and dirty mud. If it is magic un-wet water, or un-dirty mud, something else had better break in from the normal world to rescue the force of the fiction. The weak fantasies of Disneyworld avoid such challenges – insofar as they do, they, however un-naturalistic, become fantasy in the former sense.

What has recently been called 'magic realism' and regarded as a genre of postmodernism is in this way no more than the constraints of any imaginative story telling made slightly more manifest than usual. In fact there is nothing new about the form. In the stories Angela Carter tells, we are given all the patterns of expectation of fairy story, not merely the magical suspension of normal causal laws (as Fevvers grows wings in *Nights at the Circus*),[28] but the expectation of fairy story endings. What comes to matter is that Fevvers sweats and suffers for all the strangeness of her world, as we would. The 'realism' makes the magic matter, for we are thereby asked to confront just how important these 'surface' distractions are to our wilder fantasy lives. It is as if her overriding question was to ask whether at the end of the day the woodcutter married to the princess really did live happily ever after, and who did do the washing-up. In principle nothing is done here with our genre expectations, our assump-

[28] Angela Carter, *Nights at the Circus* (London: Vintage, 1994).

tions of how we should draw implications from the
text, that is not done in *The Tempest*, for the tragi-
comic forms of Shakespeare's late plays equally depend
on such genera twists.

However, strange, magic or farcical stories cut deeper
than that. The interpenetration of the strange with
what we take as realistic confronts something far more
dangerous. The running question in, for example,
Salman Rushdie's *The Satanic Verses*, is how could we
tell, and on what evidence, what or who, is really good
or evil, illuminating or misleading. To be sure, this
presents a challenge to a naïve interpretation of the idea
of a revealed text, and does so by the traditional devices
of fictions incorporated within fictions, so that the tease
to the reader is constantly to ask what story it really is
that is being told.

Tragically, as we know, such devices can themselves
cause confusion and offence. What is of considerable
importance is how very far from new they are. They are
as ancient as story-telling, for they are implicit in its
practice. For the plot patterns Rushdie uses are essen-
tially those of the *Book of Job* (whose author is
presumably by now fairly safe). Job is in many ways our
definitive and most profound moral farce. Like all farce
– that most serious of genres – it directly confronts the
limits of intelligibility and of our need for intelligibility.
In that story we are told how a manifestly good and fair
man is put to the test to see whether he is really altru-
istic or merely seeking a further reward, by what is in
effect a deal struck between God and Satan to treat him
with monstrous unfairness to find out when he will
crack, and suppose himself to be – as he knows he is not
– deserving of his sufferings. He passes the test by *not*
accepting (as his false comforters wish him to) that he
deserves his suffering. Satan here is very far from the

Christian Devil. Rather he is the Questioner: God's External Examiner. Job is put to the test as if by two slightly demented dons unable to credit a student's excellent work. 'Hast thou', says God to Satan, 'considered my servant Job?'. But surely 'no man does good for ought'. So the experiment is run to its limits. We, the readers, see behind the scenes what Job cannot see, and in doing so can see just how unfairly God has permitted him to be treated. (Everything depends here on the tension between what we, as opposed to the protagonist, can understand or be puzzled by). Job's test is to resist his false comforters, who in the traditional language of moral sermonizers through the centuries, attempt to persuade him that he deserves his sufferings. That would make a certain sense, at least, but not if goodness may not be the outcome of a deal even, or especially, with God. Finally, and absurdly, given the assumptions of the story, he is rewarded – for realizing that rewards are not the point. His question 'why do the wicked prosper' is left unanswered as irrelevant. His confrontation with God's works in nature is, on the face of it, to make the simple, if uncomfortable, point that if he expects to get a straight answer from a divine source he is asking the impossible. Unlike us, in a world of science, for Job the natural world is *manifestly* incomprehensible. Like us, he demands of the moral world that we may *attempt* to make sense of it. The core of the comedy is that in order to follow the story at all we can make perfect sense of what is happening (an examiner's meeting of the faculty of the Sons of God) though by no means the sense that Job, or we, want. What we can make sense of is that we do seek such intelligibility, but that if we do we are, as Job has to accept that he is, on our own in doing so.

Part of what such stories as *Job* are concerned with

concerns the foundations of moral intelligibility, but the issue is wider than that. If, as Plato's *Euthrypho* puts it, the gods are good because they love what is good this is something we can attempt to make sense of but then there is no need of the gods to show us what goodness is. If on the other hand piety, goodness, is simply whatever the gods love, we inevitably run the risk that goodness becomes unintelligible to us. No way can we have it both ways: the search for intelligibility, which includes a recognition of the limits of what we may grasp, requires the recognition that we are on our own, not, as many have thought – as in the post-Nietzschian, post-Dostoevskyan tradition of the Death of God would have it – that 'everything is permitted' but rather, that this is what constitutes a responsibility towards the intelligible.

What redeems Job is not that he is humbled (God says to him 'stand upon thy feet and be a man') but that he, and we as we read the text, experience a form of delighted awe. Wonder may be, and in religious contexts all too often is, a form of imaginative subservience. The significance of Job's wonder is that it is the reverse of subservient. For Kant such awe was the heart of the sense of the Sublime, essentially for him a moral category that celebrates the limits of our own powers of thought and action, but which does so at the opposite end of the scale from subservience. In this century we have abandoned the term 'sublime' largely because we have enlarged its scope far beyond what early Romanticism would have recognized. What redeems the cruelty of the farce in *Job* is the celebration of wonder at the limits of intelligibility, in Job's case of the natural – and thus of the created – world. (It is significant how much of the text of Mary Shelley's *Frankenstein* chimes with this.) In Rushdie's stories the

limits of the intelligibility of the human world provide an occasion for a corresponding celebration. Comedy and farce at its deepest celebrates and delights in the wondrous absurdity of us humans.

Troilus tells Cressida 'Tis the monstrosity of love lady that the will is infinite, the execution is confin'd and the act a slave to limit'. Read one way this sounds like a deep expression of the human predicament in a confusing world. Read another way (a very proper reading in the context of a play about erotic disaster) it is a richly comic description of the failure of male sexual aspiration. What matters is to take it both ways. To find ourselves comic, absurd, perhaps especially in erotic contexts, where notoriously our most elevated romantic desires co-exist with our strange and awkward behaviour, is to confront ourselves as those beings who are in Kant's phrase 'at once both animal and rational'.[29] Kant would have been shocked to think so, but the Rabelaisian tradition of vulgar comedy and the Sublime of the Romantics are two sides of the same coin. This is the common coin of James Joyce, Samuel Beckett, Henry Miller, but coin minted when first stories were told. Dennis Potter disturbs television audiences with this simple fact. We mistake it for what it is when we suppose it to be about the limits of decorum: it is really about the limits of intelligibility.

Wittgenstein remarked in the *Tractatus* that the limits of my language are the limits of my world. One way of taking this is that what we can understand can never go beyond what we can communicate. In a rather obvious sense this is true, but its corollary is that we tend to live at those limits. If the representational, mimetic, arts are concerned with any one thing it is to confront this fact.

[29] *Critique of Judgment*, part 1, First Moment, section 5.

Often enough the result may be worth little, for much serious endeavour in the arts, as anywhere else, has indeed resulted in genuine nonsense and failure. Sometimes – just often enough – the result may be to establish a new possibility of a shareable world.

BIBLIOGRAPHY

Leon Battista Alberti, *On Painting*, trans. with an introduction by John R. Spenser (New Haven and London: Yale University Press, 1966).

Svetlana Alpers, *The Art of Describing. Dutch Art in the Seventeenth Century* (London: John Murray in association with University of Chicago Press, 1983).

Aristotle, *Aristotle's Poetics and Rhetoric, Demetrius on Style, Longinus on the Sublime*, trans. T. A. Moxon (London: Dent, 1955).

——, *The Poetics of Aristotle*, trans. Stephan Halliwell (Chapel Hill: University of North Carolina Press, 1987).

——, *The Ethics of Aristotle*, trans. J. A. K. Thomson, (Harmondsworth: Penguin Books, 1953).

Michael Baxendall, *Patterns of Intention, On the Historical Interpretation of Pictures* (New Haven, Conn.: Yale University Press, 1985).

Monroe C. Beardsley, *Aesthetic Inquiry* (Belmont, California: Dickenson, 1967)

——, *The Aesthetic Point of View* (Ithaca, New York: Cornell University Press, 1982).

John Berger, *The Success and Failure of Picasso* (Harmondsworth: Penguin Books, 1965).

197

George Berkeley, *New Theory of Vision and Other Writings* (London: Dent, 1910).

Max Black, *Models and Metaphors* (Ithaca, New York: Cornell University Press, 1962).

Simon Blackburn, *Spreading the Word, Groundings in the Philosophy of Language* (Oxford: Clarendon Press, 1984).

Neil Brown (ed.), *Occasional Seminars in Art Education* (Sydney: University of New South Wales, 1993).

Ernst Cassirer, *Language and Myth*, trans. Susanne K. Langer (New York: Dover, 1952).

Stanley Cavell, *Must We Mean What We Say?* (London: Cambridge University Press, 1976).

R. G. Collingwood, *The Principles of Art* (Oxford: Clarendon Press, 1938).

David Cooper, (ed.), *A Companion to Aesthetics* (Oxford: Blackwell, 1992).

Arthur Danto, *The Transfiguration of the Commonplace* (Cambridge, Mass.: Harvard University Press, 1981).

Donald Davidson, *Inquiries into Truth and Interpretation* (Oxford: Clarendon Press, 1984).

Donald Davie, *Articulate Energy*, reprinted with postscript (London: Routledge and Kegan Paul, 1976).

Daniel Dennett, *Brainstorms* (Brighton: Harvester Press, 1985).

René Descartes, *The Philosophical Writings of Descartes*, trans. John Cottingham, Robert Stoothoff and Dugald Murdock (London: Cambridge University Press, 1985).

William Empson, *The Structure of Complex Words*, third edition (London: Chatto and Windus, 1977).

——, Seven Types of Ambiguity (Harmondsworth: Penguin Books, reprint 1961).

Paul Feyerabend, *Against Method*, revised edition (London: Verso, 1988).

Galilei, *Dialogue Concerning the Two Chief World Systems*, trans. Stillman Drake (University of California Press, 1962).

E. H. Gombrich, *Art and Illusion* (London, New York: Pantheon Books, 1960).

——, *The Image and the Eye: Further Studies in the Psychology of Perception* (Oxford: Phaidon, 1982).

——, *Meditations on a Hobby Horse and Other Essays on the Theory of Art*, fourth edition (Oxford: Phaidon, 1985).

Nelson Goodman, *Languages of Art* (Indianapolis: Hackett, 1976).

——, *Ways of World-making* (Hassocks: Harvester, 1978 and Indianapolis: Hackett, 1978).

——— and Catherine Z. Elgin, *Reconceptions in Philosophy and Other Arts and Sciences* (London: Routledge, 1988).

Richard Gregory, *The Intelligent Eye* (London: Weidenfeld and Nicolson, 1971).

Roy Harris, *Reading Saussure: A Critical Commentary on the Cours de Linguistique Générale* (London: Duckworth, 1987).

——, *Language, Saussure and Wittgenstein: How to Play Games with Words* (London: Routledge, 1988).

Andrew Harrison, *Making and Thinking* (Hassocks: Harvester, and Indianapolis: Hackett, 1978).

——, (ed.), *Philosophy and The Visual Arts, Seeing and Abstracting*, Royal Institute of Philosophy Conferences (Dordrecht: Reidel, 1987).

John Hayman, *The Imitation of Nature* (Oxford: Blackwells, 1995).

Michael Ann Holly, *Panofsky and the Foundations of Art History* (Ithaca and London: Cornell University Press, 1984).

T. E. Hulme, *Speculations: Essays on the Philosophy of Art and Humanism*, ed. H. Read (London: Routledge 1936).

David Hume, *Treatise of Human Nature*, ed. L. A. Selby-Bigg (Oxford: Clarendon Press, 1978).

——, *Enquiries Concerning the Human Understanding*, ed. L. A. Selby-Bigg (Oxford: Clarendon Press, 1975).

——, *Of the Standard of Taste and Other Essays*, ed. J. W. Lenz (New York: Bobbs-Merrill, 1965).

Immanuel Kant, *Critique of Judgment*, trans J. C. Meredith (Oxford: Clarendon Press, 1961).

——, *Critique of Pure Reason*, trans. Norman Kemp Smith (London: Macmillan, 1929).

——, *Selections*, translated and edited by Lewis White Beck (New York: Macmillian, 1988).

Salim Kemal and Ivan Gaskell (eds.), *The Language of Art History* (Cambridge University Press, 1991).

Johannes Kepler, *Kepler's Somnium*, trans. Edward Rosen (Madison: University of Wisconsin Press, 1967).

Søren Kierkegaard, *The Journals of Søren Kierkegaard*, trans. Alexander Dru (London: Oxford University Press, 1938).

Paul Klee, *The Thinking Eye, The Notebooks of Paul Klee*, trans. Ralph Manheim (London: Lund Humphries, 1961).

L. C. Knights, *Explorations* (London: Chatto and Windus, 1958).

Saul Kripke, Naming and Necessity (Oxford: Blackwells, 1980).

Thomas S. Kuhn, *The Structure of Scientific Revolutions*, second edition (Chicago University Press, 1970).

George Lakoff and Mark Johnson, *Metaphors we Live By* (Chicago University Press, 1980).

Peter Lamarque, *Truth, Fiction and Literature*, (Oxford: Clarendon Press, 1996).

Gotthold Ephraim Lessing, *Laocoon*, trans. R. Phillimore (London: Routledge, 1874).

F. R. Leavis, *The Great Tradition: George Eliot, Henry James, Joseph Conrad*, new ed. (London: Chatto and Windus, 1960).

C. S. Lewis, *The Allegory of Love*, (Oxford University Press, 1936).

David Lewis, *Counterfactuals* (Oxford: Blackwells, 1973).

John Locke, *Essay Concerning Human Understanding*, ed. Peter H. Nidditch (Oxford: Clarendon Press, 1975).

Thomas Nagel, *Mortal Questions* (Cambridge University Press, 1979).

Erwin Panofsky, *Perspective as Symbolic Form*, trans. Christopher S. Wood (New York: Zone Books, 1991). Derek Parfitt, *Reasons and Persons* (Oxford: Clarendon Press, 1984).

David Pears, *The False Prison, A study in the Development of Wittgenstein's Philosophy* (Oxford: Clarendon Press, 1988).

Steven Pinker, *The Language Instinct, the New Science of Language and Mind* (London: Penguin, 1995).

Andrew Pyle, *Atomism and its Critics* (Bristol: Thoemmes Press, 1995).

Willard van Orman Quine, *From a Logical Point of View*, second edition (Cambridge, Mass.: Harvard University Press, 1980).

―― and J. S. Ullian, *The Web of Belief* (New York: Random House, 1978).

John Ruskin, *Modern Painters* (Orpington: George Allen, 1888) edited and abridged by David Barrie (New York: Alfred A. Knopf, 1987).

Bertrand Russell, *An Enquiry into Meaning & Truth* (London: Allen and Unwin, 1940; Harmondsworth: Penguin, 1962).

Gilbert Ryle, *The Concept of Mind* (reprinted London: Penguin Books, 1995).

——, *Dilemmas: The Tarner Lectures, 1953* (Cambridge University Press, 1954).

Flint Schier, *Deeper into Pictures* (Cambridge University Press, 1986).

Donald Schon, *Displacement of Concepts* (London: Tavistock Publications, 1963).

Roger Scruton, *Art and Imagination* (London: Methuen, 1974).

——, *The Aesthetic Understanding* (Manchester: Carcanet Press, 1983).

David L. Sills (ed.), *International Encyclopedia of the Social Sciences* (New York: Macmillan, 1968).

Paul Smith, *Cézanne* (London: Tate Gallery, 1996).

David Summers, *The Judgement of Sense: Renaissance Naturalism and the Rise of Aesthetics* (Cambridge University Press: 1987).

Charles Taylor, *Sources of the Self* (Cambridge University Press, 1994).

Godfrey Vesey (ed.), *Philosophy and the Arts*, Royal Institute of Philosophy Lectures, vol. 6 (London: Macmillan, 1973).

Kendall L. Walton, *Mimesis as Make-Believe* (Cambridge, Mass.: Harvard University Press, 1990).

Kathleen V. Wilkes, *Real People: Personal Identity Without Thought Experiments* (Oxford: Clarendon Press, 1988).

Raymond Williams, *Keywords, A Vocabulary of Culture and Society*, revised edition (London: Fontana, 1983).

W. K. Wimsatt, *The Verbal Icon* (Lexington: University of Kentucky Press, 1954).

Ludwig Wittgenstein, *Tractatus Logico-Philosophicus*, trans. D. Pears and B. McGuinness (London: Routledge & Kegan Paul, 1961).

———, *Philosophical Investigations*, trans. G. E. M. Anscombe (Oxford: Blackwell, 1958).

———, *Zettel*, (Oxford: Blackwell, 1967).

———, *Culture and Value*, ed. G. H. von Wright with Heiki Nyman, trans. Peter Winch (Oxford: Blackwells, 1980).

Richard Wollheim, *Art and its Objects*, second edition (Cambridge University Press, 1980).

———, *On Art and the Mind* (London: Allen Lane, 1973).

———, *Painting as an Art* (London: Thames and Hudson, 1987).

———, *The Mind and its Depths* (London and Cambridge, Mass.: Harvard University Press, 1993).

Nicholas Wolterstorff, *Works and Worlds of Art* (Oxford: Clarendon Press, 1980).

INDEX